THE GREAT WAR
IN PORTRAITS

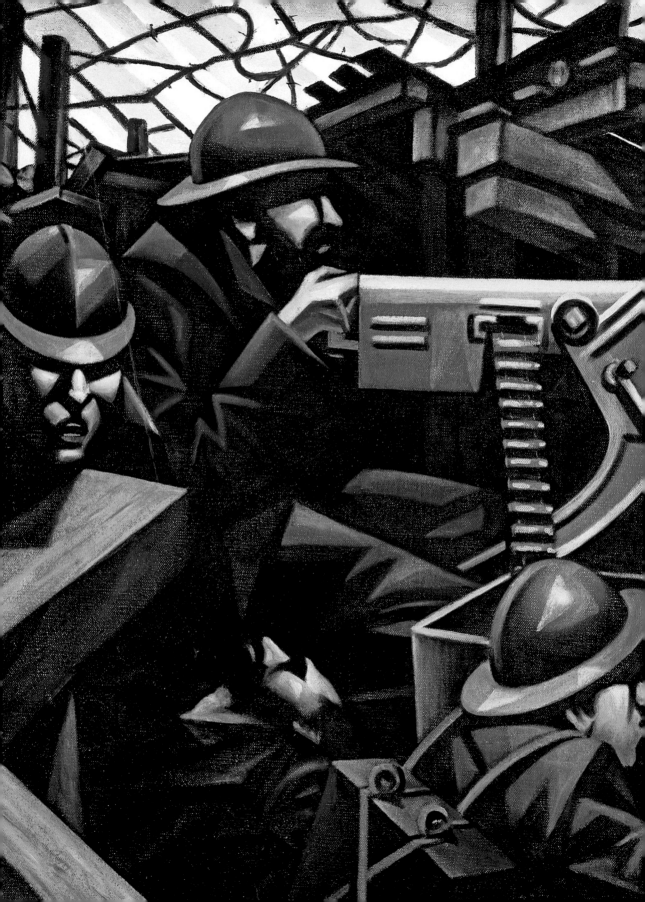

THE GREAT WAR
IN PORTRAITS

PAUL MOORHOUSE

with an essay by **SEBASTIAN FAULKS**

NATIONAL PORTRAIT GALLERY, LONDON

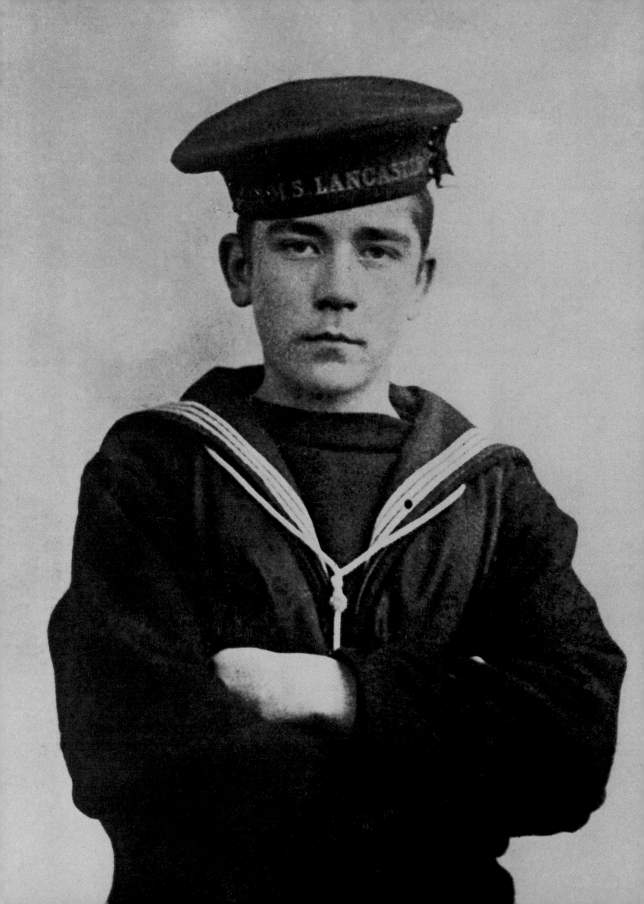

CONTENTS

DIRECTOR'S FOREWORD

In all my dreams, before my helpless sight,
He plunges at me, guttering, choking, drowning …
Wilfred Owen MC, 'Dulce et Decorum est',
1917–18

How can words, or works of art, represent a
conflict widely regarded as indescribable because
it is so appalling and extends so far beyond any
previous experience? The question was examined
by Paul Fussell in his *Great War and Modern Memory*,
published nearly forty years ago. The poignant
descriptions he analysed, in letters and cards
sent back from the trenches (which in turn fed
into poems on memoirs), exemplified a process
by which words masked what could not be
confronted directly: the dead were alluded to as
'the fallen'; horses became 'steeds'; arms and legs
were replaced by the more abstract 'limbs'. Such
masking might also apply to formal portraiture,
images crafted with the particular purpose of
honouring those selected to be recorded and
which are then transferred into history. Perhaps
this was less the case for those artists and
photographers who were direct participants (if
they were able to avoid official censorship), who,
like their fellow poets and writers, struggled
to make sense of their own suffering or the
experiences of those around them.

A hundred years after the event we may look
back with more equanimity but perhaps no more
understanding of the scale of the conflagration
and the losses. However, to examine painted or
photographic portraits, whether formal portrayals
of heads of state, politicians and generals, or
documentary portraits of soldiers and civilians, is
to trace an important path – be it fragmentary and
selective – back to the participants. We can try to
look at those who were part of the Great War, even
if we still struggle to understand it.

The National Portrait Gallery has developed
several strands to its centenary commemorations:
this exhibition of portraits and its accompanying
publication; a project involving young people made
with partner museums across the United Kingdom
and generously supported by the Paul Hamlyn
Foundation; displays of material from the Reference
Collection; the conservation of the large-scale
group portrait by Arthur Stockdale Cope of naval
commanders; and a music programme led by the
newly formed Portrait Choir.

Paul Moorhouse, Curator of Twentieth-
Century Portraits at the National Portrait Gallery,
has created in this exhibition a well-argued and
balanced view that cuts across questions of rank,
class and nation. I am most grateful to him, and to
Clare Barlow, Assistant Curator, who, with Rosie
Wilson, Head of Exhibitions, and Ian Gardner,
Designer, have worked so hard to assemble and
shape it, and to Pim Baxter, Deputy Director, who
has overseen the wider programme. I am especially
grateful to Sebastian Faulks for his brilliant
evocation of the connecting threads between the
testimony of survivors and published literary texts.

There are many others at the Gallery I should
also thank, including Michael Barrett, Nick Budden,
Robert Carr-Archer, Andrea Easey, Neil Evans,
Michelle Greaves, Justine McLisky, Ruth Müller-
Wirth, Doris Pearce, Vivienne Reiss, Andrew Roff,

Nicola Saunders, Christopher Tinker, Sarah Tinsley, Denise Vogelsang and Helen Whiteoak.

The National Portrait Gallery is very grateful to all those who have lent works for the exhibition, and I wish to acknowledge the considerable support offered by colleagues at the Imperial War Museum in its research and development, and to thank Diane Lees, Director-General, for approving a number of important loans and encouraging such a creative collaboration between national institutions.

In addition, I would like to acknowledge the help of individual supporters of this exhibition, who have played a valuable part in making *The Great War in Portraits* possible.

Sandy Nairne
Director, National Portrait Gallery, London

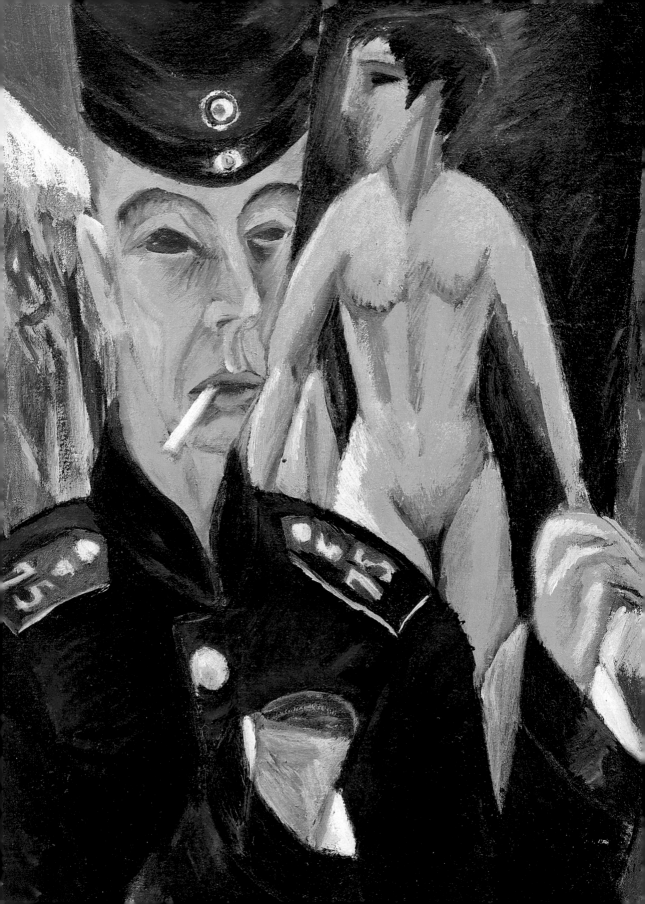

CURATOR'S FOREWORD

This book is not a military history. It accompanies an exhibition organised to mark the centenary of the outbreak of the Great War. But neither the publication nor the selection of exhibits is principally concerned with strategies, battles and outcomes, however momentous. While extraordinary martial developments define one of the worst conflicts of the twentieth century, the events of 1914–18 are still, almost a hundred years later, difficult to comprehend. Indeed, it could be argued that with the passing of the last surviving participant we are further away than ever from understanding what the war was like for those who experienced it, what it meant to the individuals involved, and how it was perceived by its observers. Statistics relating to the huge losses sustained, the reconstruction of events and analysis of the wider context all provide an indispensable framework for approaching this enormous subject. But to grasp the war in its human aspect, a different and, arguably, more immediate perspective is needed.

In curating *The Great War in Portraits*, these considerations were my starting point. The First World War can seem remote. The passage of time and the overwhelming historical significance of the first ever global conflict have removed it from the realm of the everyday. Yet in other ways it strikes a vital, even intimate chord. Seen in terms of its protagonists – those who were there, acting and reacting, seeing, thinking and feeling – human sensibility provides a common currency that unites different backgrounds and nations. Whether conveying pride or fear, confidence or doubt,

portraits form a rich repository of experience, bridging the years and speaking to us directly in terms we can recognise. Such images say much about the lives of those men and women who were caught up in the war's unfolding narrative and, ultimately, their different destinies. They also tell us a great deal about those who created these images. The work of painters, sculptors, photographers, filmmakers and propagandists appears in the following pages. Their distinctive responses are permeated by ideas, attitudes and values that bear the stamp of the time and, in some cases, the imprint of personal involvement. Finally, portraits made during the Great War may be tested for their capacity to influence those who first saw them when searching for meaning amidst events that, even then, seemed incomprehensible.

This book presents a view of the Great War seen through the lens of portraiture. It examines the ways that an international catastrophe was represented through a rich and diverse visual record of its participants, and it explores the effect that portraits and images of individuals had on the way the war was perceived and understood. The essay title 'A Richer Dust' refers to a phrase in Rupert Brooke's poem 'The Soldier'. Brooke's words are significant in the present context because they allude to the twin themes of the exhibition. Primarily, I have used the epithet 'a richer dust' to convey something of the bitter-sweet nature of the human drama enacted. 'Dust' evokes the dreadful consequences of mechanised fighting. For the first time, human slaughter was perpetrated on an industrial scale as artillery and machine-gun fire

replaced the cavalry charge and the sabre. But, as Brooke implied, there was an inherent nobility in this all-too-frail flesh. The very vulnerability of those who took up arms illuminates a human conduct that continues to move us and to command respect. Acts of remarkable courage and selfless endeavour, sustained by friendship and loyalty, provide a vital counter-balance to humanity's darker side. Both these facets – tragic and noble – are revealed in the portraits selected, forming a telling account of human nature under duress.

Brooke's poetic imagery also alludes to the theme of identity, which connects the various representations assembled here. It evokes the human spirit, which, though atomised and mixed with earth, is, in a profound sense, indestructible and contains the seeds of rebirth. 'A pulse in the eternal mind' – whether collective memory, the cosmos or a noumenal reality – the individual endures. Structured around people, both the book and exhibition investigate and celebrate the idea of identity, exploring its visual representations in the context of the war. This approach intimates the different roles and responsibilities that this unique generation assumed, the stories they inhabited, their achievements and the fates that befell them.

Divided into six sections, *The Great War in Portraits* opens with 'The Rock Drill', the title of one of the great early Modernist sculptures by Jacob Epstein. An apotheosis of modern mechanised man that also ranks as a self-portrait, this dismembered figure acts as a prologue to the ensuing narrative. The changes that Epstein made to the sculpture between 1913 and 1916 mark a move from excited anticipation to disillusionment, a passage that characterises the war as a whole. Next, 'Royalty and the Assassin' comprises formal portraits of heads of state. For reasons of space, the exhibition cannot do full justice to the international nature of the conflict. This section therefore draws together emblematic regal portraits of the principal players – Austria-Hungary, Britain, France, Germany and Russia – and attempts to convey a sense of the attitudes that, in part, created the conditions for war. Pride, imperial majesty and military might were complicit ingredients. A photograph of Gavrilo Princip, the assassin of Archduke Franz Ferdinand, suggests the catalyst for the conflagration, which reduced grandeur to tatters.

'Leaders and Followers' focuses on the military leaders who directed the process of mobilisation following the declarations of war in 1914. The senior figures depicted – Haig, Foch, Hindenburg and Brusilov – were each associated with major battles and staggering casualties. Nevertheless, through formal portraits and widely reproduced imagery, they all attained a remarkable degree of celebrity, their perceived importance underpinned by the projection of personal status and the trappings of achievement. This contrasts sharply with portraits of ordinary soldiers, characterised by anonymity and generalisation. As will be seen, stripping the rank and file of their individuality was calculated to promote an ethos essential to the conduct of war, that of selfless duty.

The final sections concentrate on a complex range of experience. 'Fact and Fiction' examines the representation of a single event, the Battle of the Somme, from a British and a German perspective. In both cases, cinema was employed for, and susceptible to, the aims of propaganda. Framed by the opposed ideas of achievement and destruction, 'The Valiant and the Damned' brings together photographs of forty individuals from different walks of life. As the accompanying stories demonstrate, the war was a lottery, a game of

chance played out irrespective of personal background or history. For those ennobled by military decoration and others killed in action, honour and death were cards dealt impartially. 'Tradition and the Avant-garde' forms a conclusion or, rather, an epilogue. By 1916, the spectacle of individual lives wrecked by the violence of war had assumed a depressing normality, posing questions about human nature and its capacity to perpetrate such horrors. This section examines the work of artists as they struggled to make sense of a changed world. Their efforts encapsulate the book's ultimate theme. In the search for an appropriate visual language in which to respond to the war's terrible legacy, portraiture conveyed a radically altered perception of mankind.

Paul Moorhouse
Curator of Twentieth-Century Portraits
National Portrait Gallery, London

THE MEMORY OF WAR

Sebastian Faulks

Our memory of the First World War – the Great War – has always been a problem. Look at the events that surrounded the death at the age of 111 of the so-called 'last fighting Tommy', Harry Patch, in 2009. Patch saw action for three months, from June to September 1917, before being wounded at the Battle of Passchendaele, taken out of the line and shipped back to England in December. He believed war was 'organised murder'. He said in 2005: 'Why should the British government call me up and take me out to a battlefield to shoot a man I never knew, whose language I couldn't speak? All those lives lost for a war finished over a table. Now what is the sense in that?'[1]

Yet towards the end of his life, two poet laureates wrote poems for him; Bristol University awarded him an honorary degree; he was given the freedom of the city of Wells; Radiohead composed a song for him; Bloomsbury published a biography of him; he was honoured by French and Belgian governments; he had a racehorse named after him; his funeral was held in Wells Cathedral and the Prince of Wales paid tribute. All this not for a

military exemplar but for someone who believed that war is the 'condoned slaughter of human beings', which 'isn't worth one life'.[2]

For more than eighty years, Harry Patch was a plumber; he then lived in retirement in Bristol. During this time, no one interviewed him about the Great War and he didn't talk about it. He was clearly a much-liked man; but the excessive attention paid to his death seemed to be motivated in part by a sense of guilt about our collective failure to inquire into the nature of that holocaust. Could making a fuss of one reluctant Lewis-gunner with three months' active service to his credit somehow make up for the fact that for decades we had failed to grasp the enormity of what took place, or extend to those who fought in the war the compassion and curiosity that was their due?

There are some good reasons why remembering has been so difficult. First among these is that those in a position to remember – the servicemen – largely chose not to. Imagine. You leave your factory, office or farm because your country is at war and you want to 'do your bit'. Other chaps are going, too – old schoolmates, work colleagues. Training is brief and outdated, based on the experience of colonial wars of the last century, with mounted cavalry expected to be decisive. Then you find yourself in the greatest slaughterhouse of history, where almost ten million men will be exterminated by mounted machine guns and tens of millions more will be maimed, crippled or wounded. You will hear that three empires have collapsed as you build your makeshift home in mud and excrement and body parts.

And when you return home, on leave, or wounded, or, with luck, demobilised in 1918, you will find that people have little idea of what you have endured, and not much interest in it either. They

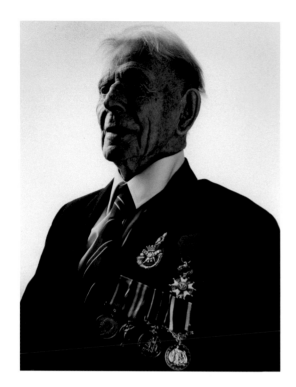

Harry Patch
Giles Price, 7 December 2004

aggressively journalistic about them, as they attempt to expose the 'old lie' that it is a fine thing to die for one's country by counter-proposing a harshly coloured picture of the reality of fighting; Wilfred Owen threw out almost all he knew of poetic diction to find a new language for subjects not previously deemed 'poetic'. His best poems, however, are to some extent distress signals and by their nature lack perspective (Owen was killed shortly before the Armistice). The famous memoirs that emerged in the late 1920s had gained some distance, but most have an officer-class irony and are still numb with the sense of a trauma that has not been assimilated. The war novels of the period are largely re-workings of personal experience with some names changed, though in the best of them, such as Frederic Manning's *The Middle Parts of Fortune* (1929), there is a sense of the material starting to be shaped.

The theatres of the Great War were all overseas; there were no battles in this country and that fact may also have contributed to our difficulties with memory. A 'foreign' war – even one that has personally affected almost every family in the country – is in some ways easier to forget. There was no eight-month siege of Dundee, no 60,000 casualties in a single day at Gloucester. In France, it was natural in the decades after the war for families to make regular pilgrimages to the charnel houses of Verdun. They had private grief, but they had public pride as well; and they dealt with their memories in a more active way – sometimes, it must be said, in a manner so franco-centric that it could overlook the participation of other countries. Doubtless this grief, tended and watered like a shrub at the foot of a war grave headstone, had a bearing on the popularity of the deal that Pétain struck with Hitler at Montoire in 1940.

have their lives to get on with; and they urge you to do likewise. How then would you put into words the experiences that no human being before you had undergone? The answer is that few men tried. 'Whereof one cannot speak, thereof one must be silent,' as Ludwig Wittgenstein, a much-decorated veteran of the Russian front, fighting for Austro-Hungary, remarked.[3] Wittgenstein may have had a philosophical axiom in mind, but his was the approach adopted in practical terms by most soldiers of modest education.

The poetry that was written at the time did go some way to filling the silence. Many of the most memorable poems have something

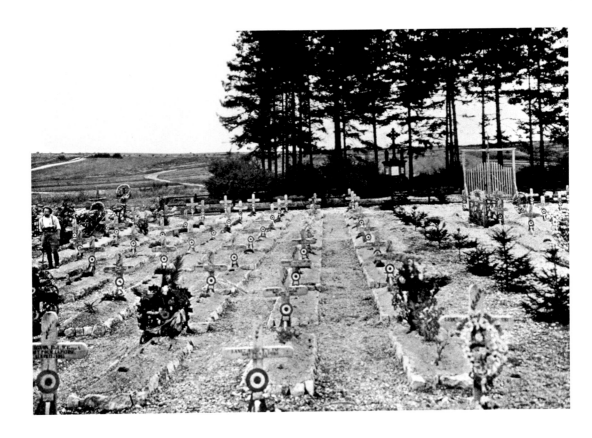

A French military cemetery
Verdun, September 1916

So at this point, when the population at large, with writers as their spokesmen, might have been expected to bring the events of 1914–18 into focus, a new disaster prevented them. John Maynard Keynes's view that the Treaty of Versailles would be no more than a ceasefire for twenty years proved accurate. And the Second World War was to be remembered in quite different ways. The most important was that in which worldwide Jewry insisted that the victims of the Nazi Holocaust be enumerated, named and honoured. This admirably energetic memorialisation was co-ordinated across many countries and continues to the present day.

An unintended consequence was – though it is hard to prove in practical terms – that it threw a further smokescreen across the events of 1914–18. While the average serviceman or woman was laconic about his or her part in the Second World War (those who were not reticent were lampooned as 'saloon-bar majors' who were 'shooting a line') there were novelists, historians and, especially, filmmakers who were anxious to remember and celebrate the role this country had played in a more obviously just and glamorous conflict. Spitfires, Desert Rats and Dambusters had more to commend them than trench foot, lice and slaughter.

Here is another stumbling block to proper memory: no one seems able to say for sure whether the Great War represents simply (as Harry Patch for one believed) a catastrophic human failure, with

warring monarchs, many of whom were closely related, politicians and diplomats guilty of unleashing hell through their negligence, bumbling and self-interest; or whether Britain was obliged by its relations with France and Belgium to halt the intolerable advance of German imperialism. Was it, in other words, a form of natural disaster on an unprecedented scale; or was it a reasonable war, with more complex and nuanced justification than that of 1939–45, but essentially comparable?

And then there are the men themselves. It all comes back to the memory of the private soldier in his shell hole, the staff officer behind the lines, the stretcher-bearer, the sapper; the individual sailor, airman, runner. I met and talked to quite a few while it was possible to do so, in the 1980s and 1990s. Their memories tended to have crystallised

Letter from an unknown British soldier to Alfred Summerson, a solicitor at Pocklington, Yorkshire, recounting the Battle of Messines on 7 June 1917. (Letter dated 15 June 1917)

Harold, the unknown British soldier, describes the night of the battle:

I went to sleep a short time and was awoke about 3 a.m. & told to be ready so I loaded my rifle & fixed my bayonet & saw that everything was ready then for a few minutes all was quiet. Suddenly the earth rocked & swayed & a terrific shirt of flame shot high in the air followed by an explosion that I think can neither be described nor imagined. We were on our feet immediately & away towards the Bosche lines with shells screaming over us from our guns. I think the only way to describe the gun fire is to tell you to listen to a lot of Kettle drums, only of course the noise was something awful.

I join with my grateful people
in sending you this memorial
of a brave life given for others
in the Great War.

George R.I.

Printed letter of condolence bearing the facsimile
signature of King George V, 1918.

into anecdotes that they would happily retell, but
they struggled to give an overall picture of what it
was 'really' like; it was hard for them to bridge that
gap of years: 'I cannot paint what then I was ...', as
Wordsworth put it.[4]

For many lonely men, the day-long company
of others brought comfort. For those from the
impoverished slums, the very idea of two meals a
day was a novelty – and there were no complaints
from them about the bully beef. The friendships
they formed were profound. A minority 'went over
the top' into the great killing fields; the majority
survived – many had jobs behind the lines in
'transport' and administration. Some men lost faith
in God and man on 1 July 1916, seeing swathes of
England, Scotland, Wales and Ulster annihilated on
the first day of the Battle of the Somme; the best
this country had to offer – men who should have
lived to make it a better place than it turned out to
be – mown down and sacrificed for no clear reason.
Others continued to believe they were fighting in a
worthwhile cause.

The soldiers were not allowed to keep diaries
(though many did); their record of the war exists
mostly in letters home, preserved at the Imperial
War Museum and other archives round the country.
They are not quite 'memories'; they are snapshots
of a day or a moment and they need a reader or
interpreter (page 15).

Visual images – whether paintings or
photographs, of kings or corpses – have that same
vitality, but also the sense of needing something
more: what Keats called a 'greeting of the spirit'.[5]
These portraits have the priceless quality of being of
their time; but this contemporaneous authenticity
is nothing without the participation of the viewer.

I have trailed through thousands of written
documents and still dread the letter home that says,

'We are going to attack. We are all merry and bright, thumbs up and trusting to the best of luck' because it is almost always followed by a message of condolence from the King (opposite). Even at the distance of a century these letters and images have the power to fill one with rage, sorrow and despair.

The trauma they underwent and the way that history conspired against them made it difficult for the men who fought in the Great War to give a full picture of that experience. We, in the decades that followed, have found it difficult to 'remember' for them.

It is, however, possible that the passage of a hundred years has given us the necessary perspective; it has certainly given us distance. It is too late for those involved to revisit, relive and finally to understand, with whatever grief, the nature of the convulsion. It has fallen to a later generation to complete the process by the energy of its imaginative outreach.

Notes

1 'War is useless – that's what my message would be', Press Association, 7 November 2005, Home News, Nick Foley, PA.

2 'Veteran, 109, revisits WWI trench', BBC News, 30 July 2007 (news.bbc.co.uk/1/hi/england/somerset/6921217.stm; accessed 11 June 2013).

3 Ludwig Wittgenstein, *Tractacus Logico-Philosophicus*, trans. C.K. Ogden (Kegan Paul, London, 1922).

4 William Wordsworth, 'Lines written a few miles above Tintern Abbey', published in *Lyrical Ballads* (London, 1798).

5 'The Human Seasons' (quoted in letter from Keats to Benjamin Bailey [13 March 1818] in which Keats includes draft of 'The Human Seasons').

A RICHER DUST: THE GREAT WAR IN PORTRAITS

Paul Moorhouse

On 30 May 1917, William Orpen completed a striking portrait of Field Marshal Sir Douglas Haig, Commander-in-Chief of the British Expeditionary Force in France (opposite). Newly promoted to the rank of major, Orpen had travelled from Boulogne to Hesdin, his base in northern France, the preceding month. With the engagement at Arras about to commence, Orpen arrived at the battle zone as an official war artist. Charged with the task of depicting Britain's military leaders, its soldiers and scenes of war, he was expected to create a formal record of the conflict and its protagonists. As such, his work would address the propaganda-driven objectives of the Department of Information, which sought a controlled supply of images with which to inform the British public about the progress of the war. In the longer term, works of art relating to the war, especially portraits of leaders, would also be a lasting inspiration to the men who had served.

Orpen's portrait of the senior British commander was the first he made on French soil.

Having been summoned on 11 May to General Headquarters, he had embarked on a number of preparatory studies, evidently anxious to make a success of his commission. The painting of Haig that resulted was in some ways an 'official' view. Then fifty-six, Haig had succeeded his predecessor, Sir John French, as Commander-in-Chief on 10 December 1915. His first real test had been the major offensive on the Somme, which got underway on 1 July 1916 and lasted until 14 November. Under his direction, the operation resulted in over 400,000 British casualties, a figure that ranks among the highest losses suffered in British military history. This was an appalling price to pay for an advance on the German lines that amounted to little more than a morning's walk, around six miles at most. Within weeks of sitting to Orpen, Haig would launch another massive attack, this time at Passchendaele. As at the Somme, the operation involved huge numbers of men with the prospect of concomitant losses, a prospect that tragically came to pass with, as before, very little gain.

If such matters weighed upon Haig, as they surely must, there is no obvious evidence of this in the portrait created by Orpen. The man who confronts the viewer appears as the artist found him: calm and controlled. Alert to his situation, he nevertheless stands apart from it. Orpen presents Haig against an abstracted background of cloudy shapes. These intimations of sky and smoke evoke rather than describe the context, introducing an element of distance between the sitter and his world. The focus, rather than on the man, is on his position, authority and status: elements signalled

Field Marshal Sir Douglas Haig
William Orpen, 1917 (detail of cat. 11)

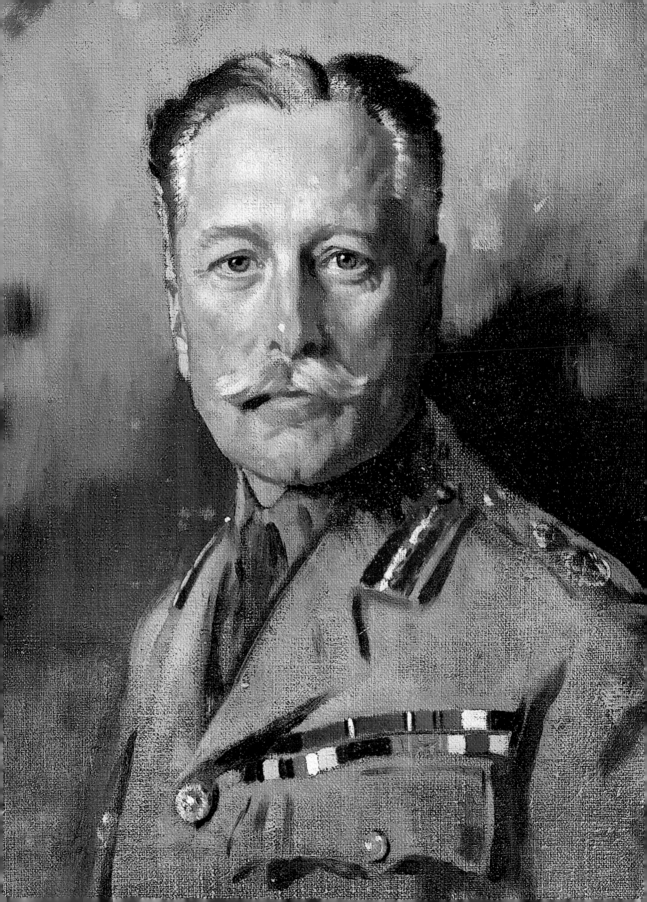

in the form of an eye-catching array of medals and the insignia of rank. That said, the portrait is far from being merely emblematic. Orpen was on friendly terms with Haig, who had secured the painter's appointment as a war artist. He also greatly respected this leader of men. He later recorded that he had never heard a single soldier serving under Haig utter a word of complaint against his commander. For his part, Haig was filled with compassion for those in his charge and was well aware of their bravery and the sacrifices they made. In his memoirs, Orpen recalled that Haig had exhorted: 'Why waste your time painting me? Go and paint the men. They're the fellows who are saving the world, and they're getting killed every day.'[1] In Orpen's sensitive rendering of Haig's features there is a suggestion of humanity, a psychological presence that infiltrates the official view and transcends it.

In addition to the shocking statistics for those killed in battle during the Great War, the toll in terms of those injured, maimed and crippled was even worse, running into millions. Among these, the most horrific casualties were those facially disfigured by bullet wounds, shrapnel and burns. The results ranged from the loss of parts of the face to widespread damage. Unlike those paraded in the press, whose bodily injuries, though harrowing, were regarded as evidence of honourable sacrifice, soldiers with severe facial trauma occupied a world of reconstructive surgery and rehabilitation. Shortly after the conflict at the Somme had commenced, the first victims of facial disfigurement started to arrive at the Cambridge Hospital, Aldershot. The institution had set up a specialised unit in 1915 to manage the rapidly expanding need for treatment of facio-maxillary injuries. When this site became overwhelmed with

Ready to Start
William Orpen, 1917

The first of Orpen's three self-portraits as an official war artist. Painted shortly after his arrival at Hesdin, France, the artist depicts himself in his new role.

cases, it was replaced in August 1917 by a new centre that opened at the Queen's Hospital in Sidcup, Kent. Active at both locations, the pioneering plastic surgeon Harold Gillies directed the task of assessment and treatment. Through reconstructive work, he aimed to return a semblance of normality to the shattered faces of those in his care.

Such injuries, by wrecking the outward appearance, seemed to strike at an individual's dignity and very being. The families of patients and even nurses sometimes felt the need to avert their gaze. As a result, images of facial injury were confined to a medical context. Photography played an important role in documenting the operations undertaken by Gillies and his team during the war and for several years afterwards. The photographic

evidence of this aspect of the war is therefore extensive. Reproduced on page 146 is a case record relating to one of Gillies' patients, Private Dalrymple (1918 and 1920, cat. 73). It provides disturbing testimony to the capacity of such images to evoke the destructive nature of war. Connecting identity to physiognomy, the vital signifier – the face – has been mutilated, its expressive function undermined. Arguably, the feelings of horror engendered are not only connected with the physical damage. They also relate to the corruption of war now indelibly stamped upon a man's features.

Orpen's portrait of Haig, a highly visible if controversial military leader, was included in his exhibition *War* at Thomas Agnew, Bond Street, London, in 1918. The case record relating to Private Dalrymple has remained largely unseen since its creation. Yet, in their radically different ways, both images frame responses to one of the worst conflicts in history in the form of portraiture. At one end of the spectrum, this is accomplished in terms of fine art: a commissioned, formal portrait depicts a celebrated leader. Irrespective of how the military evidence is interpreted, Haig influenced the lives of thousands of men under his command and put his mark on history. Orpen's nuanced portrait underlines Haig's importance and intimates his individuality, while stopping short of exploring his interior life. At the opposite end, Gillies' patient is recorded in the form of medical photographs. Seen objectively and represented dispassionately, his appearance and, above all, his experiences are foregrounded. The sitter's highly exposed empirical life is the sum total of the image. In essence, the former emphasises a formal display of military authority; the latter counterbalances this with unblinking realism, evoking an affecting vulnerability.

Portraying war

The Great War was depicted in a degree of visual detail that was unprecedented in the history of conflict. Between the poles of formal portraiture and objective medical documentation, a breadth of different styles and media evolved. This rich visual response was not confined to Britain but characterised all the combatant nations.

In September 1914, a propaganda bureau had been set up by the Foreign Office at Wellington House, London, led by the Liberal MP, Charles Masterman. Acting on the advice of the painter William Rothenstein, Masterman appointed Muirhead Bone as Britain's first official war artist in May 1916. The bureau was redesignated as the Department of Information in 1917 and its subsequent creation of an Official War Artists programme was designed to augment a monitored flow of information with drawings and paintings made by artists at the front. In Britain, as urged by Haig, formal paintings of commanders and other senior staff were supplemented by paintings and drawings of ordinary soldiers, not only by Bone and Orpen but also by a range of artists, both official and unofficial. Notable among these were Walter Sickert, whose early paintings in response to the war were based on newspaper photographs, Jacob Epstein, who enlisted but did not see action, and C.R.W. Nevinson and Gilbert Rogers, both of whom served in France. In addition to the rank and file, painted portraits of heroes and flying aces provided greater gravitas, and, on occasion, celebrity, with such artists as Orpen, Edward Newling and Leon Underwood turning to distinguished servicemen as sitters.

Photography and film were conspicuous innovations. Official photographers such as Ernest

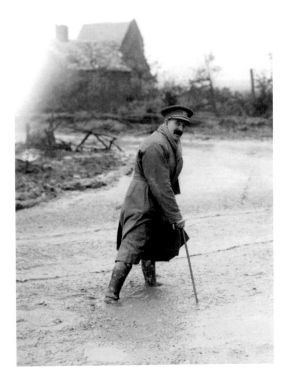

highly visible contexts of exhibition, publication and reproduction, material generated within a discrete medical environment had limited exposure. A rich tributary of information evolved in the form of postcards. On both sides, the sending and receiving of postcards became enormously popular during the war, with reproduced paintings and private photographs being printed as cards that could be sent through the mail. This craze also included sentimental portraits of soldiers dreaming of home, as well as overtly patriotic creations. Irrespective of nationality, postcard imagery explored shared themes. Heads of state, politicians and military leaders were celebrated as 'men of the moment' (page 24); ordinary soldiers at the front were shown receiving medals, writing letters, cooking or sorting parcels. Aside from postcards, in Germany, a more sombre iconography developed in the form of deathcards. Photographs of soldiers killed in action were produced as small, black-bordered mementos for funeral services, complete with details about the deceased and the circumstances of their death.

Brooks recorded events as they unfolded, presenting the war to a wide audience through the pages of books and through newspapers. The *Daily Mail* circulated photographs taken in the field of battle as collectable postcards. The cinema-tographers Geoffrey Malins and John McDowell expanded the reach of photographic imagery in other directions, their work being seen in well-attended cinemas. Their film *Battle of the Somme* (1916, cat. 22) was a landmark in war reporting. In common with its German counterpart *Bei unseren Helden an der Somme* (1917, cat. 23) it combined actual war footage with additional staged material, blurring the line between realism and imaginative reconstruction.

Arising from all these different sources, images of those involved in the conflict proliferated. Even so, accessibility depended on the nature of the material pictured. While official portraits of heads of state and military leaders were presented in the

As the war progressed, and with mounting losses on all sides, early fervour was replaced by a complex psychological mix. The idealised celebration of achievement, determined cheerfulness, growing disillusionment and a darkening realism all infected the mood of the combatants. Throughout, photographic imagery provided a vital source of information alongside more formal portraiture. Books such as the annual

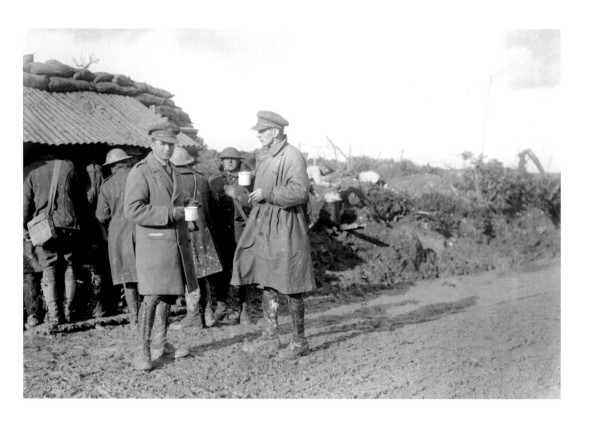

Lieutenant Ernest Brooks, the first British official war photographer (left), with the official cinematographer, Lieutenant Geoffrey Malins, at a coffee stall behind the lines at the Somme
Unknown photographer, 1916

series *The Year Illustrated* provided an overview of the war's events and also had an evident patriotic function, seeking to provide 'a record of notable achievements'.[2] Its reports concentrated on British successes and presented adverse developments in the best possible light. Within its pages, drawings of servicemen in action found a corollary in photographs of gallant recipients of the Victoria Cross. As part of the ethos to inspire, formal depictions of medal-bedecked leaders including Haig, Lord Kitchener, the Russian cavalry general Aleksei Brusilov and others were joined by portraits of ordinary soldiers. Whether photographic, drawn or painted, reproducible portraiture was an important part of the cult of celebrity that sprang up around heroic figures.

However, the veneer of achievement could not be maintained continuously. Seen by cinema audiences of around twenty million, *Battle of the Somme* was a popular success but aroused controversy because it depicted wounded and dead soldiers. The taste for greater realism, indeed the demand for veracity that the film engendered among some, underpinned a general movement towards imagery of a darker nature. In portraiture this did not supplant idealised depictions of military achievers. But there was a growing recognition among photographers such as Malins, as well as painters including Orpen, Nevinson, Rogers and Eric Kennington, that other, less palatable, aspects of the human experience of war

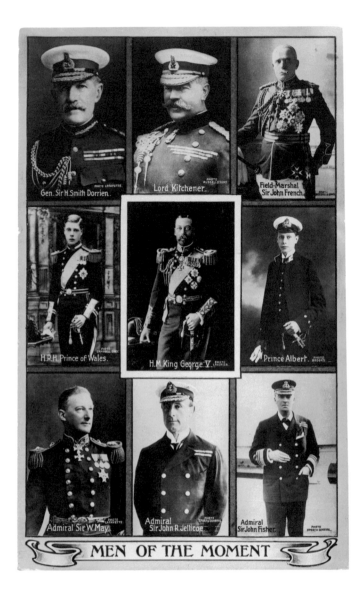

'Men of the Moment'
Postcard, c.1914

Portraits of the leading figures of the day gained a wide currency as postcards. This postcard features (clockwise from top left): General Sir H. Smith Dorrien, Lord Kitchener, Field Marshal Sir John French, Prince Albert (later King George VI), Admiral Sir John Fisher, Admiral Sir John R. Jellicoe, Admiral Sir W. May, H.R.H. Prince of Wales (later King Edward VIII); H.M. King George V (middle).

could not be denied. Orpen's drawing of a dead German soldier (page 154), Nevinson's controversial depiction of British war dead in his caustically titled painting *Paths of Glory* (1917, page 96), Kennington's unflinching depiction of the gassed and wounded (cat. 71), and Rogers' sombre evocation of a dead stretcher-bearer on the battlefield (cat. 21) – all were significant stepping-stones on the muddy track to greater truthfulness, however bitter.

Embracing these diverse visual responses to the Great War, portraiture traced a passage from idealised formality to moral protest. The process was galvanised by a vast torrent of human experience, which moved from hubris and pride through pain, silence and stunned resignation to outrage. In 1914, deeply traditional portraits of heads of state representing the warring nations were seen as emblems of power. By 1918, this

elevated imagery had been joined by the work of a range of modern artists. They were not so much depicting the war as seeking, through images of people, to articulate an appropriate response to it. In Britain, painters such as Orpen, Isaac Rosenberg and Glyn Philpot sought a semblance of reassurance in the steadying hand of tradition, part of the 'return to order' that, for some, the war had impelled. In Germany, others – notably, Max Beckmann, Otto Dix, Ernst Ludwig Kirchner and Lovis Corinth – evinced a powerful disillusionment with history. As if sensing that the conflict had severed all meaningful contact with the past, they sought a new visual language. Only too aware of the violence wrought by men on men, for these artists the human figure became a canvas on which to record the legacy of war. In their portraits, an expressive violence seemed truer to the visceral suffering that several of these artists had themselves witnessed directly.

Whether depicting heads of state or ordinary soldiers, distinguished leaders or those bearing the scars of war, celebrated or anonymous individuals, portraits of the Great War's protagonists are, as we have seen, vital repositories of information. Such images work on different levels. In a primary way, as with all successful portraits, they convey a sense of the individual depicted. Rooted in appearance, other elements – uniform, medals, situation and attitude – tell us about that person's role, rank, status, achievements and experiences. The kind and quantity of information varies according to the nature of the portrait. A formal, state portrait may impress as a cipher of regal magnificence while saying little about the occupant of that role. An Orpen drawing of an exhausted soldier may not tell us the identity of the sitter but speaks volumes about his physical and mental condition.

The portrait itself – a physical object, nuanced by style, medium and its creator – provides a second tier of implication. A formal image of a recipient of the Victoria Cross will represent a great deal about the achievements of the sitter. It can also intimate the way the subject was viewed by the artist. In contrast, a scene from *Battle of the Somme* depicts a soldier carrying an injured comrade. The accompanying text states: 'This man died 30 minutes after reaching the trenches.' At one end of the scale there exists idealisation, at the other despair. Whether refracted through the mind of a painter or the lens of a camera, the resulting image bears the imprint of a creative intelligence whose attitude will be evident to a greater or lesser degree. In certain Expressionist portraits, for example Kirchner's extraordinary *Self-Portrait as a Soldier* (1915, cat. 78), the painter's own interior life is paramount.

A final category of significance involves the circumstances in which a portrait was created, its purpose, use and the reception it received. The artist's or photographer's subjective response would have been coloured by the wider cultural and historical context. During the Great War, the official agenda for propaganda and the public thirst for truth were opposed mindsets. In this regard, the diverse portraits that emerged from a four-year period of global strife and instability were influenced by these external forces. The portraits that resulted are, however, far from being mere documents for they also shaped attitudes in powerful and subtle ways.

Thus, while it is essential to examine portraits connected with the Great War in terms of what they say about the individual depicted, the extent to which they reflected outside conditions also deserves critical consideration. Beyond both these perspectives, a further vital issue is the effect of portraiture on the way the war was perceived by the wider world.

The *Rock Drill*

In December 1913 the painter David Bomberg visited the London studio of sculptor Jacob Epstein. Bomberg had recently been expelled from the Slade and was connected with various avant-garde factions within the British art world. At that time Epstein was based in Lamb's Conduit Street. There Bomberg was confronted by an extraordinary, recently completed work that appeared to take Epstein's notorious capacity for shocking and offending to new heights. In 1908, the pioneering Modernist had caused outrage with the eighteen nude figures he had produced for the facade of the British Medical Association building on the Strand in London. Further controversy had followed in 1912. The tomb he carved for the grave of Oscar Wilde in the Père Lachaise cemetery in Paris had been deemed indecent in the local press and the authorities had instructed that it should be covered with a tarpaulin. The focus of attention had been the artist's depiction of genitalia in his treatment of the winged figure adorning the tomb. At the time of Bomberg's visit, the tarpaulin remained in place. Against this background of dissent, Epstein's latest sculpture now made sexual provocation an inescapable fact.

The *Rock* Drill, the work seen by Bomberg, comprised an inhuman-looking figure, nearly seven feet tall, in white plaster astride a real pneumatic drill (right). The position of the metallic tool in relation to the man's crotch carried an aggressive

phallic connotation. From Epstein's initial sketches for this work it is clear that a sexual significance was indeed intended, the drawings also containing references to female genitalia (page 28). That said, from the outset the elusive meaning of this alarming image went beyond the obvious. Significantly, Bomberg's response was to perceive in this work 'a prophetic symbol ... of the

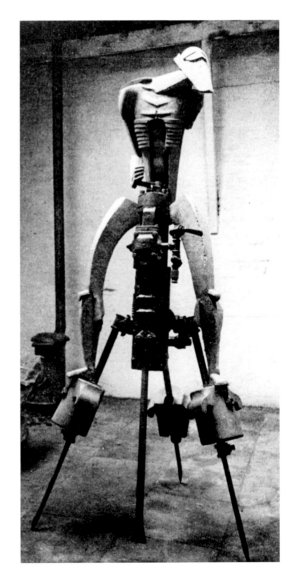

The *Rock Drill* (first version)
Jacob Epstein, 1913

The *Rock Drill* in its first incarnation, as seen by David Bomberg and, on a separate occasion, by Henri Gaudier-Brzeska and Ezra Pound.

impending war'.[3] Commenting later on the work, Epstein himself explained:

It was in the experimental pre-war days of 1913 that I was fired to do the rock drill, and my ardour for machinery (short-lived) expended itself on the purchase of an actual drill, second-hand, and upon this I made and mounted a machine-like robot, visored, menacing, and carrying within itself its progeny, protectively ensconced. Here is the armed, sinister figure of today and tomorrow. No humanity, only the terrible Frankenstein's monster we have made ourselves into.[4]

Even allowing for the retrospective nature of these remarks, Epstein's perception of an armed, menacing figure echoes Bomberg's interpretation of the work as a warning of approaching conflict.

Epstein's elision of man and machine, creating a 'robot', must be seen in relation to the contemporary Futurist celebration of mechanisation and speed. His association at this time with Percy Wyndham Lewis, Henri Gaudier-Brzeska, Ezra Pound and others linked with London's avant-garde has also led to the *Rock Drill* being connected with the incipient Vorticist movement. For some, this dehumanised embodiment of mechanical power was the supreme manifestation of Vorticist sculpture. But Epstein's creation was an ambiguous creature, not simply androgenous and not only an unqualified mechanised monster. Its attitude departed from the predatory figure of the earlier drawings. Instead, in its sculptural form, the robot was devoid of arms. The impression produced was indeed one of 'menace' but, unable to manhandle the drill, this was coupled with an anxious inability to restrain. Carrying a foetus, an embodiment of

the future, the robot was cast in a situation that may well spin out of its control. Created on the eve of war, the *Rock Drill* was not only a Vorticist evocation of man in thrall to a machine world. Already doubt had infected the relationship, and in the work's first incarnation the sense of menace was inseparable from one of apprehension.

The concept of the *Rock Drill* evolved over the course of three years. In March 1915, when the war was in its seventh month, Epstein prepared the work for exhibition with the London Group, of which he had been a founder member the previous year. Returning to the robot figure, he now gave it arms (see reconstruction, page 29). It gripped the drill with its right hand; the left arm was angled in front of the abdomen cavity containing the foetus. These modifications were subtle but critical in terms of the overall sense of the work. With hindsight, the impression is one of even greater ambiguity. Armed, as it were, the robot is closer to representing a recognisable being. However, though now controlling its awesome means of destruction, the intimation of a protective gesture around the small life within its body deepens the feeling of vulnerability. While enhanced in terms of the mechanised power within its grasp, simultaneously this anthropomorphic creature fears for its own future. The use of unnatural force, it seems, contains the seeds of its own undoing. The 'menace' that Epstein later attributed to the work is now less sexual than aggressive, but it is also underpinned by fear.

Epstein was following the war with mounting anxiety. In June 1915, the twenty-two-year-old Gaudier-Brzeska was killed in action. In January 1916, a bill was passed rendering all single men liable to be called up for service. A bill extending this measure to married men followed in May and

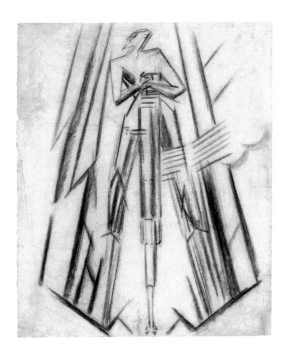

Study for the *Rock Drill*
Jacob Epstein, c.1913

In this early drawing, the *Rock Drill* has a sexual connotation suggested by the horizontal lines at the bottom of the image intimating parted thighs.

torso and the left arm remained, the legs and right arm having been removed. The effect of presenting the figure in this truncated form, based on a plinth, was to change its significance and affective character completely. No longer predatory, its geometric, visored features and angular body shapes retain an echo of armour, but now this seems defensive rather than assertive. Indeed, this dismembered figure seems cowed. Seen at a lower level, the bent attitude of the neck and head, previously imperious, now seem watchful and dejected. Presented in closer proximity to the viewer, the embryonic form contained within the ribcage assumes greater importance within the reduced overall context. And, as before, the angled forearm provides a protective barrier around a tiny evocation of human life.

Retitled *Torso in Metal from the Rock Drill*, Epstein's original creation attained, through a process of progressive transformation, its final state. Even the revised appellation conveys a sense of loss, implying a surviving part from some greater whole. It is difficult to separate these developments, however enigmatic, from the circumstances that formed the backdrop to the work's formation and to its reception. The work's changing character, from mechanised aggression to amputation, speaks of external events, images and concerns that acquired a growing currency throughout its gestation. The extent to which this was intended is a matter for speculation. But in this instance the proximity of art and life seems real and immediate.

As such the *Rock Drill* is not only one of the great pioneering Modernist sculptures of British art. The narrative of its mutable appearance also forms a counterpoint to the events that unfolded from the time of its creation on the eve of war to the conflict's mid point. Most significant of all, the

was in force by the end of the year. Married and a naturalised British citizen since 1910, American-born Epstein was in his mid thirties and so eligible to serve. While care must be exercised not to restrict any work of art to a single reading, this background to the *Rock Drill*'s evolution must be taken into account. In anticipation of the fourth London Group's exhibition in June 1916, Epstein revisited the sculpture and carried out a further, more radical revision.

In its final incarnation, the figure was cut down (1916, cat. 1). Cast in bronze, only the head,

vehicle for these issues was a represented human form, however abstracted and depersonalised. In that respect, Epstein anticipated the powerful significance that portraiture would have as a barometer for the experience of war.

The *Rock Drill* (second version)
Reconstruction by Ken Cook and Ann Christopher RA after Jacob Epstein's 1915 version, 1974

Having added arms to the figure, Epstein considered – and then abandoned – the idea of adding pneumatic power to set the drill in motion, creating a fusion of man and machine.

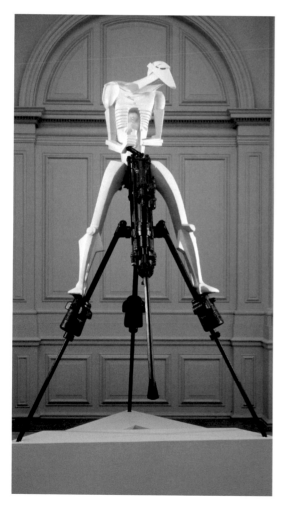

Royalty and the assassin

The funeral of King Edward VII in May 1910 followed two days of mourning, during which a quarter of a million people filed past the body of the dead monarch. Huge crowds then witnessed a procession on a magnificent scale. Following the gun carriage were members of the British royal family, Edward VII's successor King George V riding alongside his cousin Kaiser Wilhelm II of Germany, as well as eight kings and numerous crown princes, archdukes, grand dukes and princes (page 30). The occasion was a splendid reminder that in the early twentieth century monarchical prestige remained potent.

It was also a moment to reflect on the blood ties uniting the royal families of Europe. In addition to the deceased King's son and nephew, others riding behind the coffin included his brother, several brothers-in-law, nephews, nephews-in-law, sons-in-law and several second cousins. Following in carriages were his widow, daughter, several granddaughters, nieces and sisters-in-law, as well as many other relations also representing royalty from around the world. In the period preceding the outbreak of the Great War, there was not a European court that did not in some way form part of this extensive network of family connections. Four years later, as a consequence of the war, many of the countries linked by royal blood had fought each other to a virtual standstill. Worse, three great empires – those of Russia, Germany and Austria-Hungary – had crumbled. Although Britain emerged on the side of the victors, its empire was weakened significantly. Royalty provided a semblance of pre-war unity in Europe but this did nothing to prevent war when it beckoned. The cost of the ensuing conflict was to deprive many rulers of their crowns.

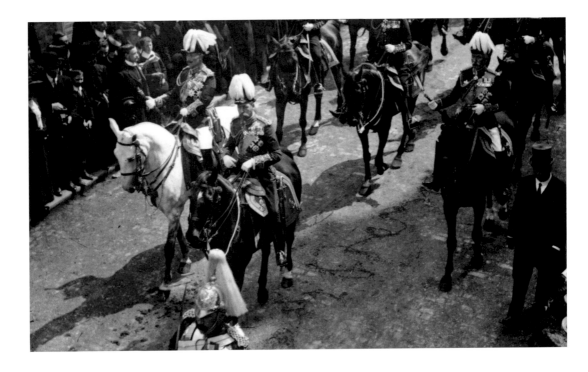

King George V (middle) and Kaiser Wilhelm II (left)
Unknown photographer, 20 May 1910

Having acceded to the throne on 6 May 1910, George V
leads the funeral cortege of his father Edward VII, together
with his cousin Wilhelm II, near Paddington, London. Just
over four years later, Britain and Germany would be locked
in a bitter conflict.

Some sense of the gravity of these ensuing
changes can be gleaned from portraits of the heads
of state of those countries drawn into war in 1914.
Luke Fildes' splendid portrait of George V (1912) is
an eloquent record of the way the British monarch
was represented and perceived on the eve of the
conflict. An official state portrait painted early in the
King's reign, its purpose was a traditional one: to
create an image that, through replicas (after 1912,
cat. 2) and reproduction, could transmit the ruler's
presence throughout his kingdom. In keeping with
convention, it follows precedents established by
Lawrence and Ramsay in their portraits of earlier

British monarchs. Following those historic models,
the King is shown standing, wearing his robes of
state, against a backdrop of heavily swagged curtains
with the imperial state crown on a stool to one side.
Conventional in manner, its entire purpose is
founded on the concept of tradition. The image
of the King is intended as a reassuring emblem
of continuity with the past. As such, George V's
characteristics as an individual are suppressed.
These are intimated only by the relatively
understated nature of the image (in keeping with
the King's straightforward manner) and his
uniform, reflecting his longstanding connection
with the navy. Presenting the King in terms of what
he represents, such characteristics can be said to
stand for the pre-war nation as a whole: a deep
attachment to tradition and profound pride in
Britain's maritime achievements.

In an age of commercially available
photographic portraits, formal painted portraits

continued to confer a gravitas, and to signify prestige, above and beyond that available to modern media. Convention and tradition were therefore the stock-in-trade of painters such as Fildes, whose work essentially extends the tropes of nineteenth-century portraiture. This is no less true of formal portraits of other European heads of state created before and during the war. If anything, August Böcher's resplendent portrait of Kaiser Wilhelm II (cat. 3), painted in 1917, not only draws heavily on historic precedent but also raises the bar in terms of ostentation. Not to be outdone by his British cousin, the German emperor is represented in full ceremonial uniform, hand assertively on sword. Seen against a relatively plain backdrop, the Kaiser fills the space with his confrontational, imperious presence. Although impressively formal, Böcher's portrait nevertheless conveys much about the sitter's psychology. Following his accession in 1888, Wilhelm II's agenda to assert Germany's imperial and military presence in the world quickly became apparent. In addition to colonial expansion and – in a direct challenge to Britain – increasing the size of the navy, he elevated the culture of his own court to an unprecedented level of lavish, regal splendour. Acutely aware of the power of the modern media, Wilhelm II played to the camera, obsessed with sustaining the impressive visibility of his own image. But the spectacle of his grand appearance called for even greater solemnity. While photography effectively disseminated a show of hubris, Böcher's remarkable painting added that essential ingredient: deference.

Made before and during the Great War, formal portraits of the participating nations' heads of state provide insights into wider cultural circumstances, values and attitudes. No less than political alliances and military strategies, these factors – though in some ways abstract – also played their part in creating and sustaining the conditions for a European conflict. Kasimir Pochwalski's portrait of Franz Josef I (c.1900, cat. 4), Emperor of Austria and King of Hungary, depicts a ruler who was eighty-four years old when war broke out. Commensurate with his age, history was his vindication. As a Hapsburg monarch, Franz Josef believed he ruled by divine right. As such, the portrait encapsulates Austria-Hungary's position in the pre-war period. Antiquated and authoritarian, the empire's importance was increasingly out of step in a changing, modern world. In common with other portraits of the dual monarch, Franz Josef is represented in a field marshal's uniform, signifying his status as commander-in-chief. Once again, a regal presence has a military significance. Even when transmitted as an official photograph, as in a telling image of King George V with his cousin Tsar Nicholas II, the connection between royalty and war is close and intimate (cat. 6). Photographed in 1913, the Russian emperor wears a British uniform while George V is shown in Russian regimentals. This double portrait evokes their alliance, the close bond between two empires implied by family resemblance and cemented by a change of wardrobe. Such intimacies were not confined to photographic portraits. In 1916, an imperial presentation box bearing a miniature of the Tsar was presented to Gabriel Hanotaux who, as France's Minister of Foreign Affairs from 1894 to 1898, did much to develop the political alliance between France and Russia (1916, cat. 7). Such gifts were a confirmation of the relations between countries.

In regarding state portraiture as a litmus test of national characteristics and attitudes, it is instructive to observe the significance that attached

to the medium employed. Whereas the great imperial nations – Britain, Germany, Austria-Hungary and Russia – reached into the past, seeking prestige in the portraitist's brush, republics such as France generally avoided an impression of elitism, favouring the more egalitarian medium of photography. The official portraits of President Poincaré that circulated in reproduction and as postcards are more down-to-earth and sober. Dressed formally, the French head of state goes no further than a display of medals. Nor – unlike his European counterparts – did he regard such portraiture as an opportunity for a display of military prowess. But Poincaré was fervent in furthering his nationalist convictions. The state visits he made to England and Russia in 1913 and 1914 were, arguably, influential in increasing German anxieties about encircling alliances. However, the proud uniform and sheathed sword are nowhere in evidence. Instead, the hand of diplomacy is the message.

Whatever the medium, such official state portraits convey a cultural intelligence and act as representations of power – whether actual or implied. Viewed in this light, the individuals depicted personify those deeper forces which, by June 1914, had in complex ways created the conditions for war. Notable among these were Britain's anxieties about the growth of the German navy; Germany's determination to assert its colonial ambitions and protect itself against potential adversaries; the imperative felt by the Austro-Hungarian and Russian empires to arrest the slow decline of their historic prestige; and France's resolve to strengthen its ties with Britain and Russia. In the end, however, the catalyst would come from an unexpected corner. During an official visit to Bosnia, the heir to the Austro-Hungarian throne, Archduke Franz Ferdinand, was assassinated by Gavrilo Princip, a nineteen-year-old student and a Serb nationalist, on a street in Sarajevo. The date was 28 June 1914. Despite the interconnectedness of Europe's royalty, this opportunistic act ignited an atmosphere of hubris and mutual distrust.

Two portraits of the principal players reflect their different worlds. Theodor Breitwieser's painting of Archduke Franz Ferdinand is an early official portrait, which shows a Hapsburg, third in the line of succession, who was destined to succeed by default. In 1889, Franz Josef's son had shot himself. His brother, Franz Ferdinand's father, died seven years later. These circumstances made Franz Ferdinand the heir apparent. A photograph taken after his arrest shows the abject assailant, Gavrilo Princip. Sent by members of the Black Hand, a Serb society opposed to Austria-Hungary's earlier annexation of Bosnia, his was the finger on the trigger. These two individuals were brought together when Princip emerged from a café to find the Archduke's car had taken a wrong turn. Taking advantage of the situation, Princip shot the Archduke and his wife at close range. All were protagonists in a farce that quickly became a tragedy. Franz Ferdinand's last words were 'It is nothing.'[5]

Leaders and followers

On 28 July 1914, Austria-Hungary formally commenced hostilities against Serbia whom it held responsible for the outrage in Sarajevo. A network of alliances and prepared strategies then took effect, with one nation after another declaring war on its perceived or intended adversaries. During the

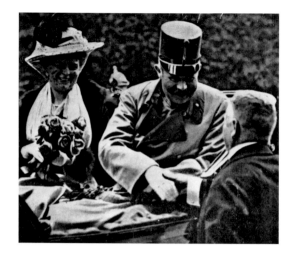

Archduke Franz Ferdinand and his wife Sophie, Duchess of Hohenberg
Unknown photographer, 28 June 1914

Taken in Sarajevo, this photograph shows the couple just an hour before they were both shot.

next thirteen days, the battle lines were drawn as Germany, Britain, Russia and France all issued or received notifications of war. This process continued in November with Turkey joining in. Italy, Romania, China and many others, not least the United States, all subsequently became involved. It is a supreme irony that the sovereigns of the combatant nations – despite their official status as supreme commanders-in-chief – had limited influence on the conduct of war. As soon as the mobilisation of armies began, responsibility devolved to the senior military leaders of each participating country. It goes without saying that, while the senior officers assumed strategic control, the actual fighting fell to another stratum of military life: ordinary soldiers acting according to instructions dispensed downwards through the chain of command. In terms of portraiture, this hierarchy was expressed as a dichotomy, with

portraits of leaders carrying a very different significance from depictions of those who confronted the enemy directly.

Following his appointment as Secretary of State for War on 5 August 1914, Kitchener's first decision had been to despatch the British Expeditionary Force to France in order to oppose the German advance westwards through Belgium. On 25 August, there were reports of atrocities committed by Germans against Belgian civilians. The effect of these revelations was to incite an intense antipathy to the 'bloody Germans'.[6] In

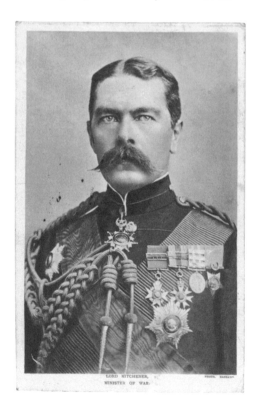

Lord Kitchener, Secretary of State for War
Postcard, c.1914–18 (photograph by Bassano, 1895)

One of the few to predict a lengthy war, Kitchener did not live to see its end. He was drowned on 5 June 1916 when HMS *Hampshire* hit an enemy mine near Scapa Flow, off the Orkneys, and sank with the loss of over 640 lives.

Britain, Sickert was one of the first artists to respond to the war. German-born, his sympathies were, nevertheless, entirely with the Allies. He told the painter Ethel Sands that 'The German Empire had to be smashed ...'.[7] His ire took the form of two paintings, *Soldiers of King Albert the Ready* and *The Integrity of Belgium*, both completed in late 1914 (pages 78–9). Apparently inspired by newspaper photographs, these works portray actual soldiers in the field of battle. Through its depiction of active agents in the fighting, his work acquired an immediacy. His view as yet unclouded by subsequent horrors, Sickert saw his depiction of fighting men as having an inspirational purpose: 'a definite patriotic and recruiting value.'[8]

Such ideals were easier to sustain at the beginning of the war. Even so, the Government took no chances. On 8 August 1914 Parliament passed the Defence of the Realm Act. This aimed to control discourse relating to the conduct of the war, whether expressed in words or pictures. Its target was material, critical in tone, 'likely to prejudice the recruiting and discipline of His Majesty's Forces.' Within the ensuing atmosphere of regulation, a highly significant development was the Department of Information's creation in 1917 of the Official War Artists programme. Its purpose was not only to document the war, but also to influence the way it was perceived. This thinking provided the context for Orpen's arrival in France and, as we have seen, his summons shortly afterwards to paint 'the Chief'.[9] Following Haig, the roll call of distinguished military leaders painted by Orpen grew and included portraits of the French Commander-in-Chief, Marshal Foch, in August 1918 (cat. 15). This was followed in October 1918 by a painting of General Plumer (cat. 13). As these portraits demonstrate, Orpen's achievement was to fulfil the demands of his brief by creating a formal image while at the same time managing to convey something of the individual character of his sitters.

Marshal Foch had been appointed Allied Supreme Commander in March 1918. A brilliant strategist, at the time of his sitting with Orpen he was planning a major offensive which was due to begin at the end of September. A connecting thread in Orpen's portraits of leaders is the balance struck between the formal evidence of huge responsibility and an intimation of the human being occupying the role. The impression made upon Orpen was that of a 'great little man, deep in the study of his maps, very calm, very quiet.'[10] His response in visual terms is both impressive as a formal image and yet, on a human level, believable. General Plumer commanded the Second Army on the Western Front from May 1915 onwards. His conduct of the Battle of Messines in June 1917 involved careful planning, with 450 tons of explosives positioned in tunnels beneath the German lines. Detonated before the British offensive, the ensuing eruption – then the loudest in history – enabled Plumer's troops to advance with relatively few casualties. This approach, based on calculation and an emphasis on reducing losses to a minimum, was characteristic and won Plumer widespread respect and affection among those under his command. Orpen's portrait captures something of this genial figure: 'A strange man with a small head, and a large, though not fat, body and a great brain full of humour.'[11]

The imperative to create such portraits was, in part, inspired by the example of Britain's allies and opponents. On 7 May 1917, Masterman wrote to the novelist John Buchan (then a colonel in the British army), who had been appointed Director of the Department of Information earlier that year:

I am always, however, as you know, pressing for greater publicity in connection with our leaders and also for men who have in any way distinguished themselves in the war. In France and Germany, for example, you can see everywhere portraits not only of Hindenburg and Nivelle, but also of the Captain of the 'Deutschland' ….[12]

Masterman was right: images of important foreign leaders were ubiquitous. As Commander-in-Chief of the German army, and the victor of two momentous early engagements at Tannenburg and the Masurian Lakes, Field Marshal von Hindenburg was venerated. During the war he was portrayed by various artists including Böcher, Heinrich Iser, Max Liebermann and others. The painting by Böcher reproduced on page 84 (cat. 14) invests its austere subject with a powerful sense of gravitas. At one point it hung in the battle cruiser *Hindenburg*, from which it was recovered after the ship was scuttled in 1919. Copies were made and circulated as postcards, while numerous photographs of the great man were also made available. Other combatant nations were equally keen to exalt their military leaders. The commander-in-chief of the Russian army, General Aleksei Brusilov, was one of the war's most successful leaders. Photographs taken after the celebrated offensive of 1916 that bears his name are telling (cat. 16). Resorting to the conventions of state portraiture, they focus on the sitter's splendid uniform and extensive military decorations, replacing a crown with the plumed hat of a general. These portraits were again distributed as postcards, copied as paintings and reproduced as lithographs. Masterman's thinking was clear: such images had an inspirational value and Britain should not be outdone.

By 1916, there was a widespread, growing realisation that the war had not turned out as anticipated. In Britain the prospect of a quick victory had long faded and with conscription, growing casualties and deadlock on the Western Front, patriotic fervour was replaced by disillusionment. These developments did not concur with the official line. One consequence of the Government's control over the way the war was reported was an increased appetite for candour. For some, the drive to suppress negative perceptions sharpened the imperative to communicate the truth. A turning point was Nevinson's exhibition *Paintings and Drawings of War*, held at the Leicester Galleries, London, in September 1916. The product of Nevinson's experiences as a Red Cross ambulance driver at the front in France in 1914–15, his Futurist-inspired images advanced beyond the desire to inspire, idealise or reassure. As *La Mitrailleuse* (1915, cat. 11) demonstrates, a visual language of jagged form and dissonant colour was employed to convey a harsher reality: sharper, more down-to-earth and brutal. The show made a point and was a well-attended success. Nor was its significance overlooked, either by the Department of Information or by other artists. Masterman's memorandum to Buchan also contained an observation about Orpen, who by then had already departed for France: 'I do not think we should use Orpen for such work [i.e. portraits of leaders], except for the Commander-in-Chief, as I think he would be far more useful for paintings and drawings of actual scenes and incidents in the war.'[13] Alongside the depiction of leaders, the need to capture the reality of war more directly was recognised.

In terms of portraiture, Orpen, Epstein and Nevinson, among others, made singular contributions. From early 1917, Orpen's range broadened to include several portraits of servicemen. Notable among these were two

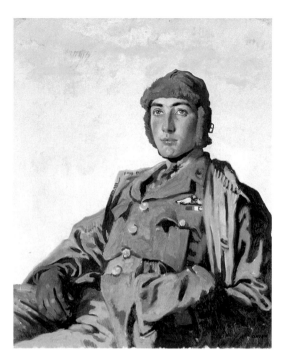

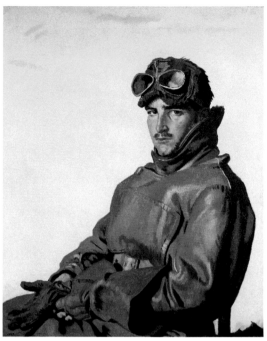

Lieutenant A.P.F. Rhys Davids, DSO, MC
William Orpen, 1917

An Airman: Lieutenant R.T.C. Hoidge, MC
William Orpen, 1917

remarkable images of pilots – *Lieutenant A.P.F. Rhys Davids, DSO, MC* (left) and *An Airman: Lieutenant R.T.C. Hoidge, MC* (right) – as well as the unidentified, but no less arresting *A Grenadier Guardsman* (cat. 17). Hoidge and Davids both attracted Orpen's attention by virtue of their achievements. By the end of October, Hoidge had scored twenty-seven victories and had been awarded a Bar to his Military Cross for gallantry. Davids was also a flying ace, credited with twenty-five victories including a celebrated dogfight with the German flyer, Werner Voss, whom he shot down. Awarded the Distinguished Service Order, Military Cross and Bar, Davids was killed on 27 October. Heroism and tragedy now became ingredients in Orpen's portrayal of war. However, as his portrait of an anonymous Guardsman intimated, the ordinary serviceman was no less a

hero. He too is presented straightforwardly, at rest while still gripping his rifle. There is a sense that his distinction is that of carrying out his duty and simply being there. Moreover, in being depicted anonymously, that distinction applied generically to all soldiers in his situation. Epstein's bronze heads – *The Tin Hat* and *An American Soldier* (pages 90–1) – also possess, in their very namelessness, a similar dignity. Such is the power of Epstein's use of understatement that this dignity seems to arise from the very fact of being a soldier.

Orpen and Epstein's portraits of ordinary soldiers were based on direct observation and, as a result, have an appealing spontaneity. At the same time, they retain a certain formality. Like Orpen's paintings of military leaders, the individuals are depicted in an abstracted setting or, as in the case of Epstein's heads, exist on their own self-contained

terms. Conversely, Orpen's drawings of soldiers, while also made from life, make use of outdoor settings and particular situations. They therefore took the movement towards greater contextual realism further. Relatively understated, his sketches show soldiers in off-guard moments. Resting in a trench, sitting exhausted, wearing a gas mask or just waiting, these individuals have a vital immediacy that locates them in the real world. However, while his watercolour *A Dead German in a Trench* (1917, page 154) portrays the remains of a German soldier, he mainly demurred from showing British corpses.

It would fall to Nevinson and Rogers to depict the inadmissible. Nevinson's *A Group of Soldiers* (1917, page 80) stirred the official censor Major Arthur Lee into action. He responded to Nevinson's unidealised depiction of ordinary servicemen as representing a 'type of man … not worthy of the British army.'[14] The artist bristled indignantly. In an unsent letter to Lee, a copy of which he forwarded to Masterman, Nevinson declared that 'you have censored one of my best pictures as "too ugly",' and

asserted his refusal to paint 'Castrated Lancelots'.[15] His subsequent painting *Paths of Glory* went further by depicting dead Tommies. For that, Lee felt that a decision by the War Office was necessary. As recorded in a Department of Information internal memorandum addressed to Masterman, it was determined that the painting 'should not be reproduced or exhibited.' Nevinson's riposte, when the work was finally exhibited at the Leicester Galleries in March 1918, was to display it partially covered by a brown paper strip bearing the word 'CENSORED'. The painting had found its target: the suppression of truth. By 1919, when Rogers painted *Gassed: In arduis fidelis* (below, 1919), it was no longer credible to withhold the facts. In its stark portrayal of death, the painting encapsulates the fate that cast a long shadow across an entire generation. But while the war continued, the depiction of the dead remained a deeply fraught issue.

Gassed: In arduis fidelis
Gilbert Rogers, 1919

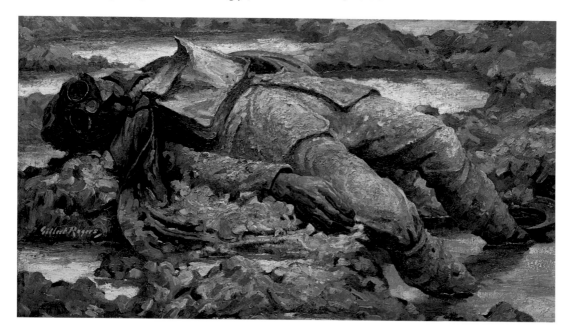

Fact and fiction:
the Battle of the Somme in film

The debate within the Department of Information about Nevinson's work suggests that the official view about the representation of mortality continued to change. Referring to *Paths of Glory*, an internal memorandum to Masterman written in December 1917 contains the caution: 'the War Office, on military grounds, has prohibited the appearance of dead bodies, even Germans, in any official photograph or film.'[16] A separate note, also addressed to Masterman, reports that the War Office had no alternative but to endorse the decision of General Headquarters: 'representations of the dead have an ill effect at home. Photographs of the kind are now rigidly suppressed.'[17] Yet only the previous year the official propaganda film *Battle of the Somme* had stunned audiences with its graphic depiction of dead soldiers, both British and German. These comments reveal an ongoing discomfort with such imagery, even though the public response to the film was extremely positive. The views of the press were no less appreciative of the film's realism, the evidence of which was seen as its willingness to include images of the dead and wounded. Collectively, the film was regarded as a landmark, not only as a piece of documentary filmmaking but also in terms of involving a domestic audience more truthfully in the horror of warfare. That said, the extent of the film's veracity has been a moot point ever since. In addition, its effectiveness as propaganda was, even then, an open question.

The events recorded by the film are centred on the campaign planned by Haig, the purpose of which was to breach the German trenches north of the River Somme between Amiens and Picardy. Involving 750,000 men, the offensive was preceded by an eight-day bombardment of the enemy lines during which 1.5 million shells were expended. The artillery having done its work, at 7.30am on 1 July, thirteen British and eleven French divisions then left their trenches and began walking across no-man's-land. It was expected that, following the earlier siege, resistance would be minimal. The reality was different. Having survived the intended destruction of their positions, the Germans re-established their machine gun placements. Caught in the barbed wire defences, which had remained intact, the advance was mown down with extraordinary ease and dreadful ferocity. Before nightfall, the casualties suffered on the first day by the British army alone numbered 57,470, including 19,240 dead. Referring to the losses suffered, Haig noted in his diary the following day: 'this cannot be considered severe in view of the numbers involved and the length of front attacked.'[18]

The propaganda value of film in reporting the war had been recognised by the Government relatively early in the conflict. It was a key assumption that photography – especially film – provided a recognisable stamp of authenticity. While the appeal of art was its capacity to filter events through a perceiving sensibility, the ability of the camera to provide an objective record presented an attractive, credible alternative. Accordingly, having secured the necessary agreements with the war's leaders, the first official film footage appeared in late 1915. In general, these films had a didactic purpose and took the form of factual newsreel material. As part of these developments, cinematographers Malins and McDowell were despatched to the Somme to cover the planned offensive. Malins began filming on 25 June and McDowell commenced at a separate location on 29 June. Their early arrival enabled them to document

the preparations and build-up to the assault, and they continued to work on location until 10 July, nine days after the battle's calamitous beginning.

Returning to London, the footage they had secured was then seen by the British Topical Committee for War Films, the body charged with the creation of propaganda films. So taken were they by Malins' and McDowell's work that a decision was taken to combine their material and issue it as a full-length feature. The next, less visible stage is significant for it involved editing the 'rushes', or first prints, in order to impose a structure on what became a visual narrative lasting over an hour. The end result was seen at a private screening held on 10 August 1916 at the Scala Theatre in Fitzroy Square, London. *Battle of the Somme* went on view at thirty-four London cinemas from 21 August and was distributed nationwide the following week. It was later circulated internationally, being seen in eighteen other countries.

The film's much discussed realism arose not merely from its vivid evocation of place. Set against the expansive backdrop of the opening scenes, the compelling portrait that emerged was that of the ordinary British soldier, seen en masse and, in certain scenes, in close-up. For the audience, the

SCALA THEATRE,

CHARLOTTE STREET, FITZROY SQUARE, W.

Proprietor : Dr. E. Distin Maddick.

THE BRITISH TOPICAL COMMITTEE FOR WAR FILMS

request the pleasure of the company of Bearer and Friend on

THURSDAY NEXT, AUGUST 10th, at 11.30 a.m. prompt,

when they will present

OFFICIAL PICTURES

of the

"BATTLE of the SOMME,"

Taken by Special Arrangement with the

WAR OFFICE

and under their direction.

¶ No "Exclusive Rights" of this film will be granted.
Schedule of prices can be obtained from the sole booking director, W. F. JURY.

Invitation card for the premiere of
Battle of the Somme, 10 August 1916

Lloyd George, the Secretary of State for War, sent a message of support that was read to the audience.

prospect of being able recognise a familiar face would have added notably to its affective power. The film's three-part structure provided, in the first part, a detailed depiction of the soldiers' movements and activities prior to the attack. The central section featured the launch of the offensive and included a celebrated scene depicting soldiers going 'over the top'. The final part of the film addressed the aftermath, with scenes of the dead and wounded, prisoners of war, destruction wreaked upon the landscape and, in a powerful conclusion, images of those who did not survive. Even a brief synopsis conveys a sense of the ability of the film to arrest and hold the attention, to inform, to shock and, for many, to engage the emotions. In contrast to traditional depictions of soldiers at war, in which heroism and patriotic duty were overt elements, the film's down-to-earth treatment of its human subjects struck a new note of believability. With a portrayal of fighting men at its core, for many *Battle of the Somme* seemed to present the war as it was. The *Spectator* referred to 'the thrill of battle' that it conveyed.[19] Others, such as the Dean of Durham, objected to the offence its immediacy gave to those affected by bereavement.

Despite the film's undoubted impact, the balance it struck between fact and fiction is less clear. The objectivity with which the battle's casualties are treated is indisputable. That said, when the film is held up against reality, as suggested by contemporary reports and by the grotesque statistics that in many ways speak for themselves, a gap is apparent. Although the film's audience may have felt they had experienced the thrill of war, relatively little is seen of the fighting itself. The enemy is depicted captured, wounded and dead – but as an antagonist is nowhere visible. Nor is there any suggestion of the actual extent of the dreadful, shattering carnage. Presumably, if such footage existed, it was censored at the editing stage. Other qualifications can be made. The scene of British soldiers leaving their trenches is generally regarded as having been staged. None of the British army's leaders has any part in the narrative. Finally, and most questionable of all, a human disaster was presented as a spectacle to which audiences could respond in places designed for entertainment. However the film was regarded in terms of propaganda, the tension between truth and titillation was not entirely resolved. It is perhaps for this reason that, for the remainder of the war, the portrayal of the dead remained officially off-limits.

Such qualifications are enabled by hindsight. These were not the views held by an audience seeing what would have been an astonishingly vivid account of events that were even then unfolding. For that reason, the example set by *Battle of the Somme* was not lost in a German context. The success of the film, and its effectiveness in presenting dire adversity in a positive light, suggested that a German version of events was needed. The first steps to create a German propaganda film office were taken in mid-1916. Known from January 1917 as the Photograph and Film Bureau (Bild und Film-Amt, or BUFA), this organisation decided to create a counterpart to the British film, which served as a model, for distribution to a national and international audience. From the start, this initiative evolved too late to enable an entirely effective outcome. Premiered on 19 January, five months after the appearance of *Battle of the Somme* and two months

Poster for *Bei unseren Helden an der Somme*
(With our Heroes on the Somme)
Designed by Hans Rudi Erdt, 1917

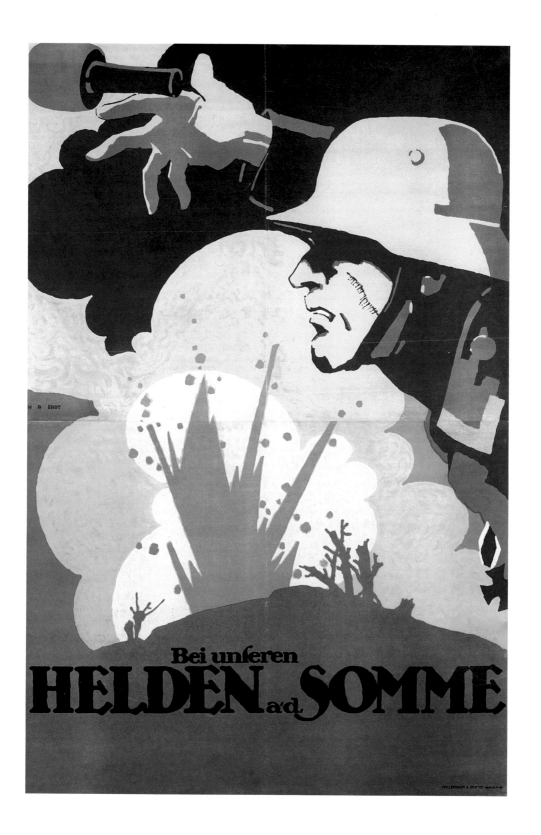

after the battle itself had ended, the result was *Bei unseren Helden an der Somme* (With our Heroes on the Somme). Also presented as an official war film, this feature addressed the same conflict but with markedly different results.

Bei unseren Helden an der Somme was in three parts and, like *Battle of the Somme*, it portrayed the ordinary soldier. The first part focuses on the German advance from behind the lines and, in common with its counterpart, it includes footage of enemy wounded. While shot on location, questions are raised, however, by the depiction of German troops wearing spiked Pickelhaube helmets, a class of equipment superseded by the time the battle took place. The implication is that some of this material may date from another, earlier period. The final two-thirds of the film contain footage that is clearly faked. The proximity of the camera to the purported battle scenes, and its position in front of advancing German troops – to name but two instances – are evidence of scenes staged safely elsewhere, outside the conflict zone. Although *Bei unseren Helden* enjoyed some domestic success and it too was praised for its authenticity, the inclusion of unconvincing footage robbed the film of the more enduring, wider appeal of the British original. While both films tested fact and fiction, it seems that, respectively, truth to appearances was a matter of degree.

The valiant and the damned

It is frequently said by historians that the Great War can be seen as the defining event of the twentieth century. As the first truly global conflict, its toll in human terms – over nine million soldiers killed and twenty-one million wounded – underscores its singular, unprecedented impact. Even now these statistics are difficult to comprehend. They confound the imagination, the reality of what actually occurred only really being within the grasp of those who experienced the war directly. More comprehensible perhaps is the effect of the conflict on those individuals who served. If it is possible to view the war, at least momentarily, less as a series of momentous events and massive undertakings and, rather, as an arena for individual human experience, then something more tangible emerges. Plunged into the most terrible conflict then known, its participants – a common humanity – endured a lottery in which private destinies played out. By focusing on its protagonists, a diverse matrix of life comes into view, in which heroism, achievement and selfless endeavour are held in tension with adversity, suffering and, for some, death. In this regard, portraits of those who took part in the war tell us much, intimating not only a record of events but also something of human nature itself.

As the war progressed, expectation encountered its nemesis – the reality of circumstances. Britain entered the conflict on 4 August 1914 and, by the end of that year, a wave of euphoria had propelled a million volunteers to the recruiting offices. A year later, the ranks of those offering themselves as servicemen had swelled to two and a half million. By 1916, though, and notwithstanding the efforts of official propaganda, this early idealism was tempered by the evidence of unfolding events. At railway stations a common spectacle was that of injured soldiers returning from the front, leaving well-equipped hospital trains. This grim picture made the effects of war an increasingly familiar sight to which the public became, of necessity, accustomed. However hard

those at work at Wellington House may have striven to control the flow of information, the physical corroboration of violence could not be staunched. Indeed, as the war's more horrific aspects became known, other expectations were generated as the public's demand for more authentic and less sanitised reporting grew. The inclusion of images of the wounded and dead in *Battle of the Somme* may thus, in part, be seen as official acknowledgement of this altered public knowledge, perception and mood. Yet from 1916, a growing tension is apparent between, on the one side, an official drive to motivate the war effort by presenting the conflict in a positive light and, on the other, the determination of artists such as Orpen, Nevinson and Kennington to present it as truthfully as possible.

These tensions are forcefully evident in one of the greatest portraits of the war: that of Winston Churchill, painted by Orpen in 1916 (cat. 64). As First Lord of the Admiralty, Churchill was held responsible for the disastrous Dardanelles campaign, an amphibious assault on Gallipoli involving British, Australian and New Zealand troops, which was launched on 25 April 1915. This multi-national attempt to capture Constantinople degenerated into fiercely contested trench warfare, resulting in 276,000 casualties including 46,000 Allied troops killed. As a result, Churchill resigned. Orpen painted Churchill at one of the darkest moments in his career. Called to appear before the Dardanelles commission, the disgraced statesman was preparing to defend himself against charges of incompetent and reckless leadership. Churchill felt constrained in the evidence he was able to submit as he could not risk damaging Kitchener's reputation. Although the portrait offers a formal view, it is a psychologically penetrating image that exposes the harrowing responsibilities of military

leadership. Orpen used to speak of the dejection in his sitter's face, calling him 'the man of misery'. Where other formal portraits had tended to focus on a particular aspect of an individual's role or situation, Orpen's portrayal of Churchill is distinguished by its suggestion of complex experience. When it was completed, Churchill told the artist, 'It is not the picture of a man, it is the picture of a man's soul.'[20]

Two main strands were by now apparent in the portraits of those involved in the war. The first addressed the public interest in individuals whose achievements were inspiring and who, in some reassuring way, enabled the war to be presented in a positive light. As a result, portraits of heroes, celebrated medal-winners and aces were reproduced in magazines and newspapers. Encouraged by the Department of Information, official portraits marking achievement fell within the remit of war artists. The second, markedly contrasting vein of activity responded to the reality of individual adversity, with images of violence created both for public consumption and private, medical documentation.

Within the first category, Orpen's contact with members of the Royal Flying Corp, from September 1917, presented him with the opportunity of meeting some of its leading pilots. In addition to Davids and Hoidge, both of whom were aces belonging to 56th Squadron, in the summer of 1918 the war's most highly decorated, top-scoring and longest-serving British flyer sat for him. By that time, Major James B. McCudden's awards included the Victoria Cross, the Military Cross and Bar, and the DSO and Bar, with fifty-seven victories to his credit. An outstanding pilot possessed of cool judgement, he twice shot down four enemy aircraft in a single day, once

HAPPY "TOMMIES" WEARING HUN HELMETS.

accomplishing this within a minute. Orpen's portrait is a formal celebration of McCudden's highly visible public profile (1918, cat. 66). Characteristically, however, he managed both to enliven that formality with a spontaneously grasped likeness while at the same time transcending the facts of his sitter's appearance. In his memoirs Orpen noted, 'well he wears his honours, and, like all great people, sat like a lamb.'[21] McCudden himself had written to a friend, 'if only one could be left alone a bit more, and not so much of the hero about it.'[22] The resulting portrait conveys an attentive stillness, illuminated by an essential, understated modesty.

This combination of formality and the intimation of interior self-possession is a characteristic of the finest portraits of heroes created towards the end of the war. Notable among these are portraits of Captain Albert Jacka, painted by Colin Gill (1919, cat. 68); the Canadian, Captain

'Happy "Tommies" wearing Hun Helmets'
Postcard, n.d.

The title of this official war photograph, one of a series of postcards published by the *Daily Mail*, gives a reassuring gloss to life on the Western Front.

G.B. McKean, portrayed by Leon Underwood (1919, cat. 67); and 2nd Lieutenant G.S.M. Insall by Edward Newling (1919, cat. 65). Australia's most famous soldier, Insall displayed conspicuous bravery at Gallipoli on 19 May 1915. Resisting attack by a consignment of Turks, who were invading the trench he occupied, Jacka shot five men with his rifle and bayoneted two others. For this single-handed action he was awarded the Victoria Cross, the first member of the Australian Imperial Force to receive this award. The following year, at the Somme offensive, Jacka again justified his reputation as a fearsome front-line soldier by charging the enemy, which was then rounding

up Australian prisoners. He received the Military Cross in recognition. On his return to Melbourne in 1920, he was given a hero's welcome.

Captain G.B. McKean's achievements were no less distinguished. Although British-born, he served in the Canadian Expeditionary Force. Cited in the *London Gazette* for actions 'beyond praise',[23] his courage was apparent when, in an action near Gavrelle during the Battle of Arras, he charged a German barbed wire barricade, killing two of the enemy. This led to a successful advance by his men. Later invalided out of the army because of injuries sustained subsequently, his portrait by Underwood carries an affecting and surprising sense of vulnerability. In contrast, Newling's portrait of 2nd Lieutenant Insall is the most overtly impressive as an emblem of gallantry. In November 1915, Insall was serving with the Royal Flying Corps in France, on patrol over the Western Front. He pursued an enemy plane deep into hostile territory. Despite sustaining damage to his own machine, after a forced landing he managed to effect repairs and return home. For these actions he received the Victoria Cross. Newling presents Insall in flying gear, confronting the viewer front-on. Unlike the relatively understated portraits by Orpen, Gill and Underwood, this is a more theatrical image calculated to assert the sitter's charismatic presence.

Portraiture, however, also addressed experiences of a very different kind. While the public wished for good news of the war's progress, welcomed celebratory images of achievement, and above all desired a speedy end to the proceedings, they did not want to be misled. The stunned but fascinated response to *Battle of the Somme*, and the success of exhibitions of war art by Orpen and Kennington in 1918, were evidence of the exceptional level of interest in imagery believed to be realistic. Thus, while the Ministry of Information (as it became in March 1918) censored images of dead soldiers, its line on depicting war wounds was softer. While distressing, injury was seen as evidence of courage and, for that reason, ennobling. In this curious way, portraits of celebrated heroes and images of wounded men, though radically different in subject matter, connected in terms of their public resonance.

In that context, at the end of the hostilities, the Committee for the Medical History of the War commissioned a team of thirteen artists to address the difficult area of representing physical trauma. Sponsored by the War Office and the Royal Army Medical Corps (RAMC), the group was managed by the Liverpool-born painter Gilbert Rogers. Having served with the RAMC as an officer, Rogers was familiar with the work of this organisation and well placed to evoke its important contribution. Exemplified by *An RAMC Stretcher-Bearer, Fully Equipped* (1919, cat. 69), his output encompasses portraits of medical personnel. He also depicted the ghastly results of injuries – and the fatalities. Confronted by gas, artillery fire and bullets as well as trench foot, gangrene and fever, his subjects were plentiful. In meeting the demand for veracity, works such as *The Dead Stretcher-Bearer* (1919, cat. 21) were persuasive. Here, an abject realism is refracted through an art historical prism, intimating crucifixion. Exhibited at Crystal Palace in 1920, the work of Rogers and his team of artists was reviewed by *The Times* under the title 'Grisly truthfulness'.[24]

Rogers' paintings were a shocking indictment of the cost of war at a deeply personal level. Sweeping aside the abstraction of statistics, they focused with harrowing intensity on ordinary soldiers' actual experience of war. They transmit a sense of the

collective pain and degradation suffered, and the efforts of medical personnel to mitigate individual trauma. However, these paintings were retrospective and came after the war had ended. For a more immediate, eyewitness response we must look to Orpen and Kennington, who both produced raw portraits that revealed physical and psychological injuries with appalling directness. Though Orpen recoiled from making images of British war dead, he depicted soldiers in the receiving room of a military hospital (1917, cat. 70), an exhausted soldier straight from the heat of battle (1917, cat. 19), and, most disturbing of all, a semi-naked Tommy driven to distraction by shelling (page 138). Kennington, who from August 1917 also served as an official war artist, was no less dedicated to depicting the lot of ordinary servicemen. A veteran of the 13th Battalion, London Regiment, in 1914–15, he was acquainted with front-line duties but having been injured was invalided out of the army. Returning in an artistic capacity, he confronted pain itself with a powerful combination of empathy and objectivity. In such paintings as *Gassed and Wounded* (1918, cat. 71), for example, the tightly cropped image contains a moment of searing distress.

Harrowing though such images are, when they were exhibited their harshness satisfied a fascinated audience who felt that the truth of things had been imparted. It is perhaps ironic, therefore, that a far worse reality remained undisclosed. Before the war, Henry Tonks had studied medicine, after which he became an assistant professor at the Slade School of Fine Art, teaching drawing and anatomy. Too old to enlist, from January 1916 to the end of that year he served as a lieutenant in the RAMC. He then took up a position at the Cambridge Hospital, Aldershot, where he was responsible for assessing which injured soldiers were fit to return to duty. At Aldershot, and later at the Queen's Hospital, Sidcup, Tonks worked with the surgeon Harold Gillies. Initially Tonks provided Gillies with diagrammatic drawings designed to assist the process of facial plastic surgery. Subsequently, working from life, he made numerous pastel portraits of the servicemen undergoing reconstructive operations (cat. 72).

The purpose of these images is not known for certain. On one level they resemble the photographs that were also taken. In other ways, comparison with particular photographs of the same sitters reveals fundamental differences. A black and white photograph depicts a catastrophically disfigured man with mechanical indifference. Whether the individual's features have been burnt by gas or ripped asunder by gunshots, the photographic medium records these traumatic facts objectively. In contrast, Tonks's drawings are the product of the same predicament viewed through the lens of a perceiving mind. Colour, delicate texture and a tender abstraction are evidence of a human gaze.

As such they restore to a subject divested of dignity, and denied even the consolation of another's contemplation, something vital – a sustained looking. In this way art and medicine coalesced in the context of portraiture. However, for the wider public, facial injury remained taboo and even Tonks conceded that these images were 'rather dreadful subjects for public view.'[25]

Lieutenant Tonks, RAMC, at Aldershot, Hampshire
Photographed by Sidney Wallbridge, 1916

Depicting a range of facio-maxillary injuries, some of Tonks's 'remarkable pastel drawings', as Harold Gillies described them, are visible in the background.

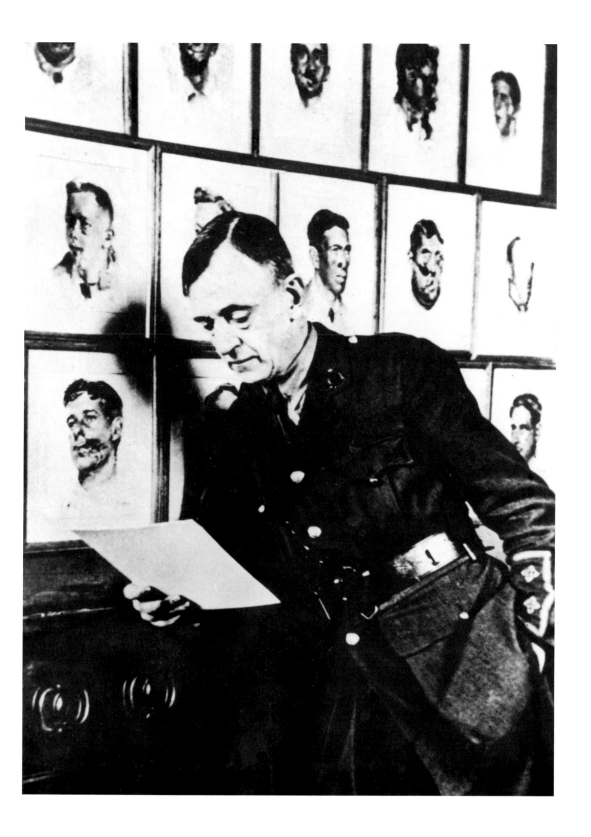

Tradition and the avant-garde

The Great War had hewn deep chasms that divided humanity in previously unimaginable ways. New forms of aggression and vastly enhanced means of maiming, destroying and annihilating had been devised in its name. Traditional strategies employing cavalry were largely sidelined. Instead, modern warfare employed snipers, barbed wire, machine guns, hand grenades, artillery and gas to devastating effect. The horror wreaked by such methods divested the battlefields of any semblance of glory. In its place was a bitter recognition of inhuman cruelty and, in consequence, mutual loathing. This is ironic given that none of the combatants were above using such methods. A further paradox lies in another, unforeseen outcome. In enduring a common catastrophe, the opposing sides were now united by a shared predicament: how to make sense of all that had occurred? As the war drew to a close, and indeed during a long aftermath, the paramount concern was to find meaning in the war, not least to explain the disturbing, altered perception of human nature that had arisen.

In confronting such issues, portraiture again played a significant role. Depicting those involved, often themselves, artists on both sides used the human form as a means of exploring and expressing their experiences. But because the war had so radically changed those who had lived through it, if only by transforming initial fervour into disillusionment, the pressing question for artists was to find an appropriate means of representation. Violence to the individual on every level – physical, psychological and spiritual – called for a language capable of conveying a heavy burden of implication. It is telling to examine the portraits that emerged. In considering the responses of two participant countries, Britain and Germany, a polarity is apparent. The reasons for this bifurcation are complex and, beyond a simple identification with the outcome of the war, such portraits resonate with deeper cultural meaning.

In Britain the effect of the war was to interrupt the progress of the incipient Modernist movement and then to drain it of vital energy. In the first decade of the century there had been opportunities to view the works of European masters such as Cézanne, Matisse and Gauguin in important exhibitions held in London. In 1910–11 and late 1912, two landmark Post-Impressionist exhibitions were organised by the critic Roger Fry. Among a receptive minority, these events were profoundly influential. Such revelations of avant-garde art abroad spawned pockets of Modernist innovation. In 1914, the exhibition *Twentieth-Century Art: A Review of Modern Movements* was held at the Whitechapel Gallery, London. This chiefly comprised British artists working in progressive styles. However, such development was cut short. Among the ranks of the more forward-looking, Epstein drew back from the radical experimentation he instigated in 1913. Gaudier-Brzeska, as we have seen, was killed in action in 1915. Others were deflected by active service: Henry Lamb was based in Palestine, working as a medical officer; Kennington, Nevinson, Wyndham Lewis, brothers John and Paul Nash and William Roberts all served in France; Stanley Spencer spent time abroad in Solonika and his brother Gilbert was occupied in the Middle East. This is not to suggest that Modernism in Britain was killed off by the hiatus the war imposed. However, in the visual arts its impetus was lost and, during the inter-war years, remained the preserve of a distinguished few.

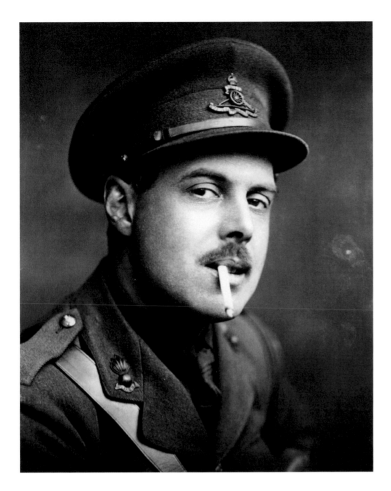

Wyndham Lewis
George Charles Beresford, 1917

In December 1917 Wyndham Lewis
became an official war artist for
both the British and Canadian
governments.

Notable among those who exhibited at the Whitechapel Gallery in 1914 was the poet and painter Isaac Rosenberg. Having trained at the Slade School of Fine Art, Rosenberg was acquainted with Roberts, Nevinson and Spencer. In common with them he, too, served in the army. After failing to obtain a place in the RAMC, he was assigned to the Bantam battalion which took men below the army's required minimum height. A self-portrait completed in 1915 (cat. 74), shortly before he left for the Western Front, was the last of several he made during a prolific period lasting from 1912 to 1914, during which he also completed two privately published collections of poetry, *Night and Day* (1912)

and *Youth* (1915). The portrait depicts a confident young artist, insouciant and bold in equal measure. Compelling and intimate, in this image Rosenberg can be seen probing a Post-Impressionist way of working, his authority already evident. After arriving in France, he continued to write, producing celebrated poems such as 'Break of Day in the Trenches'. Rosenberg did not return to fulfil his early promise. On 1 April 1918 he was killed near Fampous, in the vicinity of Arras, and was buried in an unmarked grave.

In the same year that Rosenberg arrived at the trenches, another poet – Siegfried Sassoon – was commissioned in the Royal Welsh Fusiliers and also

despatched to the Western Front. Unlike Rosenberg, Sassoon's poetic potential was developed rather than extinguished by his wartime experiences. Published in 1917 and 1918, the acerbic but compassionate tone of his war poems established his reputation. Wounded in April 1917, Sassoon was invalided out of the army. While convalescing his portrait was painted by Glyn Philpot, who had also recently been demobilised on medical grounds. Recorded by Sassoon in his memoir *Siegfried's Journey 1916–1920*, the encounter between the two men is illuminating. Sassoon recalled, 'We did not talk about the War at all, and his quiet studio was a perfect place in which to forget about it.'[26] Noting his surroundings, he observed that Philpot had devised 'a delicate defence against the violence and ugly destruction which dominated the outside world.'[27] The war must have loomed large for them both. But this evident wish to shut out their experiences permeates the resulting portrait (cat. 75). Sassoon himself sensed its pacific character: 'The face shown in his portrait is almost scornfully severe and unspeculative, giving no indication of the conflict that was being enacted behind that mask …'.[28]

Philpot's portrait of Sassoon eschews a subjectively charged statement. Though more confrontational, and also more energetic in terms of its brushwork, Orpen's *Self-Portrait* (1917, cat. 76) – his third as a war artist – is, however, similarly self-contained. The first, *Ready to Start* (1917, page 20), was painted shortly after his arrival in France, on 10 June 1917. Guarded by wine bottles and a soda siphon, a mirror presents the artist's reflection as he regards himself in military uniform. Of the three, this is the most personally confessional, alluding to its creator's private consolation. Its successor, *The Artist: Self-Portrait* (opposite), depicts Orpen standing

in a battlefield. Wearing the same helmet, he holds the viewer's gaze, but his expression is strangely uncommunicative, as if feeling has been driven beneath the surface. During the summer, Orpen visited the blasted landscape of the Somme where he appears to have suffered some form of collapse. He observed: 'I was all alone … I felt strange. I cannot say even now what I felt. Afraid? Of what? The sun shone fiercely.'[29] Around the same time he began drinking more heavily. The final painting was completed that winter and shows the artist in a voluminous greatcoat and wearing a balaclava (cat. 76). Impelled by self-examination, the portrait features a turbulent, spontaneously brushed backdrop, but Orpen himself seems curiously detached, insulated against his surroundings.

This attitude of virtual denial stands in stark contrast to the stance of German painters such as Kirchner, Beckmann and Dix, whose artistic immersion in the war was all-enveloping. In their respective ways, the response of each of these artists was rooted in an art of conspicuous subjective expression. Brushwork, line and colour are vehicles carrying a weight of personal, often emotive meaning. A further important figure, Lovis Corinth should also be seen in this context. Although he distanced himself from overt Expressionism, his later work bears its influence. The roots of this approach can be traced to important developments that occurred in Germany in the decade preceding the outbreak of war. As in Britain, Wilhelmine culture was, at an official level,

The Artist: Self-Portrait
William Orpen, 1917

Orpen's second self-portrait was made around the same time as *Ready to Start* but presents the artist in the aftermath of battle.

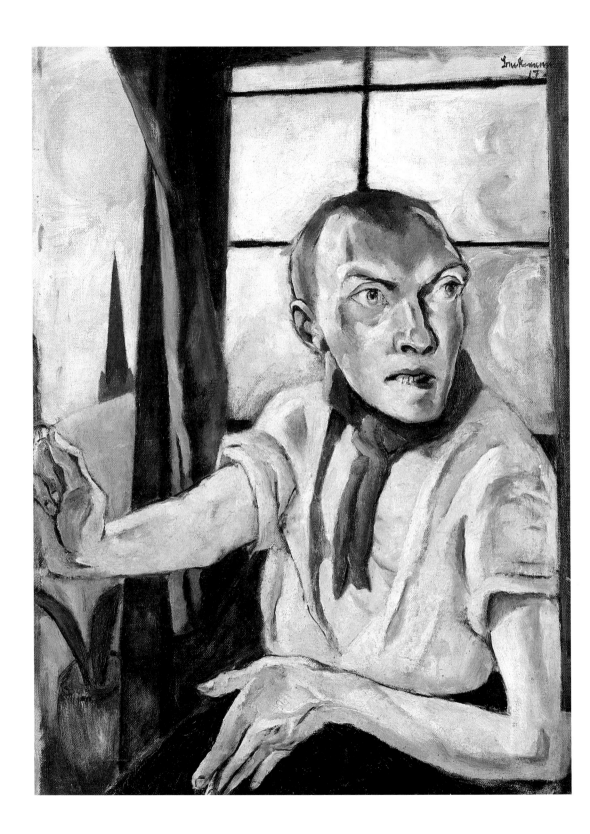

academic and conservative. However, the formation of the artistic group Die Brücke in 1905 provided a focus for a radical alternative. Drawing on the ideas of Nietzsche, and identifying with the raw, emotional character of earlier German artists such as Cranach and Grünewald, the Expressionistic style they declared sought to revitalise art by foregrounding felt experience. The pre-war period saw growing international recognition of Expressionist painting. Centred on Berlin, this style was identifiable with a quintessentially German modern culture, one that rivalled the vibrant artistic developments centred on Paris.

With the outbreak of war in August 1914, the German response was no less one of patriotic fervour. However, whereas the fledgling Modernist movement in Britain seemed to stall at the prospect of conflagration, certain painters in Germany saw the war as providing a vital impetus. The modern style they had created now found its ideal subject in the promise of a great, contemporary conflict. Thus, Beckmann could observe in April 1915, 'For me the war is a miracle, even if a rather uncomfortable one. My art can gorge itself here.'[30] Dix's view also combined apprehension with anticipation. In retrospect, he recalled, 'War was a horrible thing, but there was something tremendous about it, too. I did not want to miss it at any price.'[31] While their views would be altered subsequently by actual experience, it is clear that at the outset there was an element of opportunism. 'I am truly lucky,' Beckmann wrote on 12 April 1915. 'I am able to see

and experience so much and under such ideal circumstances ... Yesterday I spent the entire day at the front and again saw remarkable things.'[32]

Beckmann enlisted as a medical orderly in 1914 and, after serving at the front in East Prussia, volunteered for the medical corps in Belgium. His experiences during the Second Battle of Ypres in April–May 1915 were, however, a turning point. Exposed to the sight of the wounded, the dying and the dead on such a scale, on 5 May he admitted, 'now for the first time I've had enough'.[33] During his convalescence following a breakdown, Beckmann painted *Selbstbildnis mit rotem Schal* (Self-Portrait with Red Scarf, opposite). In this image the artist confronts himself and, from the wreckage of his recent experiences, assembles a disturbed emblem of the effects of war on a man's soul. The violent red of the scarf suggests an incision to the throat. With his head positioned at the intersection of the window bars, the artist – Christ-like – appears crucified, the bearer of terrible wounds. This is not to imply that Expressionist painting always transmitted extreme emotion as its subject. As President of the Berlin Secession, Corinth had previously rejected the radical experimentation of Beckmann and other progressive artists. Even so, his portrait of his friend, the etcher Herman Struck (cat. 77), painted in 1915, demonstrates a gravitation towards more agitated brushwork. Too old to enlist, Corinth had not experienced the war directly. In this painting of Struck in his officer's uniform, the artist focuses not on the psychological distress induced by conflict but on the impression of tired resignation, almost a wistful sadness, that the sitter conveys.

In the same year, 1915, Kirchner, the founder of Die Brücke, painted one of the most extreme manifestations of the capacity of portraiture to

Selbstbildnis mit rotem Schal
(Self-Portrait with Red Scarf)
Max Beckmann, 1917

Initially enthused by the promise of adventure that the war seemed to offer, Beckmann was shattered by his experiences at the front.

Selbstbildnis als Soldat
(Self-Portrait as a Soldier)
Otto Dix, 1914

This self-portrait was painted soon after Dix enlisted
as an artilleryman in August 1914.

impart the intense psychological experience of
war. Unlike Beckmann, Dix and others, Kirchner
formed an intense apprehension about the
impending conflict. To avoid being enlisted in the
infantry, in the spring of 1915 he volunteered as a
driver for the artillery. However, this involvement
was sufficient to destabilise him and he was
released from active service in order that he could
undergo psychiatric therapy. *Selbstbildnis als Soldat*
(Self-Portrait as a Soldier, 1915, cat. 78) was
created during this period of crisis. In what is one
of the great Expressionist portraits of the early
twentieth century, the artist depicts himself with a
nude model and a severed hand. This amputation,
which existed in the realm of Kirchner's

imagination only, is a violent symbol expressing
impotence, both sexual and artistic. At one with
the use of angular forms and dissonant colour, this
injury serves as a bitter indictment of the war – a
silent scream of protest.

Epilogue

After four long years, the end, when it came, was
relatively swift. In June 1918, the deadlock on the
Western Front remained entrenched. However,
major Allied assaults on the German lines from
September of that year led to a collapse in the
enemy's morale, both in the field of battle and at
home. Within a short space of time military defeat
led inexorably to revolution. The turmoil that
engulfed the defeated German nation now found
expression in extraordinary portraits by Beckmann
and Dix. In 1919, Beckmann produced a portfolio
of lithographs entitled *Die Hölle* (Hell), which took
as its subject the forces of political and social
dissent that filled the vacuum created by defeat
(cat. 79). In one of the most arresting images
within the series, Beckmann depicted himself
meeting a hideously disfigured soldier, one of the
many crippled veterans who now returned from
the front. In *Die Skatspieler* (The Skat Players,
opposite), one of the most macabre images
inspired by the war, Dix relinquished the bombast
of his earlier self-portraits, painted in 1914 and
1915. In the works he made at the outset, the artist

Die Skatspieler (The Skat Players)
Otto Dix, 1920

Dix's subjects are disfigured German war veterans,
wounded soldiers and amputees – an all-too-familiar sight
across post-war Europe.

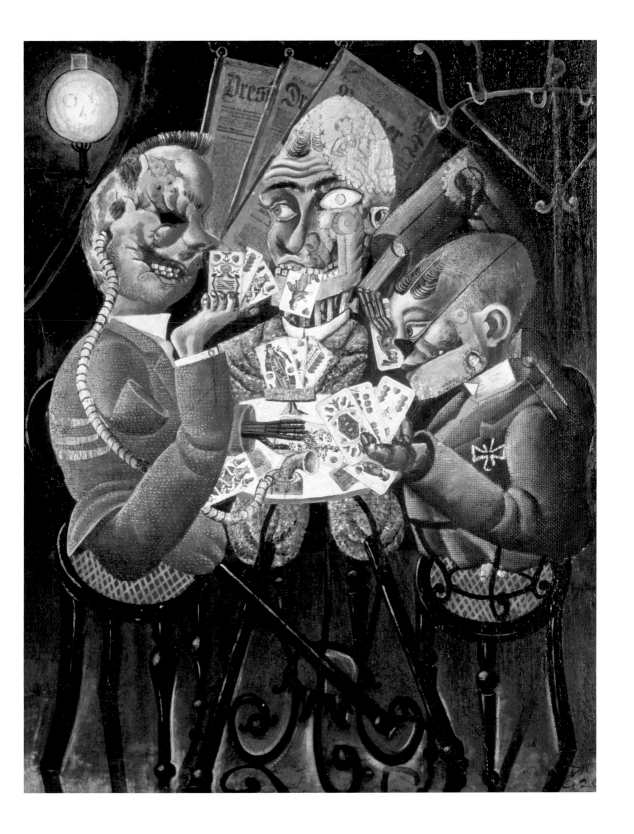

We are Making a New World
Paul Nash, 1918

During the Battle of Passchendaele both sides suffered horrific losses in appalling conditions. Nash's painting, the result of numerous preceding studies, evokes the silent devastation that resulted.

used his own image as an expression of virile military strength. Created in the aftermath of defeat, *Die Skatspieler* manifests the personal and artistic changes induced by the preceding events. The painting depicts a group of ex-soldiers, limbless and held together by prosthetic body parts. Though the war is over, they continue to play out a game of chance. Incorporating elements of collage, the painting – like its subject – is a construct of artificial substitutes. This, Dix seems to say, is the corrupted legacy of Germany's wartime past and its uncertain present.

In Britain, the official war artist Paul Nash, who had previously served as 2nd Lieutenant on the Western Front, created a series of paintings that were intended to evoke what he described as the 'bitter truth'[34] of his experiences. The most powerful of these works, the ironically titled *We are Making a New World* (1918, above), does not depict people at all. However, it still functions, poignantly, as a portrait – of absence. Those who fought have gone, but they also remain: buried by the debris of devastated earth. As if leavening the soil that is a common grave, a razed humanity

intimates an ambiguous future. This tragic image echoes sentiments expressed in Rupert Brooke's poem, 'The Soldier', which was composed during the war's first winter:

> If I should die, think only this of me
> That there's some corner of a foreign field
> That is forever England. There shall be
> In that rich earth a richer dust concealed.

In their different modes of expression, both Brooke and Nash evoke a sense of life lost, yet also containing the seeds of rebirth – a generation obliterated, yet inextinguishable.

Notes

1 William Orpen, *An Onlooker in France 1917–1919* (Williams and Norgate, London, 1924), p.28.

2 The series ran from 1909 to 1919. The first volume was *The Wonderful Year 1909: An Illustrated Record of Notable Achievements and Events* (The Daily News: London and Manchester/Headley Brothers, London). The final volume was *The Year 1919 Illustrated: A Record of Notable Achievements and Events* (The Swarthmore Press Ltd., formerly trading as Headley Bros. Publishers, Ltd., London).

3 From an unsent letter to William Roberts, quoted in Richard Cork, *David Bomberg* (Yale University Press, New Haven CT. and London, 1987), p.88.

4 Jacob Epstein, *Let There be Sculpture. An Autobiography* (Michael Joseph, London, 1940), p.70.

5 A full account of the assassination is given in Joachim Remak, *Sarajevo. The Story of a Political Murder* (Criterion Books, New York, 1959), pp.137–42.

6 Walter Sickert, letter to Ethel Sands [August 1914], Tate Archive TGA 9125/5, no.90.

7 Ibid.

8 Walter Sickert, letter to Nan Hudson, quoted in *Sickert Paintings*, edited by Wendy Baron and Richard Shone, exhibition catalogue, Royal Academy, London, 1992, p.239.

9 Orpen, *An Onlooker in France*, p.28.

10 Ibid., p.79.

11 Ibid., p.96.

12 Memorandum from Charles Masterman to Colonel Buchan, 7 May 1917, Imperial War Museum First World War Artists' Archive, file: ART/WA1/89.

13 Ibid.

14 Lee's views were reported in a letter of 21 November 1917 to Campbell Dodgson (Keeper of Prints and Drawings, British Museum) from A. Yockney (Department of Information, Wellington House, London), Imperial War Museum First World War Artists' Archive, file: 266 A/6.

15 Handwritten letter from C.R.W. Nevinson to Charles Masterman, dated 25 November 1917, Imperial War Museum First World War Artists' Archive, file: 266 A/6.

16 Memorandum to Charles Masterman from an unidentified source, dated 6 December 1917, Imperial War Museum First World War Artists' Archive, file: 266 A/6.

17 Memorandum to Charles Masterman from A. Yockney (Department of Information, Wellington House, London), dated 4 December 1917, Imperial War Museum First World War Artists' Archive, file: 266 A/6.

18 Haig's diary entry for 2 July 1916, National Library of Scotland, Acc.3155/97.

19 The *Spectator*, 26 August 1916, p.227.

20 Quoted in Bruce Arnold, *Orpen: Mirror to an Age* (London: Jonathan Cape, 1981), p.304.

21 Orpen, *An Onlooker in France*, p.70.

22 C. Cole, *McCudden VC* (Kimber, 1967), pp.173–4.

23 Supplement to the *London Gazette*, 28 June 1918.

24 Review in *The Times*, 19 August 1920.

25 Letter from Henry Tonks to the National War Museum (later the Imperial War Museum), 18 August 1917, Imperial War Museum First World War Artists' Archive, file: 300/7, Henry Tonks 1917–1946.

26 Siegfried Sassoon, *Siegfried's Journey 1916–1920* (Faber and Faber, London, 1945), p.49.

27 Ibid.

28 Ibid., p.5.

29 Orpen, *An Onlooker in France*, pp.39–40.

30 In *Max Beckmann: Self-Portrait in Word (Collected Writings and Statements, 1903–1950)*, ed. B. Copeland Buenger (University of Chicago Press, Chicago and London, 1997), p.159.

31 Dix interviewed in *Stuttgarter Zietung*, 30 November 1961, quoted in Dietrich Schubert, *Otto Dix in Selbstzeugnissen und Bild-dokumenten* (Rowohlt, Reinbek, 1980), p.24.

32 *Beckmann: Self-Portrait*, p.157.

33 Ibid., p.165.

34 Paul Nash to Margaret Nash, mid November 1917, in *Outline. An Autobiography and Other Writings* (Faber and Faber, London, 1949), p.21, quoted in Richard Cork, *A Bitter Truth, Avant-Garde Art and the Great War* (Yale University Press, New Haven and London, 1994), p.8.

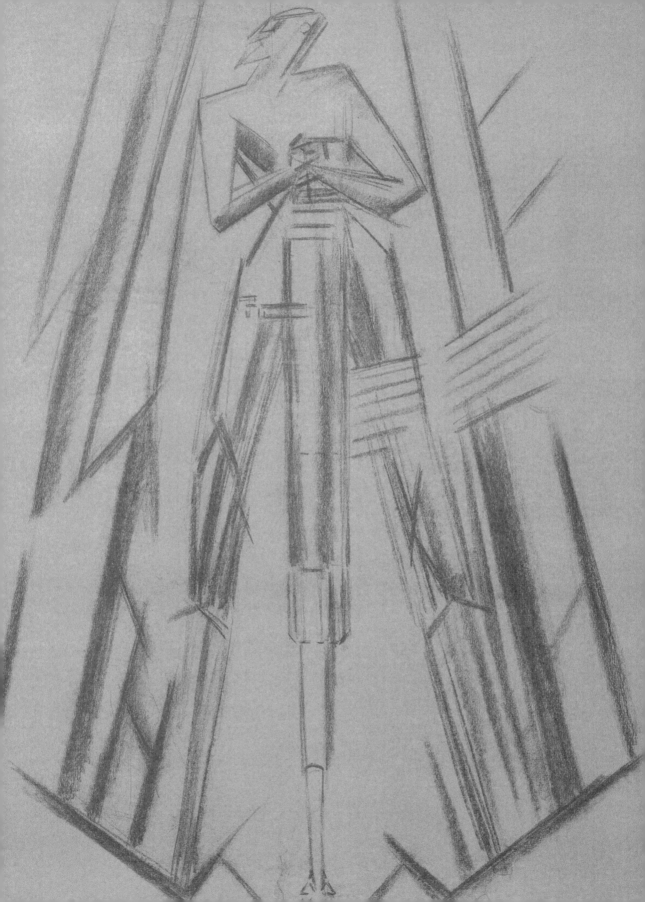

THE ROCK DRILL

In 1913, the year preceding the outbreak of war, the pioneering Modernist sculptor Jacob Epstein created an extraordinary sculpture titled the *Rock Drill*. This comprised an inhuman-looking figure – described by the sculptor as 'a machine-like robot'– astride a real pneumatic drill.[1] Devoid of compassion, the creature appeared as a disturbing automaton. The drill's phallic connotations carried a further layer of sinister meaning, implying mechanised sexual menace. As such, the sculpture reflected Epstein's affinity with the Vorticist movement, which celebrated modern man's fascination with machines, power, speed and energy.

The painter David Bomberg, who saw the *Rock Drill* in Epstein's studio, interpreted it in other ways, most profoundly as a harbinger of doom. If the sculpture could be seen in this alternative light – as an anticipation of military violence – the radical changes that Epstein made subsequently suggest his response to the mounting horror of the conflict. In 1916, he removed the drill and truncated the figure, severing the legs and the entire right arm. These amputations reflect an awareness of loss that was more than literal. Thus transformed, the sculpture can be understood as an evocation of the Great War, in which aggression gave way to resignation.

Note
1 Jacob Epstein, *Let There be Sculpture. An Autobiography*
 (Michael Joseph, London, 1940), p.70.

1

Torso in Metal from the Rock Drill
Jacob Epstein, 1913–16

Bronze, 705 x 584 x 445mm
Tate

This is the final version of the larger sculpture that
Jacob Epstein (1880–1959) originally created in 1913
(see essay, pages 26–9). Reduced in 1916 to a head,
trunk and a single arm, the figure now seems less
menacing than impotent. The reasons for this
radical change have been debated but it is clear that,
two years into the conflict, Epstein saw his creation
in a different light. With appalling losses on all
sides, the war posed an altered view of man's nature
and condition. Dismembered and androgynous, the
mechanised creature gestures pathetically, seeking
to protect the foetus within its abdomen. Devoid
of humanity, life itself seems corrupted.

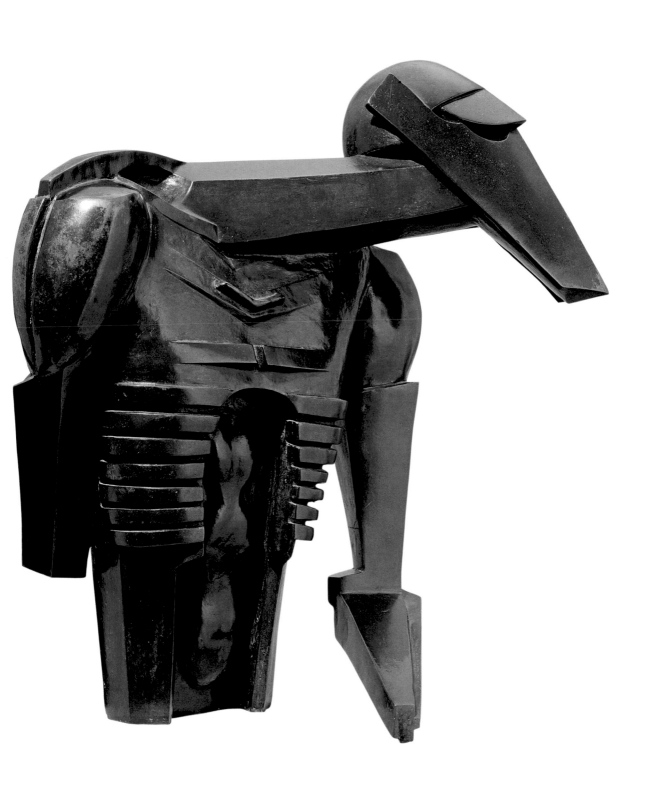

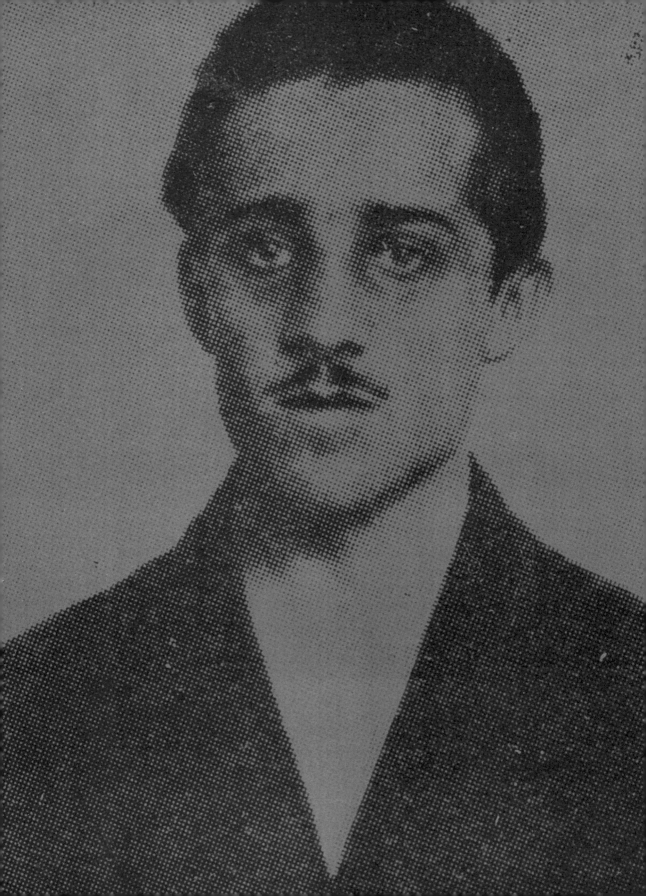

ROYALTY AND THE ASSASSIN

On 28 June 1914, a nineteen-year-old Serb, Gavrilo Princip, assassinated Archduke Franz Ferdinand, the heir apparent to the Austro-Hungarian throne. This act incited the Hapsburg empire to declare war on its neighbour, Serbia. That step triggered a series of events that dragged the major European powers – joined and divided as they were by a complex pattern of alliances and suspicion – into what eventually became a global war. The imperial, political and military power structure that was in place at the beginning of the twentieth century was, by the end of the conflict, in tatters.

Formal portraits depicting the heads of state of the participating nations evoke those values and attitudes that, in part, were ingredients in creating the conditions for war. State portraits representing the imperial nations – Britain, Germany, Austria-Hungary and Russia – transmit pride and grandeur but also hubris. Although less elitist, official photographs of the President of the French Republic are also emblematic of prestige. These impressive images contrast markedly with the understated press photograph of a dejected-looking Princip that circulated after his arrest and trial. Representing different worlds in collision, they set the scene on the eve of war – ultimate power threatened by abject insignificance.

2

King George V
Luke Fildes, 1912 (copy, after 1912)

Oil on canvas, 1870 x 1220mm
Government Art Collection

Aged forty-four, George V (1865–1936) acceded to the throne on 6 May 1910. This official state portrait was created soon after, its purpose being to create an image of the new king that, through replication and reproduction, could be disseminated throughout the realm. Following traditional models, it evokes the monarch's prestige and status. It is also to some extent emblematic, less concerned with personal characteristics than with what the head of state represents. Painted prior to the war, King George is dressed in naval uniform, a reminder of Britain's naval power. His sword is shown touching the ground, a subtle indication of restraint.

King Albert I of Belgium
Postcard, n.d. (photograph by Keturah Collings, n.d.)

Having acceded to the Belgian throne in 1909, King Albert I (1875–1934) complied with Britain's request that Germany be denied a passage through Belgium as part of an attack on France, Britain's ally. Britain was bound by the Treaty of London 1839 to preserve Belgian neutrality and independence. The invasion of Belgium in 1914 led to Britain declaring war on Germany on 4 August. During the ensuing war Albert fought alongside his troops.

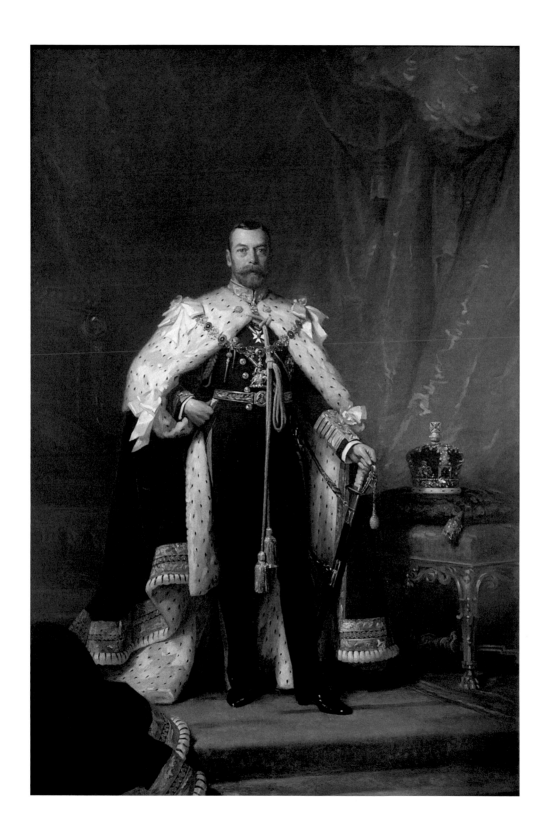

Kaiser Wilhelm II
August Böcher, 1917

Oil on canvas, 1047 x 762mm
Imperial War Museums

Kaiser Wilhelm II (1859–1941) of Germany was inordinately concerned with his public image. Having succeeded his father Frederick III in 1888, he came of age at a time when modern media was gaining ground. Through newspapers, photographs, film and reproductions of formal portraits, the Kaiser became a ubiquitous presence, setting new standards of ostentation. This flamboyant portrait shows him in full ceremonial uniform. Grandson of Queen Victoria and the cousin of King George V, Wilhelm directly challenged Britain with his policies of naval and colonial expansion. After the outbreak of war, although Supreme Commander, Wilhelm was increasingly excluded from military decisions.

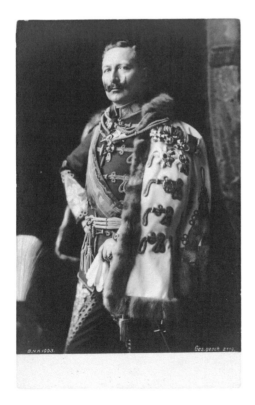

Kaiser Wilhelm II
Postcard, n.d.

As this postcard shows, Wilhelm set exacting standards in terms of ceremonial dress, the use of ornate historical costume elevating the prestige of his court. But bombast also concealed a deeper lack of confidence. A difficult birth left Wilhelm with a withered left arm, which he disguised in various ways. Here the arm is partly hidden by the draped tunic and he employs a favourite device: holding gloves to impart elegance and purpose.

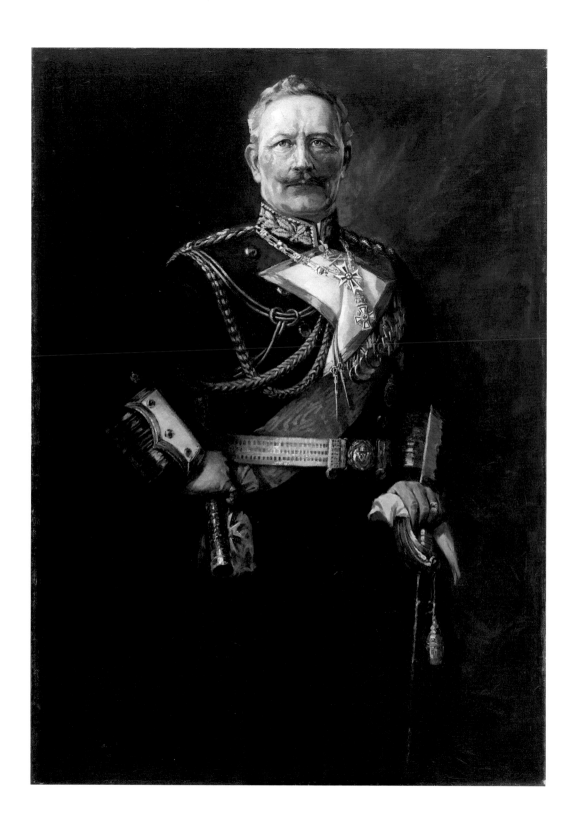

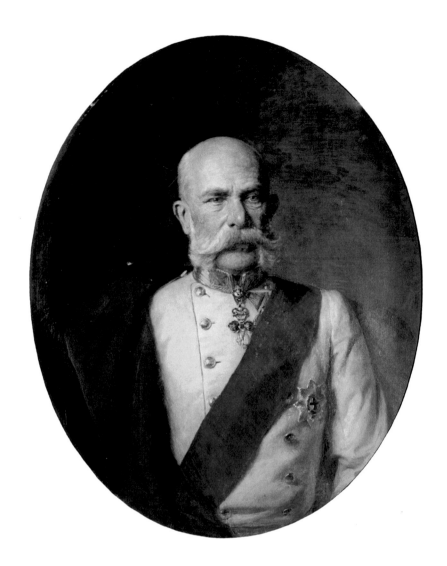

4

Franz Josef I of Austria
Kasimir Pochwalski, *c*.1900

Oil on canvas, 860 x 660mm
Government Art Collection

Franz Josef (1830–1916) became Emperor of Austria in 1848 at the age of eighteen. When the empire of Austria-Hungary was established in 1867 he became its monarch, ruling alongside his wife Elisabeth. A deeply conservative figure, he associated himself with the formality of the seventeenth-century Hapsburg courts, believing that he ruled by divine right. He saw the army as the pillar of the empire, and during his long reign he was invariably depicted wearing, as here, a white field marshal's uniform. The question of succession was a vexed one. With tragedy striking both Franz Josef's only son and both his brothers, his nephew – Archduke Franz Ferdinand – was next in line. The Emperor had little affection for him, however, and attended neither his marriage nor, after the Archduke's assassination, his funeral.

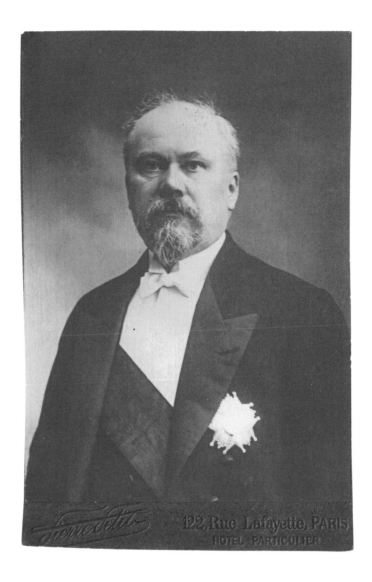

5

Raymond Poincaré, President of France
Pierre Petit, Paris, c.1913–15

Postcard (n.d.), 153 x 99mm
Private Collection

Raymond Poincaré (1860–1934) became Premier of France and its Foreign Minister in January 1912. Having formed a 'national ministry', he was dedicated to maintaining France's security, military preparedness and international standing. He worked to consolidate France's alliance with Russia and entered into a naval agreement with Britain. Recognised as his nation's leading statesman, he was elected President of the Republic in January 1913. German anxieties about encirclement were not assuaged by the state visits he made to England and Russia in June 1913 and July 1914. Official portraits of Poincaré, as here, are relatively understated, eschewing the pomp of his imperial neighbours.

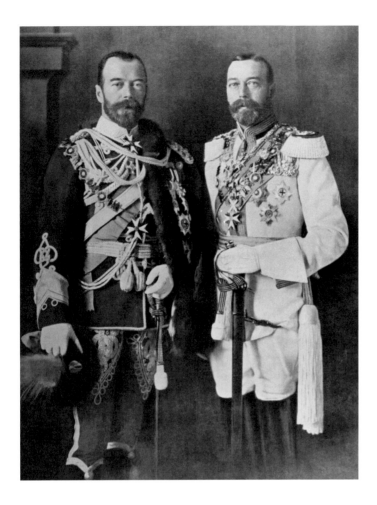

6

**Tsar Nicholas II of Russia and his cousin
King George V of Great Britain**
Ernst Sandau, 1913

Photograph, 152 x 216mm
Mansell Collection, courtesy of Time inc.

Tsar Nicholas II (1868–1918) ascended to the
Russian throne in 1894. From the outset events
conspired against him and he appeared unsuited
to the responsibilities placed upon him. At his
coronation ceremony a stampede involving
assembled crowds led to 1,400 deaths. Despite this
catastrophe the ensuing formal celebrations went

ahead. Then, in January 1905, a massacre of
protestors in St Petersburg sparked a revolution.
The following September, Russia capitulated in
the Russo-Japanese War (1904–5). This photograph
shows the Tsar with his cousin King George V.
It was taken on 24 May 1913, on the occasion of
the wedding of Victoria Louise (1892–1980), the
only daughter of Kaiser Wilhelm II, and was
reproduced on the cover of *Illustrirte Zeitung*, number
22, on 1 June 1913. Emphasising their close family
and diplomatic connections, Nicholas is wearing
an English uniform while George is dressed in
Russian regimentals.

7

Imperial Presentation Box
Workmaster Henrik Emanuel Wigström;
miniaturist Vassily Zuiev, 1916

Two-coloured gold, guilloche enamel, brilliant and rose-cut
diamonds, 33 x 95 x 64mm
The Royal Collection Trust

This presentation box contains a miniature of Tsar
Nicholas II by the court miniaturist Vassily Zuiev
(1870–1917). The Tsar is depicted wearing the
uniform of the 4th Imperial Family Rifle Guards
and the Order of St George. The guilloche
enamel design radiating out from the portrait is
a conspicuous emblem of power and prestige.
Such boxes were presented on behalf of the Tsar
to cement good relations, or, as in this case, in
recognition of services rendered. The recipient
of this box was Gabriel Hanotaux (1853–1944), a
member of the French Academy who, as Minister of
Foreign Affairs, had been instrumental in developing
the rapprochement between France and Russia.

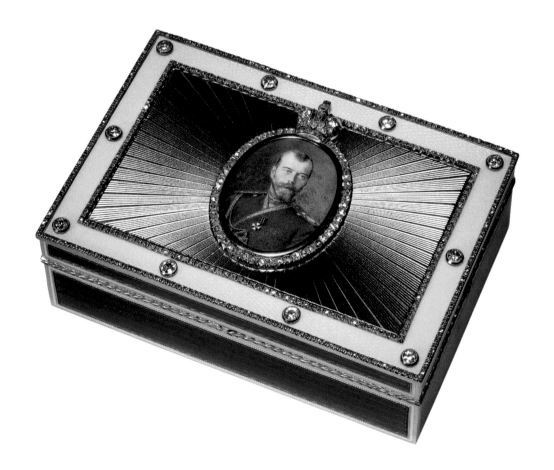

8

Archduke Franz Ferdinand
Theodor Breitwieser, n.d.

Oil on canvas, 310 x 240mm
Lobkowicz Collections

This portrait depicts the man whose assassination
led, ultimately, to the mobilisation of over seventy
million military personnel. Of these, during the
four-year conflict, over nine million were killed.
On 28 June 1914, at 9.28 am, Franz Ferdinand
(1863–1914) and his wife Sophie arrived in Sarajevo,
Bosnia, on an official visit. At 10.10am a bomb
was thrown at their car by one of seven waiting
Serbian conspirators. They escaped unhurt
but subsequently took a wrong turn and
encountered Gavrilo Princip (1894–1918), one of
the would-be assassins. Having assumed that the
plan had failed, Princip took advantage of this
error and fired two shots, killing them both.

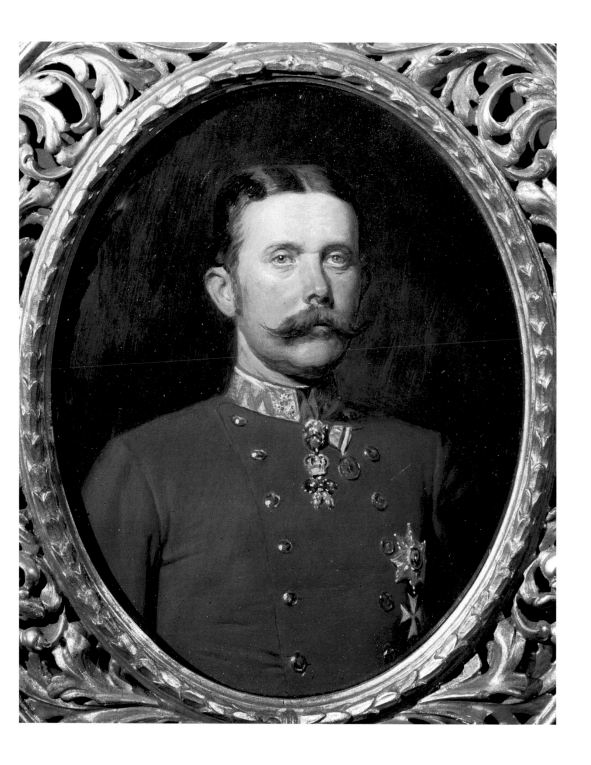

9

Gavrilo Princip
Unknown photographer, 1914

Modern print from a halftone reproduction
Imperial War Museums

Following the assassination of Archduke Franz Ferdinand, his assailant Gavrilo Princip and the other conspirators were arrested and prosecuted. The trial commenced on 12 October 1914 and sentences were announced on 28 October. Princip, a Bosnian Serb who at nineteen was too young to face the death penalty, received twenty years imprisonment. This press photograph shows him having been arrested. Blaming Serbia, Austria-Hungary declared war on its neighbour. German support for Austria and Russian support for Serbia created an explosive confrontation. When Austria threatened Serbia, the two European blocs mobilised their armies. Germany's invasion of Belgium, as part of its advance on France, then meant that British involvement became inevitable.

Nedeljko Cabrinovic (one of Princip's six conspirators) is arrested in Sarajevo
Photograph by Milos Oberajger,
28 June 1914

Moments after the shooting,
Cabrinovic is seized.

The conspirators on trial
Unknown photographer, October 1914

Princip is seated in the centre
of the front row.

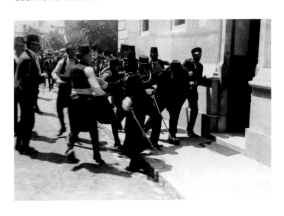

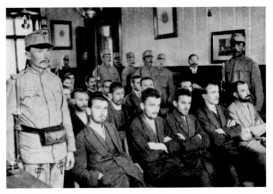

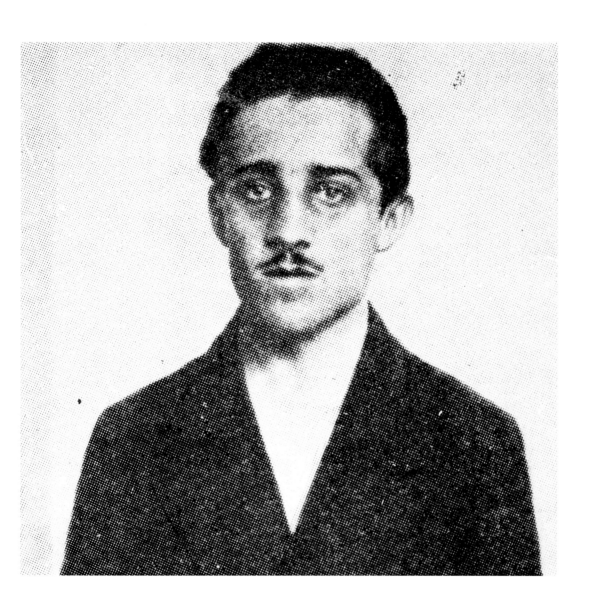

LEADERS AND FOLLOWERS

From 28 July 1914 onwards, one nation after another declared war on its perceived enemies. Immediately, power devolved from the heads of state – who, in theory, were commanders-in-chief – to their respective military leaders. Assuming strategic control, these senior officers commenced the programmes of mobilisation that drew soldiers of all nations into the different theatres of war. In this way a hierarchy was evident, ranging from symbolic leaders to ordinary servicemen.

That order of seniority, influence and role was clear in the various images of the participants that were created. Irrespective of nationality, formal portraits of commanding officers emphasise the personal profile of the depicted individual. This is manifest in their attitude of authority, uniform and, often, an array of medals signifying previous gallantry. These power portraits were copied and widely reproduced, notably as collectable postcards. The depiction of ordinary servicemen is markedly different. Represented in paintings, drawings and photographs, such images present a more down-to-earth view. Private photographs were also printed as postcards, but, unlike portraits of military leaders, these were not mass-produced and had a more personal significance. Whether the subject of formal portraits or captured in off-guard moments, frequently the servicemen shown are either anonymous or generic 'types'. This conveys a sense of depersonalised, shared experience in which duty is a central assumption.

The Integrity of Belgium
Walter Sickert, 1914

Oil on canvas, 910 x 710mm
Government Art Collection

This painting was exhibited in the 'War Relief Exhibition' held at the Royal Academy, London in January 1915. Walter Sickert (1860–1942) based this work and the related painting *Soldiers of King Albert the Ready* (below) on newspaper photographs. Both depict Belgian soldiers resisting the German advance. Sickert was appalled by reports of German atrocities against Belgian citizens. Too old to enlist, he was frustrated at not being able to play an active role and his grasp of the war was confined to reports and press images. In August 1914, he wrote to fellow artist Ethel Sands expressing his conviction that Germany had to be overpowered, adding that 'the wearing effect of [the war] is worse for us non-combatants than on a soldier.'[1]

1 Tate Archive, TGA 9125/5, no.90.

Soldiers of King Albert the Ready
Walter Sickert, 1914

As well as using newspaper photographs, Sickert based this painting and *The Integrity of Belgium* on studies made from live models wearing Belgian uniforms.

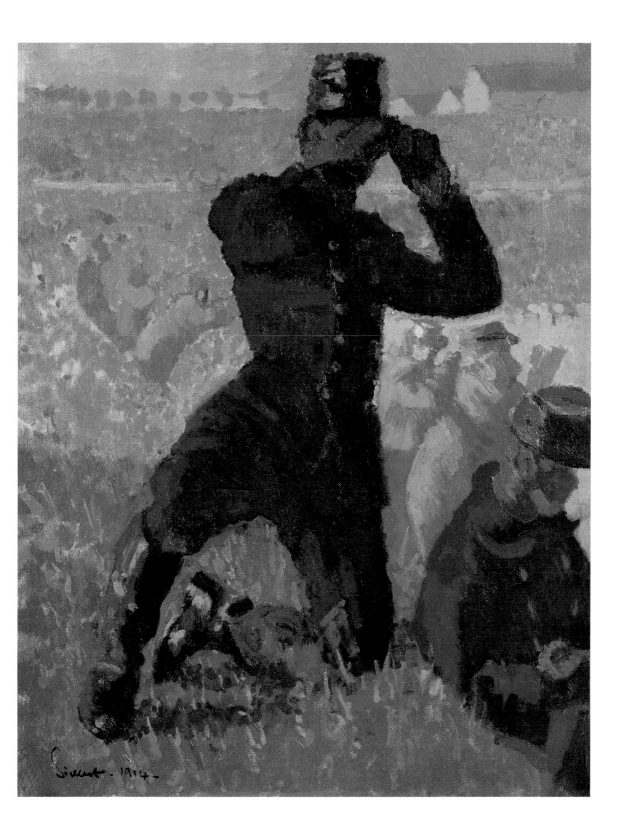

La Mitrailleuse
C.R.W. Nevinson, 1915

Oil on canvas, 610 x 508mm
Tate

C.R.W. Nevinson served as a Red Cross orderly and with the Royal Army Medical Corps (RAMC) in France and Flanders in 1915–16. Following his marriage in 1915, he painted *La Mitrailleuse* (the French term for 'machine gun') in London while he was on his honeymoon. Its fractured, angular composition reflects the Futurist idiom with which the artist identified at this time. It also draws upon his experiences as a volunteer ambulance driver, when he observed the conflict at first hand. Discharged because of illness in 1916, he returned to France in 1917. As *A Group of Soldiers* (1917, below) shows, he continued to document his observations, adopting a more naturalistic painting style.

A Group of Soldiers
C.R.W. Nevinson, 1917

The news that *A Group of Soldiers* had been rejected by the official censor Major Lee provoked a furious response from the artist. In an unsent letter to Lee, he thundered: 'I know this is how Tommies are usually represented in illustrated papers etc. – high-souled eunuchs looked mild-eyed, unable to melt butter on their tongues and mentally and physically incapable of killing a German. I refuse to insult the British Army with such sentimental bilge.' Seeking an unvarnished truth, Nevinson based his painting on four soldiers he had seen in London 'as they came from France on leave.' (See note 15, page 57.)

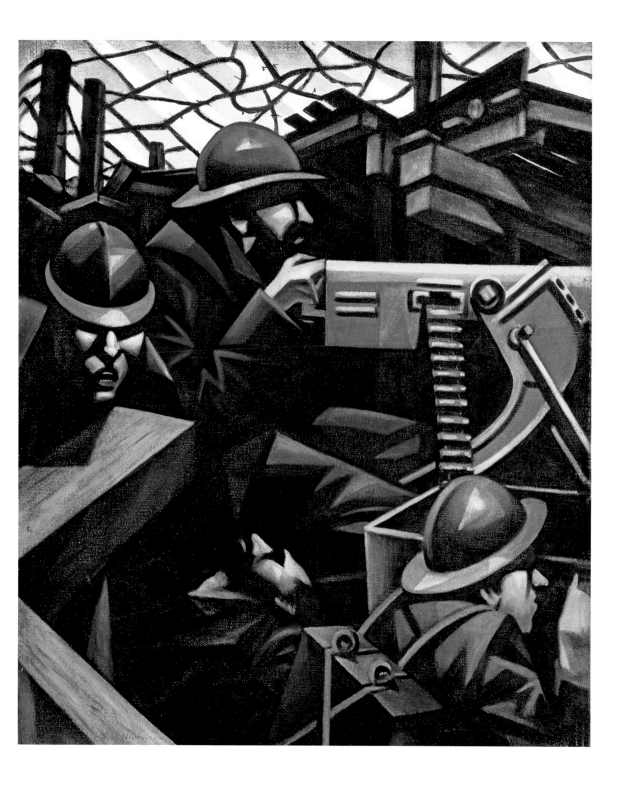

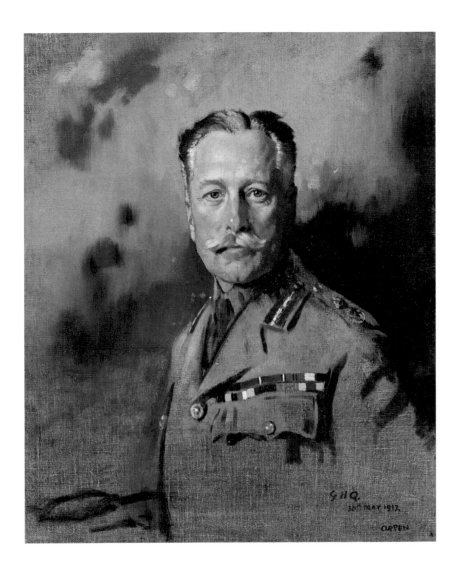

12

Field Marshal Sir Douglas Haig
William Orpen, 1917

Oil on canvas, 749 x 635mm
Imperial War Museums

Field Marshal Haig (1861–1928) arrived in France on 15 August 1914. Serving under Sir John French, Commander-in-Chief of the British Expeditionary Force (BEF), initially Haig commanded one of the two corps in France. In December 1915, he succeeded French assuming command of one and a half million men, the largest ever British field army. The battles of the Somme, Arras, Third Ypres and Cambrai, and the British advances of 1918, took place under his leadership, all incurring huge casualties. This was Orpen's first portrait as an official war artist. Responding to the sitter's compassion for his men and his sensitivity in recognising their heroism, Orpen (1878–1931) evoked these qualities in this work.

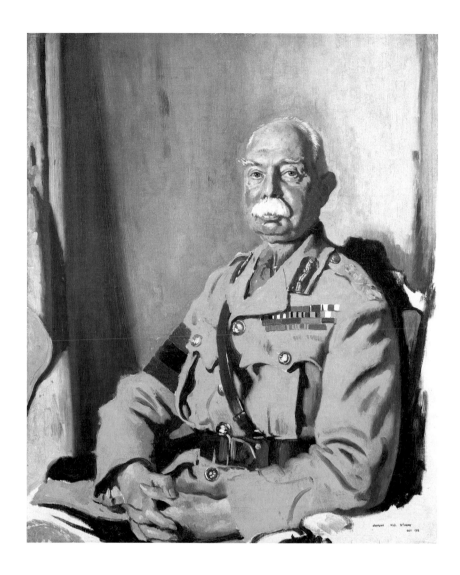

13

General Sir Herbert C.O. Plumer
William Orpen, 1918

Oil on canvas, 914 x 762mm
Imperial War Museums

General Plumer (1857–1932) arrived on the Western Front in January 1915 as commander of 5th Corps. In May 1915, he was promoted to the rank of general in command of the Second Army and served in that capacity for most of the remainder of the war. He was known to the troops as 'Daddy Plumer', a term of affection possibly connected with his strategic approach, one based on incurring the lowest number of losses. In June 1917, preceding the offensive he led on the Messines Ridge, south of Ypres, 450 tons of explosives were detonated in tunnels dug beneath the German positions. The resulting eruption was audible in London.

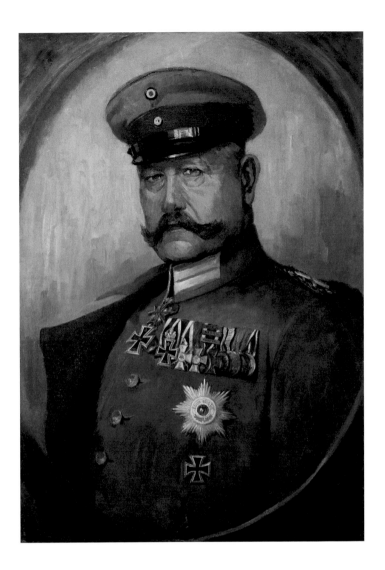

14

Field Marshal von Hindenburg
August Böcher, 1917

Oil on canvas, 800 x 571mm
Imperial War Museums

In August 1914, Paul von Hindenburg (1847–1934), then aged sixty-seven, was living in retirement, his military career supposedly over. A telegram received from the Kaiser recalled him to active service. With General Ludendorff, Hindenburg's overwhelming victory at the Battle of Tannenberg later that month annihilated the Russian army and made the two German commanders household names. There ensued an unshakeable popular belief in Hindenburg's and Ludendorff's invincibility. From late August 1916 they effectively ran Germany's war effort. Portraits of Hindenburg – a noted self-publicist – proliferated. These ranged from formal paintings to photographs and postcards. All contributed to Hindenburg's celebrity.

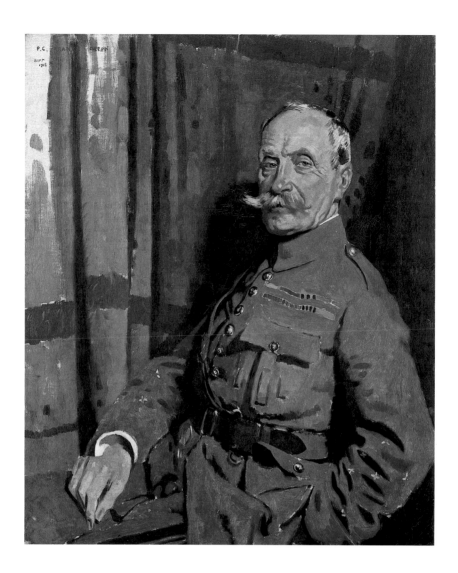

15

Marshal Foch
William Orpen, 1918

Oil on canvas, 914 x 762mm
Imperial War Museums

Ferdinand Foch (1851–1929) was one of the leading strategists of the Great War. He took up a military career in response to his country's defeat in the Franco-Prussian War of 1870–1. In September 1914, while commanding the Ninth Army, he succeeded

in repulsing the German advance during the Battle of the Marne. As a result, his prestige was greatly enhanced. On 15 May 1917 he was appointed Chief of the General Staff and on 28 March 1918 he became Allied Supreme Commander. Orpen painted this portrait in August 1918 while Foch, together with Haig, was planning the Grand Offensive that was to begin in September that year. The final Allied offensive of the war, this would lead ultimately to Germany's capitulation.

16

Aleksei Alekseevich Brusilov
Unknown photographer, n.d.

Postcard (*c.*1916), 135 x 86mm
Private Collection

This photograph dates from 1916, the year of
the major offensive that bears General Brusilov's
name. After serious defeats at Tannenberg and the
Masurian Lakes in 1914, the Russian army retreated
and was divided into three sectors. Appointed
Commander-in-Chief of the south-west sector
in March 1916, Brusilov (1853–1926) argued
successfully for an innovative, widely dispersed
attack on all three fronts. Launched in June 1916,
this spectacular offensive resulted in Austrian
losses of one and a half million men with 400,000
taken prisoner. For this, his greatest victory,
Brusilov was awarded the Sword of St George
with Diamonds. In May 1917 he became
Commander-in-Chief of the Russian army.

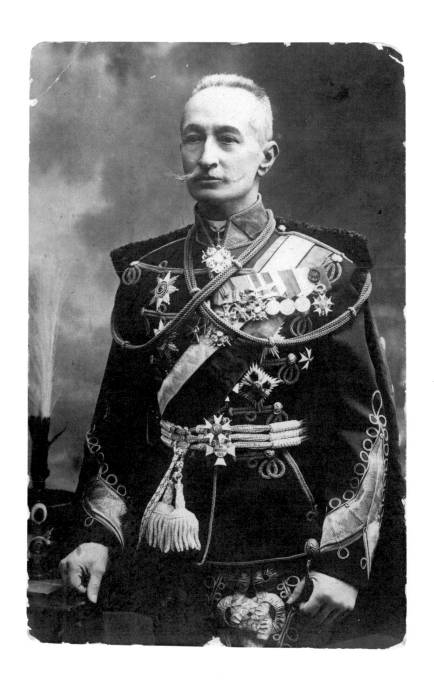

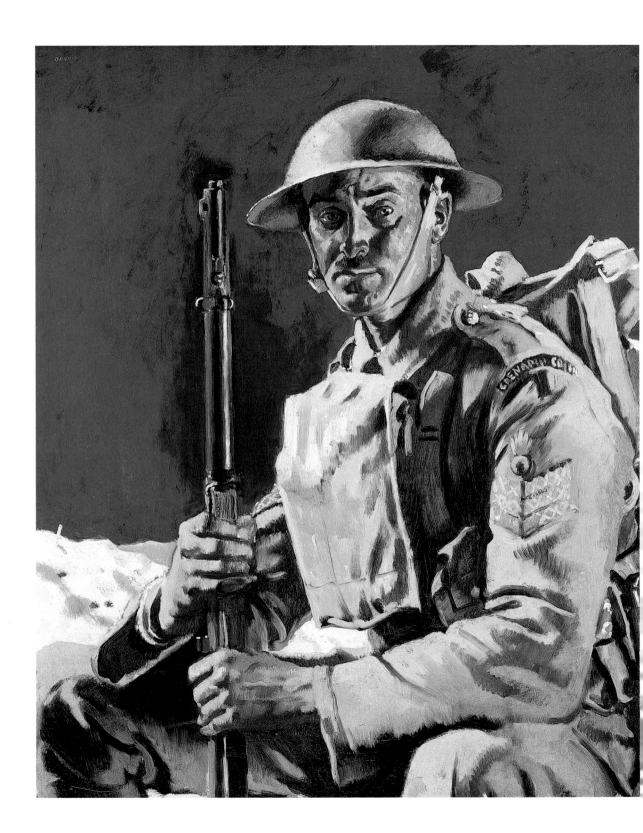

17

A Grenadier Guardsman
William Orpen, 1917

Oil on canvas, 914 x 762mm
Imperial War Museums

As an official war artist, Orpen was commissioned by the Department of Information to paint the leading Allied commanders, the intention being to heighten the publicity devoted to British commanders. However, from October 1917, five months after his arrival at the Western Front, Orpen also began making paintings of ordinary soldiers.

These contrasted with his portraits of leaders in being less formal. As *A Grenadier Guardsman* shows, although made from life, often the soldier depicted is unidentified. Rather than individual military achievement, the emphasis is on service as part of a collective endeavour.

'Type of Indian soldier'
Postcard, 1916

One of 140,000 volunteers from the Indian subcontinent who served on the Western Front; 90,000 saw action with the front-line Indian Corps and 50,000 were in auxiliary battalions.

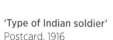

Armée Anglo-Indienne — *Type de soldat Indien*
Edit. Lenormand, Orléans

An American Soldier
Jacob Epstein, 1917

Bronze bust, 405 x 265 x 282mm
Imperial War Museums

In December 1917, Sir Martin Conway (1856–1936), the Director General of the Imperial War Museum, wrote a letter to the War Office arguing for Jacob Epstein's release from service as a private soldier in the Jewish Battalion. 'We want to employ Epstein to make a series of typical heads of private soldiers …', he observed. Epstein was keen to undertake this work, having in 1916 made *The Tin Hat* (various collections including the Imperial War Museum, London), a bronze head of an ordinary serviceman praised by Conway as 'masterly'.[1] Although that plan never materialised, Epstein did make a second head from life, this time depicting an American serviceman, which also conveys a powerful sense of rugged endurance.

1 Letter dated 13 December 1917 to General Sir William Robertson, War Office, held in Imperial War Museum, First World War Artists Archive, File Number 213/6.

The Tin Hat
Jacob Epstein, 1916

The prototype for Epstein's proposed series of portraits of ordinary soldiers.

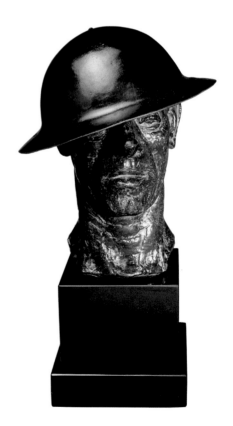

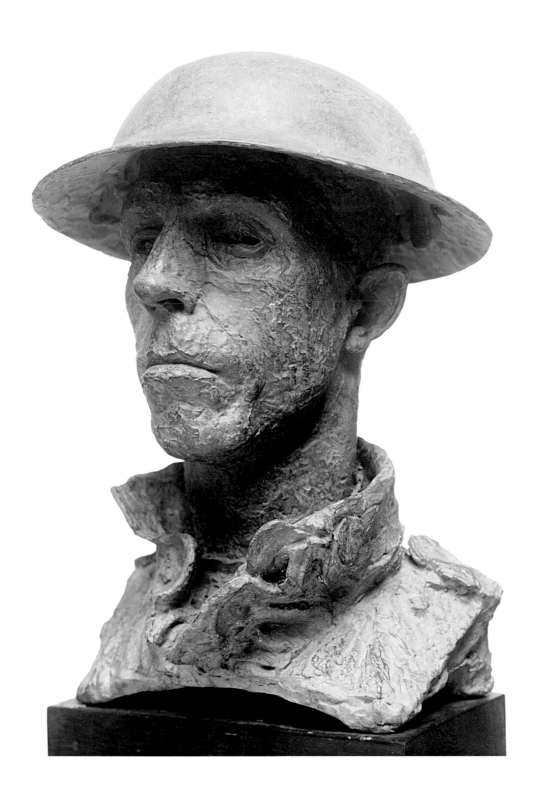

19

Royal Irish Fusiliers: 'Just come from the Chemical Works, Roeux: 21st May 1917'
William Orpen, 1917

Charcoal on paper, 520 x 419mm
Imperial War Museums

Although Orpen did not commence painting portraits of ordinary soldiers until several months after his arrival in France, he made drawings of servicemen from the outset. This portrait of an exhausted Tommy was made days before his portrait of General Haig. Orpen recalled: 'This was the time of the great fight round the chemical works at Roeux, and I was drawing the men as they came out for rest. They were mostly in a bad state, but some were quite calm.'[1] As with many such drawings, the sitter is not named but is known to be a Sergeant Slater, who was killed in November 1918.

1 William Orpen, *An Onlooker in France 1917–1919* (Williams and Norgate, London, 1924), p.28.

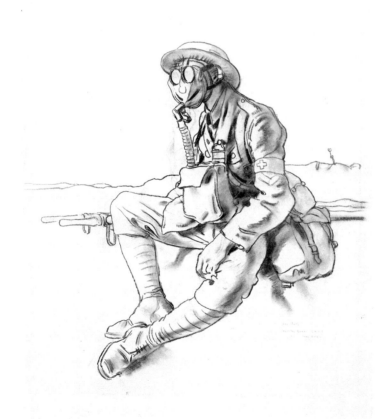

The Gas Mask. Stretcher-Bearer, RAMC, near Arras
William Orpen, 1917

Following the first large-scale use of gas as a weapon by the Germans in January 1915, by the end of that year both sides were employing chemical warfare. In this drawing, a British soldier is wearing a respirator.

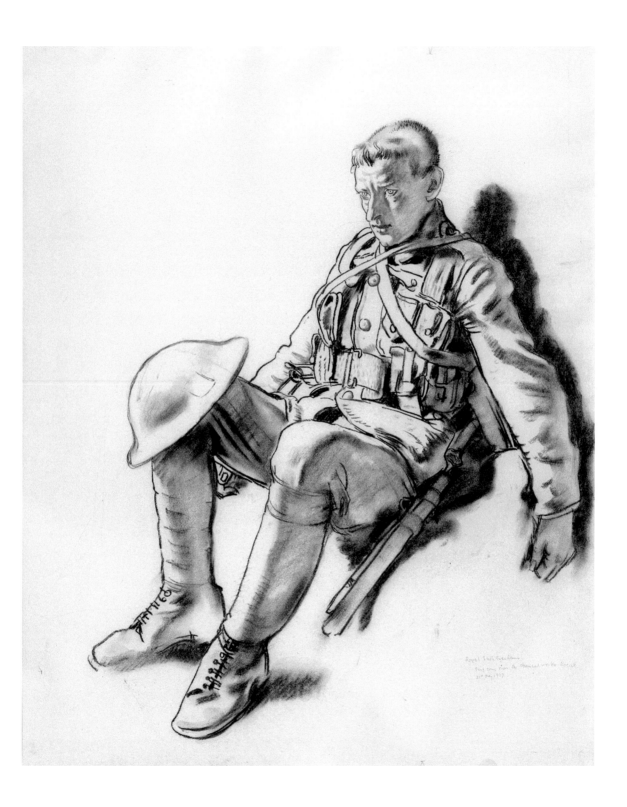

Royal Staffordshire
...
21 May 1917

20

A Man in a Trench: April 1917, two miles from the Hindenburg Line
William Orpen, 1917

Pencil and wash on paper, 482 x 381mm
Imperial War Museums

This is one of 125 drawings and paintings that Orpen exhibited at Agnew's, London, in spring 1918. Titled *An Onlooker in France*, the exhibition comprised the results of eighteen months' experience at the front. The artist later presented the works to the nation. Free to roam around, and working quickly on a daily basis, in his drawings Orpen responded to the subjects he found with an informal immediacy. As in this drawing of a resting soldier, his scenes of trench warfare capture a particular moment. They also evoke a wider context not attempted in the formal portraits.

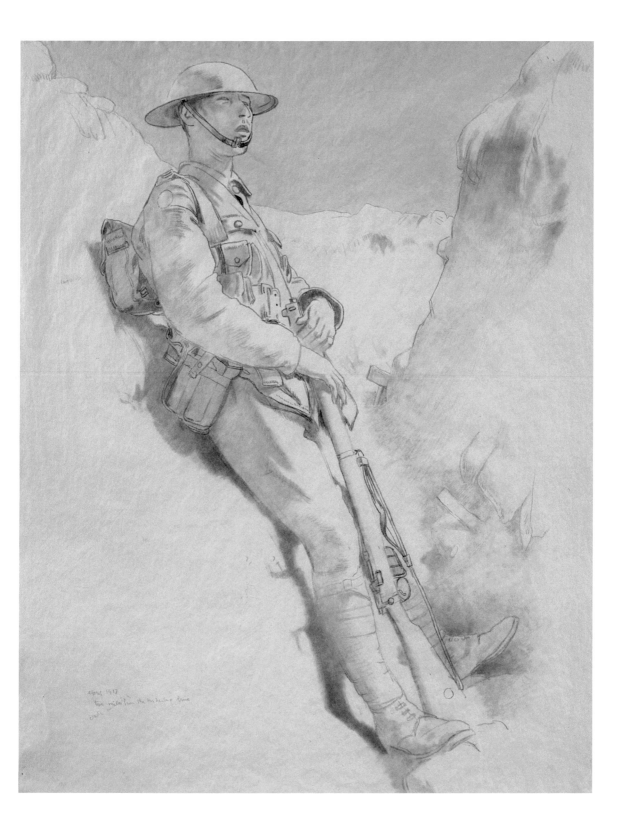

21

The Dead Stretcher-Bearer
Gilbert Rogers, 1919

Oil on canvas, 1019 x 1270mm
Imperial War Museums

Throughout the conflict, the depiction of dead soldiers remained controversial. In 1917, the War Office censored Nevinson's painting *Paths of Glory*, which portrayed dead Tommies (below). After the war, in response to an increasing public demand for truth, however appalling, the official line softened. Gilbert Rogers (fl.1915–19), who had served with

the Royal Army Medical Corps (RAMC), was appointed by the Committee for the Medical History of the War to lead a team of artists charged with representing the medical consequences of battle. This painting, and the related work *Gassed: In arduis fidelis* (page 37), represented death with an unflinching directness.

Paths of Glory
C.R.W. Nevinson, 1917

The title of this painting, like that of Wilfred Owen's poem 'Dulce et Decorum est' ('It is sweet and right [to die for one's country]'), stands in bitter contrast to its subject matter.

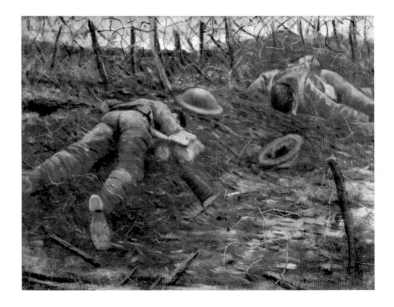

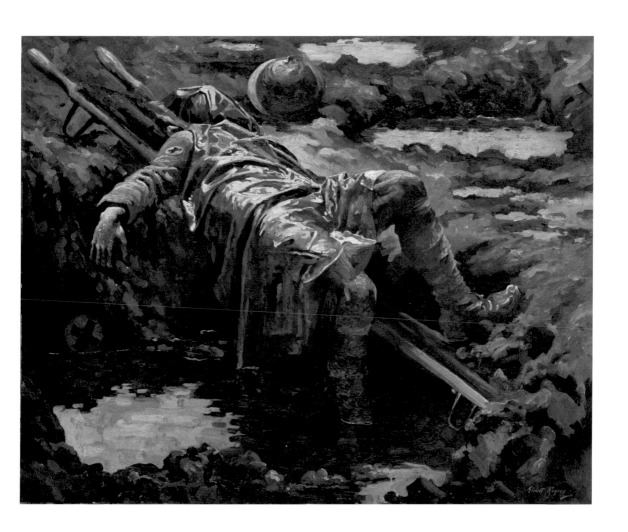

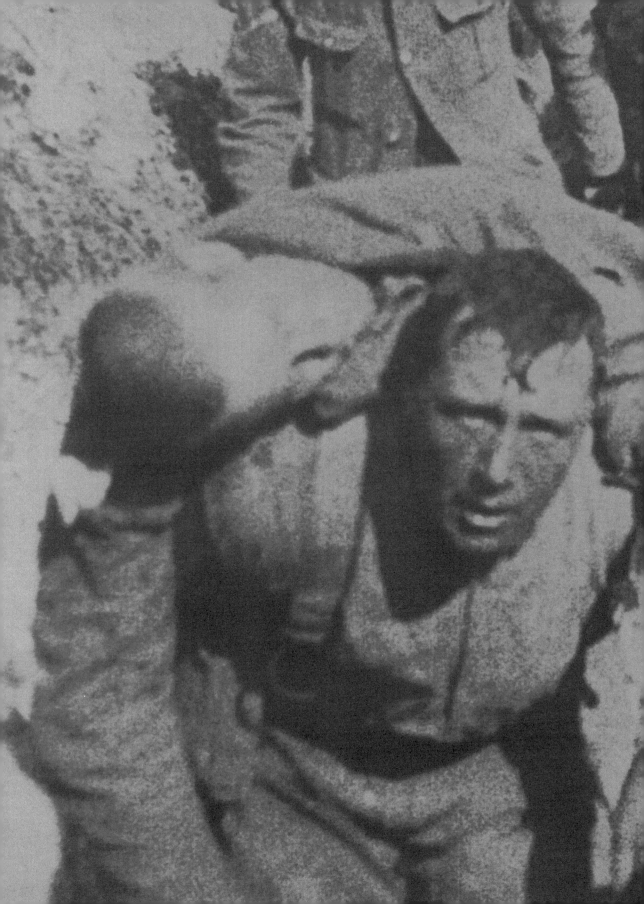

FACT AND FICTION: THE BATTLE OF THE SOMME IN FILM

The first day of the Battle of the Somme incurred the highest losses in British military history. At the end of 1 July 1916, British casualties numbered 57,470, including 19,240 dead. When the battle finally ended in November that year, total British and Commonwealth casualties had reached over 400,000. It is a deep irony that *Battle of the Somme*, a film made of the conflict, became a huge, popular success. Made by the cinematographers Geoffrey Malins and John McDowell, it was premiered in London and distributed internationally. In the capital alone it was seen by an estimated audience of twenty million, who relished the excitement of the battlefield that the film conveyed.

For many the film was a welcome innovation. The footage recorded on location had an unprecedented immediacy, and images of wounded and dead soldiers were a revelation. They presented modern warfare in a truthful light – but only up to a point. Created as propaganda, the actual extent of the carnage remained hidden. In January 1917, the German counterpart to the British propaganda bureau released a film presenting their official version of the same events. Partly flawed by scenes that were obviously faked, the German film was less successful. In both cases, fact and fiction coloured the portrayal of war.

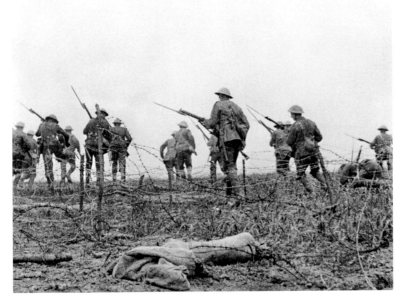

22

Scenes from *Battle of the Somme*
Geoffrey Malins and John McDowell, 1916

Film courtesy Bundesarchiv (Federal Archives);
film stills (1917) courtesy Imperial War Museums

Advertisements for *Battle of the Somme* referred to
the 'spectacle' of its realism. Purporting to present
modern warfare with an unprecedented candour,
it was claimed that the film offered a unique
experience: a glimpse of the war as it really was.

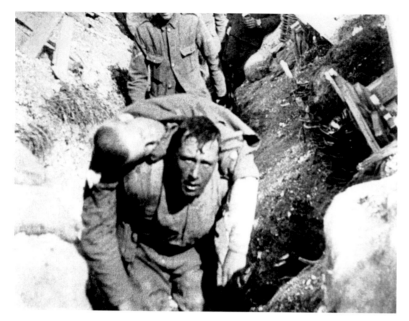

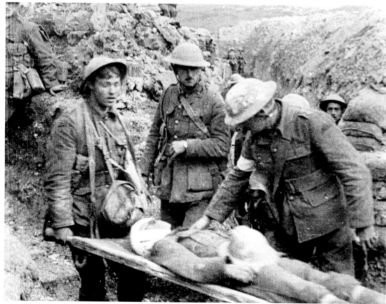

Scenes that depicted wounded soldiers (see top image; the soldier died shortly after this moment) satisfied the audience's desire for truth. But in doing so, they raised questions about intrusion into the grief of those affected by loss, and the vicarious thrill offered by the possibility of recognising the individuals depicted. As became evident later, however, there was a disparity between the appearance of the battle on the screen and the reality, with still worse horrors remaining concealed.

23

Scenes from *Bei unseren Helden an der Somme* (With our Heroes on the Somme)
Bild und Film-Amt (BUFA)

Film courtesy Bundesarchiv (Federal Archives);
film stills courtesy Imperial War Museums

Like its earlier British counterpart, the German propaganda film *Bei unseren Helden an der Somme* trod an uneasy path between veracity and entertainment. Its advance publicity stated: 'From the hell of Somme, from the flaming earth of the Saint-Pierre-Vaast forest, heroic German film team operators, at

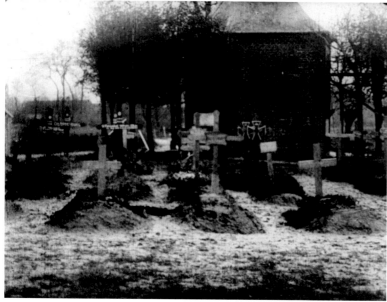

the command of the highest military leadership, have created the greatest cinematic document of this terrible war.' Despite these claims, the film's factuality was flawed. While the first part contains documentary footage, the remaining sections include faked shots that were not filmed on location at all, together with footage pre-dating the Somme Offensive. Lacking credibility, it was not a success.

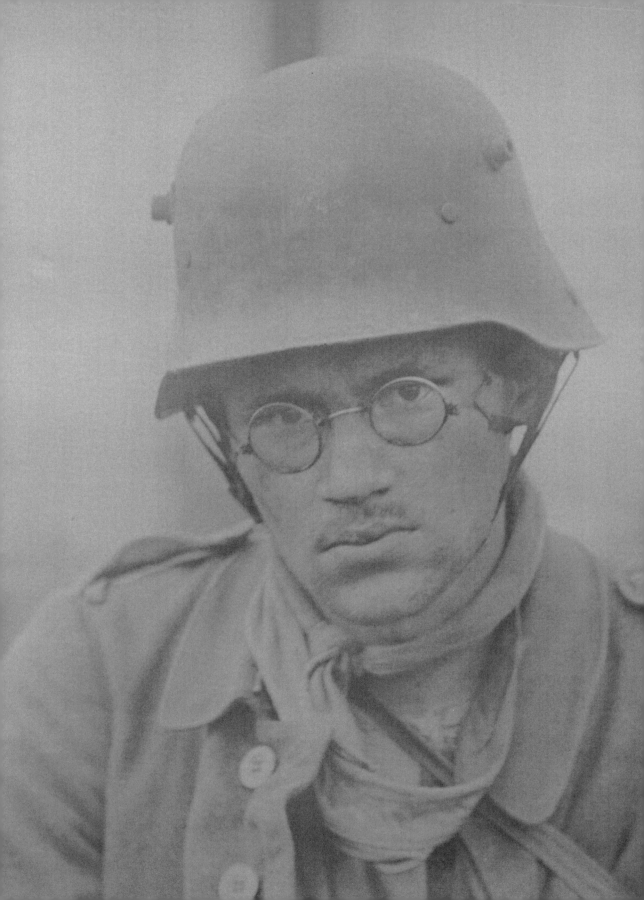

THE VALIANT AND THE DAMNED

As the war dragged on and its horrors unfolded, initial euphoria was replaced by disillusionment and, in some cases, despair. By 1916, there was a growing tension between those officials who were determined to sustain the war effort by presenting it in a positive light, and others – artists and medical staff – who were unwilling or unable to ignore its dreadful consequences. As was painfully apparent, the war was a lottery. Sucked into a vortex of violence, a common humanity was at the mercy of circumstance. Some, distinguished by their acts of gallantry and selflessness, achieved distinction as heroes and medal-winners. Others were shattered by their experiences, returning home mutilated by their wounds or, worse, met with annihilation on the field of battle. Between these two poles, human destinies were played out in diverse ways.

Portraits of the war's protagonists – paintings, drawings, photographs and medical records – convey something of these divergent individual paths. Formal portraits of highly decorated heroes were intended as documents of achievement and as a lasting inspiration. In contrast, Henry Tonks' pastels of servicemen with severe facial injuries were not intended for public consumption, but formed a human response within a hospital setting to the plight of the disfigured. Numerous photographs taken during the war, including press images and many that exchanged hands as postcards, provide a further vital account of humanity's greatest test.

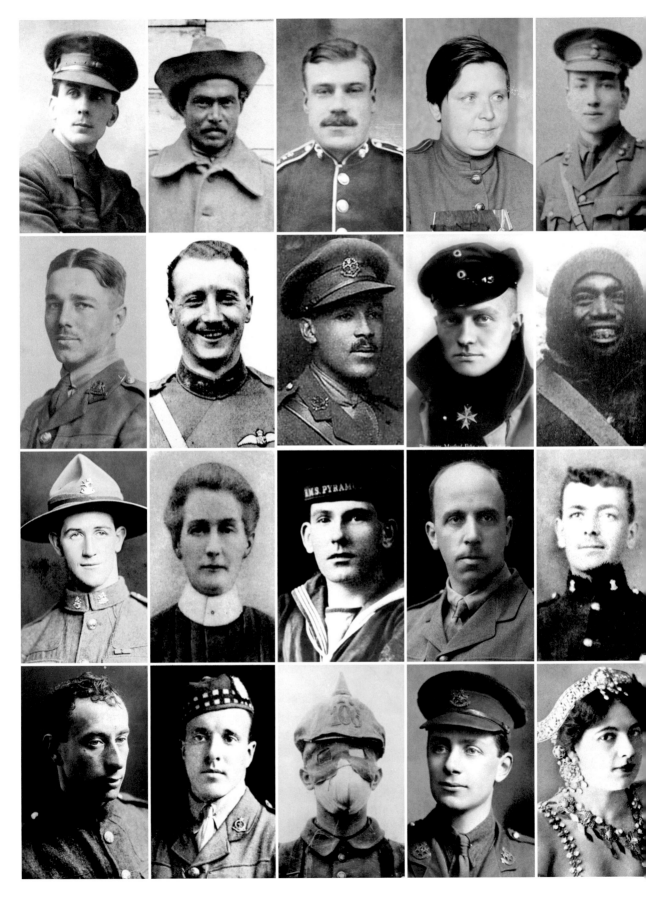

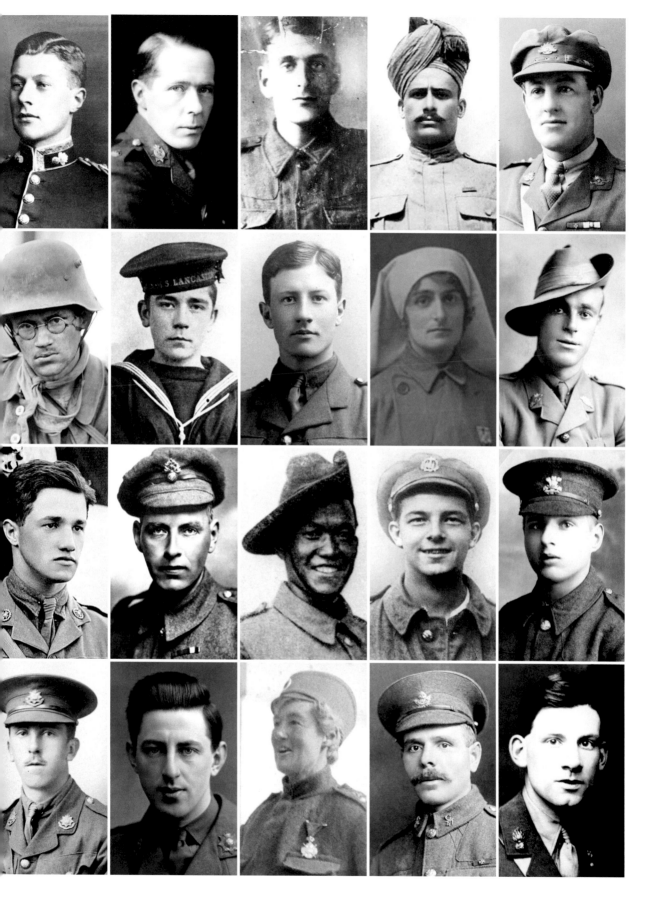

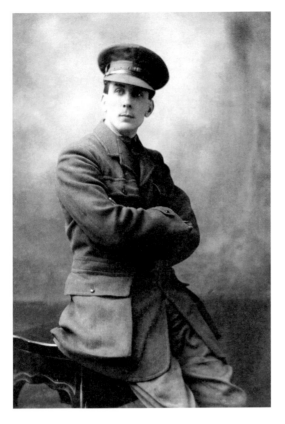

24

Geoffrey Malins

Cinematographer. Geoffrey Malins' footage of the Battle of the Somme helped to create an enduring record of one of the war's most terrible conflicts. A portrait photographer before he joined the Clarendon Film Company in London in 1910, Malins (1886–1940) became chief cameraman. Engaged by the British Topical Committee for War Films, in June 1916 he and another cinematographer, John McDowell, began filming preparations for the planned major offensive at the Somme, recording many scenes after the battle had commenced. The resulting film was a huge popular success. From April 1918 Malins was in charge of all military cameramen on the Western Front.

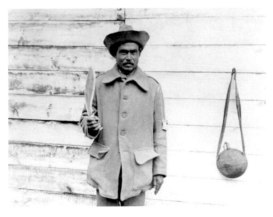

25

Unidentified

One of 100,000 Ghurkhas who fought in the Great War. Traditionally, the term 'Ghurkha' describes men of Nepal, who served in the armies of Nepal, India or Britain. During the First World War the entire Nepalese army served with the British Crown, Ghurkha battalions seeing action in France at Neuve Chapelle, Loos, Givenchy and Ypres. Apart from the Western Front, Ghurkhas also fought in Mesopotamia, Persia, Palestine, Salonika and Gallipoli. Across these different theatres of war, there were 20,000 casualties. Two Ghurkhas were awarded the Victoria Cross.

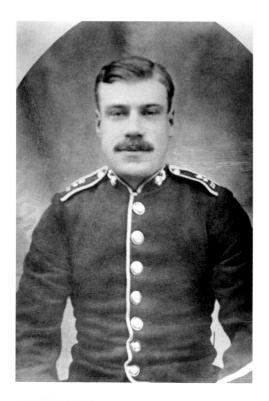

26

Private Sidney Frank Godley

First private soldier to be awarded the Victoria Cross in the Great War. Sidney Godley (1889–1957) worked in an ironmonger's shop in Kentish Town, London, before enlisting in the 4th Royal Fusiliers (City of London Regiment). This was one of the first battalions to arrive in France in August 1914. Reaching the rail bridge at Nimy, near Mons, the troops encountered a German advance. Godley single-handedly manned a machine gun to provide cover as his comrades withdrew. Despite being wounded twice, he managed to dismantle his gun before being taken prisoner. News of his award reached him while in the prison camp at Doberitz, Germany.

27

Maria Bochkareva

Russian volunteer. Born to peasant parents, in 1914 Maria Bochkareva (1889–1920) volunteered and, with the approval of the Tsar, joined the Imperial Russian Army. In 1915 she was sent to the front and won the respect of her fellow soldiers when she rescued numerous wounded men from the field of battle. Badly wounded in 1916, she later returned to active service, was promoted to sergeant, and in 1917 formed the 1st Russian Women's Battalion of Death. Her regime of harsh discipline reduced its numbers from an initial 2,000 to 300. Captured by the Bolsheviks, she was executed by firing squad on 16 May 1920.

28

Robert Graves

Poet and novelist. At the outbreak of war Robert Graves (1895–1985) was a confirmed pacifist but, shocked by the German violation of Belgium, he immediately enlisted and was commissioned into the Royal Welsh Fusiliers. He served in France from 1916 to 1917. On 20 July 1916, during the Battle of the Somme, he was badly wounded, taken to a dressing-station and reported to have died. His name appeared in the list of war dead published by *The Times*, even though he was in fact convalescing in England. Graves published two volumes of poetry based on his wartime experiences: *Over the Brazier* in 1916 and *Fairies and Fusiliers* in 1917.

29

Lieutenant Maurice Dease

First recipient of the Victoria Cross in the Great War, awarded posthumously. When war broke out, Maurice Dease (1889–1914) had been serving with the 4th Battalion Royal Fusiliers for four years. The battalion was immediately posted to the front line at Mons, Belgium, where Dease was in charge of a machine-gun section defending Nimy Bridge. During the ensuing action on 23 August 1914, under intense fire Dease repeatedly ran across open ground to ensure his gun post kept firing. He was wounded five times but continued to man his position after all his men had been killed. He died of his wounds.

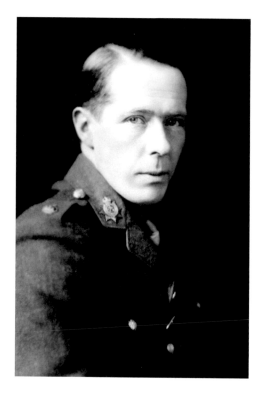

30

William Orpen

Painter. William Orpen (1878–1931) was born in County Dublin and enrolled at the Slade School of Fine Art in 1897. He subsequently amassed a considerable reputation as a successful portrait painter and from 1908 exhibited regularly at the Royal Academy. In 1917, he was appointed official war artist, the fourth under the scheme operated by the Department of Information, following Muirhead Bone, Francis Dodd and Eric Kennington. His portraits of leaders and ordinary soldiers, and scenes based on direct observation, are a vital record of the conflict. Many of these works were presented to the nation after the war. He was knighted in 1918.

31

Alec Reader

Killed in action, aged eighteen. Alec Reader (1897–1916) was posted to the Somme in April 1916. Following a severe bombardment he wrote to his mother, 'I was told I had stood it very well.' However, he remained anxious about the prospect of going into battle, adding 'war is a rotten game'. As he was under nineteen years of age, he could elect to serve away from the front. Also, under army regulations, his father, who was in uniform, could apply for his son to join his unit. But before official permission to move Reader could be granted, he was killed, on 15 September 1916, during the attack at High Wood.

32

Shahamad Khan

Indian recipient of the Victoria Cross. Shahamad Khan (1879–1947) was a Punjabi Muslim serving in the 89th Punjabis, British Indian Army, when on 12–13 April he earned the highest British award for gallantry. Manning a machine gun section on the Tigris Front in Mesopotamia, apart from two belt-fillers all his comrades became casualties. Nevertheless, he worked the gun single-handedly and repelled three attacks. When the gun was disabled, he held his ground for three hours employing rifle fire. Ordered to retire, he brought back his gun and ammunition, and rescued a wounded man. He then returned to remove his remaining arms and equipment.

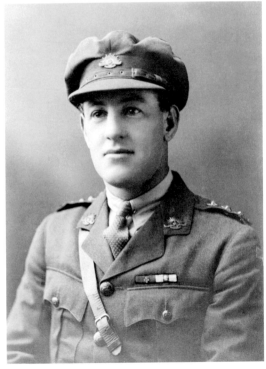

33

Captain Albert Jacka

First member of the Australian Imperial Force to receive the Victoria Cross. Captain Jacka (1893–1932) was posted to Gallipoli in April 1915. He received the Victoria Cross for single-handedly clearing a trench after it had been taken over by Turkish invaders. In August 1916 he received the Military Cross for actions involving charging the enemy near Pozières at the Somme. A Bar was added to that award in 1917, following the Australian attack on the Hindenburg Line. Undertaking a dangerous night reconnaissance of the German wire in front of the planned objective, Jacka took two German prisoners. Despite being badly gassed in May 1918, he survived the war.

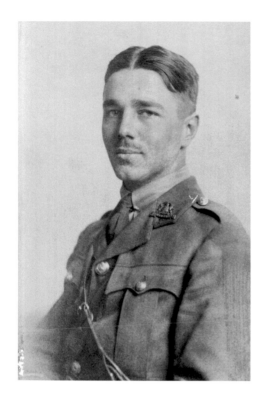

34

Wilfred Owen

Poet Wilfred Owen (1893–1918) was born in Oswestry, Shropshire. From 1913 to 1915 he taught English in Bordeaux. Returning to England in October 1915, he enlisted in the army and, following training, crossed to France on 29 December 1916. In March 1917 he was involved in fierce fighting at the Somme and suffered shell shock, which forced him to withdraw from the battle. The poems on which his reputation is based were written between August 1917 and September 1918, although only four were published during his lifetime. Pronounced fit for general service, he returned to the front and was killed on 4 November 1918, one week before the Armistice.

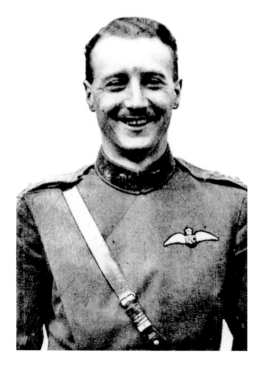

35

William Leefe Robinson

First pilot to shoot down a German airship on British soil. William Leefe Robinson (1895–1918) was born in Kaima Betta, India, and in August 1914 entered the Royal Military College, Sandhurst. Commissioned in the Worcestershire Regiment, in March 1915 he transferred to the Royal Flying Corps. Serving first in France as an observer, subsequently he qualified as a pilot and was attached to various squadrons in England. On 3 September 1916, he attacked and destroyed one of sixteen German airships raiding London. This successful action was witnessed by thousands on the ground, and the ensuing publicity allayed public anxiety about German bombing. He was awarded the Victoria Cross.

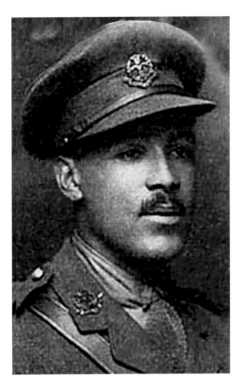

36

Walter Tull

First person of Afro-Caribbean heritage to become an officer in the British army. Walter Tull was born in Folkestone in April 1888. His grandfather had been a slave. A keen footballer, Tull abandoned a professional football career with Northampton Town to enlist with the 17th (1st Football) Battalion of the Middlesex Regiment. In November 1914 he was sent to France and in October and November 1916 fought in the Battle of the Somme. Despite military law preventing 'any negro or person of colour' being commissioned, he was promoted to lieutenant in October 1917. He was killed in action on 25 March 1918. His body was never found.

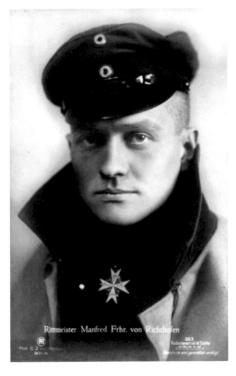

Rittmeister Manfred Frhr. von Richthofen

37

Baron von Richthofen

Leading flying ace of the war, officially credited with eighty air combat victories. Manfred Albrecht Freiherr von Richthofen (1892–1918) attended the military school at Wahlstatt and the Royal Military Academy at Lichterfelde, Germany. He became a cavalry officer and also served briefly in the trenches before transferring to the German air force in May 1915. He flew solo after twenty-four hours of flight training. In June 1917 he became commander of Jasta 11, better known as the 'Flying Circus', an elite squadron comprising Germany's top pilots. He was shot down on 21 April 1918, although the exact circumstances remain unconfirmed.

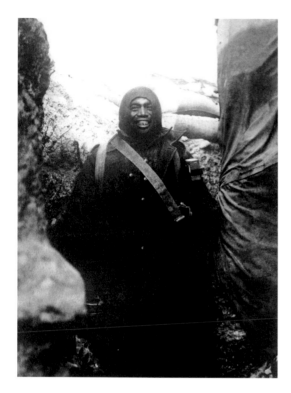

38

Unidentified

Member of the Maori Contingent, New Zealand Expeditionary Force. When war broke out, the indigenous Polynesian people of New Zealand – the Maori – had divided responses. Some opposed fighting for the British Crown, which had deprived them of land in the nineteenth century, while others enlisted. In 1915, a Maori Contingent saw action at Gallipoli and, subsequently re-formed, it served on the Western Front. In 1917, conscription was applied to the Maori. During the conflict, 2,227 Maori and 458 Pacific Islanders served. Of these 336 died on active service and 734 were wounded. This man was photographed on 30 November 1915 in the Apex trenches at Gallipoli.

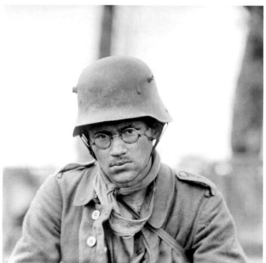

39

Unidentified

Captured German soldier. This unidentified soldier was captured in the attack on Vampire Farm by Scottish and South African troops during the Battle of the Menin Road Ridge (20–25 September 1917). Part of the major offensive known as Passchendaele, or the Third Battle of Ypres, by the end of the First and Second Battles of Passchendaele, the British Expeditionary Force had captured the long ridge that had been in German hands since 1914–15. The British casualties numbered 300,000, the Germans 260,000. This prisoner was photographed by Ernest Brooks, the first official photographer appointed by the British military, on 20 September 1917.

40

Boy (1st Class) John (Jack) Travers Cornwell

Killed in action at the age of sixteen and awarded the Victoria Cross posthumously. John Travers Cornwell (1900–16) joined the navy in July 1915. He served with HMS *Chester* during the Battle of Jutland on 31 May 1916. The *London Gazette* reported: 'Mortally wounded early in the action, … [he] remained standing alone at a most exposed post, quietly awaiting orders, until the end of the action, with the gun's crew dead and wounded around him.'[1] The Captain of the ship wrote to Travers's mother: 'He stayed there, standing and waiting, under heavy fire, with just his own brave heart and God's help to support him.'[2]

1 Second Supplement to the *London Gazette*, Friday, 15 September, 1916, Issue 29752, p.1.
2 Letter reproduced in, for example, John Ernest Hodder-Williams, Jack Cornwell; *The Story of John Travers Cornwell, V.C., "Boy – 1st Class"* (Toronto: Hodder and Stoughton, 1917). p.68.

41

Paul Cadbury

Conscientious objector who served with the Friends' Ambulance Unit. As a member of the Religious Society of Friends (Quakers), Paul Cadbury (1895–1984) was a pacifist. On the outbreak of war, he volunteered for work with the Friends' War Victims Committee in France. He later joined the Friends' Ambulance Unit (FAU), a volunteer ambulance service founded by, but independent of, the Quakers. Altogether, the FAU sent over a thousand men to France and Belgium. In France, he undertook often dangerous work, identifying infectious diseases in the war zone and, while serving on an ambulance train, evacuating the wounded from field dressing-stations.

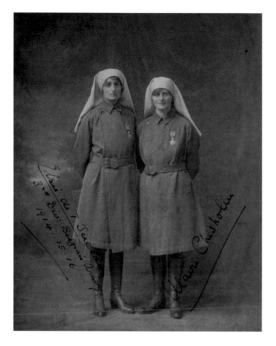

42

Elsie Knocker

Ambulance driver and first-aider. Elsie Knocker (1885–1978) was born in Exeter, Devon. She trained as a nurse and in August 1914 became a despatch rider in London with the Women's Emergency Corps. Recruited by Dr Hector Munro, founder of the Flying Ambulance Column, she left for Belgium in September 1914. With Mairi Chisholm (1896–1981, on the right), her work driving an ambulance led her to recognise the importance of giving the wounded first aid before moving them. With Dr Munro's support, both women – who became known as the Madonnas of Pervyse – set up a dressing-station yards from the front line, treating some 23,000 casualties.

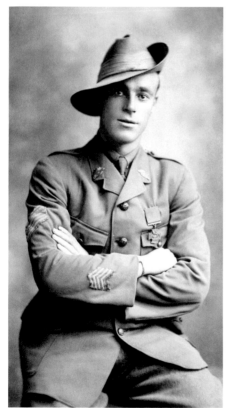

43

Private Reginald Roy Inwood

Awarded the Victoria Cross at the age of twenty-seven for bravery during an attack at Polygon Wood, near Ypres, in September 1917. Born in Broken Hill, Australia, Roy Inwood (1890–1971) enlisted in the 10th Battalion, Australian Imperial Forces, and served as a lance corporal at Gallipoli. After transferring to the Western Front, he was demoted to private for being absent without leave. Subsequently he received the Victoria Cross for capturing an enemy strong-point and taking nine prisoners, volunteering for an all-night patrol 600 yards in front of the Allied line, bombing an enemy machine gun and bringing back the surviving gunner as a prisoner.

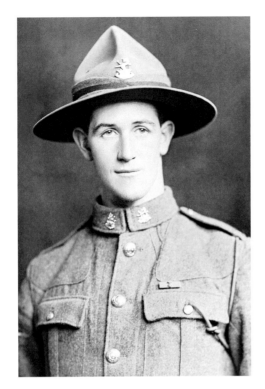

44

Corporal Leslie Wilton Andrew

Member of the New Zealand Expeditionary Force (NZEF) and awarded the Victoria Cross. Leslie Andrew (1897–1969) was born in Ashton and raised in Wanganui, New Zealand. He joined the NZEF in 1915. He was awarded the Victoria Cross for gallantry during the struggle for Messines Ridge, south-east of Ypres, in July 1917 when he led a small party in an attack on the enemy's position. His objective was a machine-gun post, which was holding up the advance of another company. Leading his men forward, he captured the gun and killed several of the crew. The citation for his award states: '[his] conduct throughout was unexampled for cool daring, initiative and fine leadership, and his magnificent example was a great stimulant to his comrades.'

45

Edith Cavell

Nurse, shot at dawn, 12 October 1915. Edith Cavell was born in 1865 in Swardeston, Norfolk, and trained as a nurse at the London Hospital in 1896. Following a number of nursing appointments, in 1907 she became director of a nurses' training school in Brussels. After the German invasion of Belgium in 1914, the training school became part of a network sheltering Allied soldiers and assisting their escape to neutral Holland. In August 1915, Cavell was arrested by the Germans, placed in solitary confinement, court-martialled and sentenced to death. Remaining composed, her final words were, 'I am glad to die for my country.'

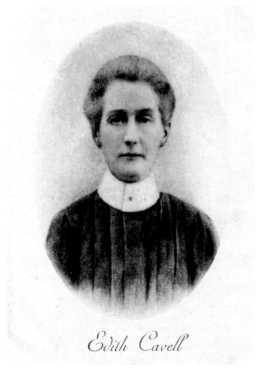

Edith Cavell

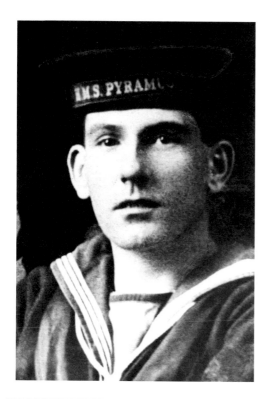

46

Stoker Petty Officer Harold Jordan

Killed at sea, 17 October 1917. Born in Leicester, Harold Jordan served in the Royal Navy and was aboard HMS *Strongbow* when the ship was sunk during an attack on the merchant ship convoy she was escorting. In 1915, 468 Allied or neutral ships were sunk by German U-boats. By 1916 this figure had risen to 967 vessels, lost to submarines. Over the course of the war one U-boat captain, Lieutenant Commander Lothar von Arnauld de la Périère, sank 194 merchant ships during ten cruises. Harold Jordan was buried, at the age of thirty, at Chatham Naval Memorial, Kent.

47

Harold Gillies

Otorhinolaryngologist (doctor of diseases of the ear, nose and throat) and pioneer of plastic surgery. Harold Delf Gillies (1882–1960) was born in Dunedin, New Zealand, and became a Fellow of the Royal College of Surgeons (FRCS) in 1908. After joining the Royal Army Medical Corps (RAMC) in 1915, he was posted to France. There he was impressed by the work of French and German surgeons treating patients with severe facial injuries. His commitment to reconstructive surgery led to the establishment of the first centre at the Cambridge Hospital, Aldershot, Hampshire, in 1915. Gillies developed the technique of using rolled skin grafts from the neck, which maintained a blood supply while attached to the damaged areas of a patient's face.

48

Private Harry Farr

Shot at dawn, 17 October 1916. Having served in the British army from 1908 to 1912, Harry Farr (1891–1916) volunteered in 1914. Posted to the Western Front, he saw action in France at the Battle of the Somme and at Neuve Chapelle. In 1915 and 1916 he reported sick four times, on one occasion spending five months in hospital with symptoms consistent with shell shock. After refusing to return to the trenches, on 16 October 1916 he was court-martialled and, the following morning, executed by firing squad. Between 1914 and 1918 an estimated 306 British soldiers were shot at dawn for cowardice and desertion. In 2006, these soldiers received formal pardons.

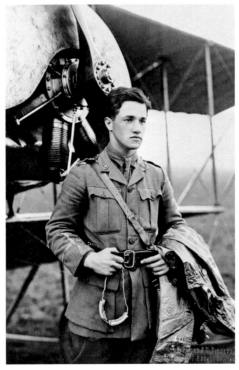

49

Albert Ball

Recipient of the Victoria Cross and the first pilot to become a British popular hero. Albert Ball (1896–1917) was born in Nottingham, and at the outbreak of war joined the Sherwood Foresters (Nottingham & Derbyshire Regiment). After training privately as a pilot, he transferred to the Royal Flying Corps (RFC) in January 1916 and was posted to France with No.11 Squadron, a fighter unit. By August 1916 he had amassed a tally of seventeen enemy aircraft destroyed, his feats attracting considerable publicity. He died on 7 May 1917 when his plane, pursuing an enemy machine, emerged from a cloud upside down and crashed. His final tally was forty-four, at that date the RFC's highest score.

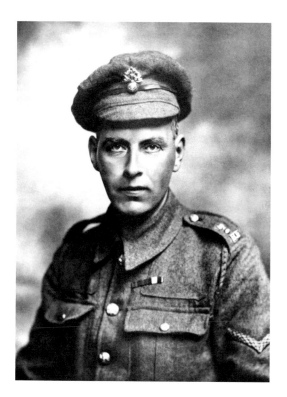

50

Lance Corporal Harry van Tromp

Killed in action, 23 May 1918. The son of the mayor of Taunton, Harry van Tromp served with the 22nd Battalion, Royal Fusiliers. This photograph was taken on his last day in England before leaving for the Western Front. He died six days later at Vimy, near Arras, in the Nord-Pas-de-Calais region of France, at the age of thirty-four. He is buried in the Zouave Valley Cemetery, Souchez.

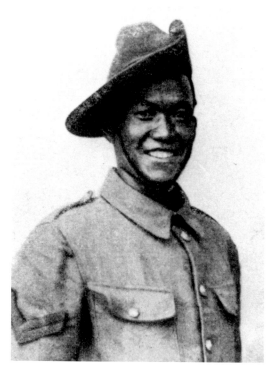

51

Kulbir Thapa

First Nepalese recipient of the Victoria Cross, at the age of twenty-six. As Rifleman in the 2nd Battalion, 3rd Queen Alexandra's Own Gurkha Rifles, British Indian Army, Kulbir Thapa (1889–1956) participated in the Battle of Loos. On 25 September 1915 he was wounded and became stranded behind the German lines. Noticing a wounded comrade, he comforted him for an entire night and then, concealed by fog, carried him over the German trenches to a shell hole for cover. After carrying back two other wounded men to his own lines, he returned and rescued the first man. This gallant action was observed by the German troops who responded with applause.

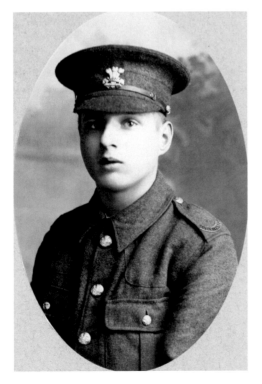

52

Private William Cecil Tickle

Killed in action on the third day of the Battle of the Somme. William Tickle volunteered for army service on 7 September 1914 and, despite being underage, was accepted. He was then posted to France and saw action on the Western Front. He was one of many soldiers whose body was never found. After his death, his mother wrote beneath his photograph: 'Mothers Billie Boy. 9th Essex Reg. Private W.C. Tickle 13510. Killed on the 3rd July 1916 Joined up on the 7th September 1914 Age 18 years. One of the very best.'

53

Private Ivor Evans

Killed in action, at the age of eighteen. Ivor Evans was born in Swansea, Wales, and enlisted in August 1914 at the age of fifteen. Although under age, he was posted abroad with the 2nd Battalion, Leister Regiment, 6th Infantry Brigade. He fought at Gallipoli and participated in the retreat in Serbia. Suffering from dysentery, malaria and frostbite, he was invalided home but, following convalescence, rejoined his regiment on the Western Front in October 1916. He was killed on 23 November 1917 and is buried at Hargicourt British Cemetery, near St Quentin, France.

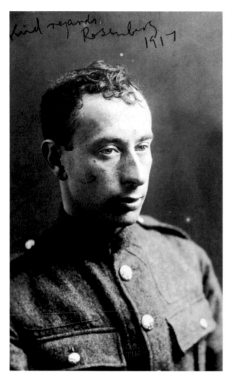

54

Isaac Rosenberg

Poet and painter, killed in action April 1918. Isaac Rosenberg (1890–1918) was born in Bristol. His father, Barnett Rosenberg, was Lithuanian and had emigrated from Moscow to avoid conscription into the Russian army. In 1911 Isaac attended the Slade School of Fine Art while continuing to write poetry. There his fellow students included the painters Mark Gertler, David Bomberg, C.R.W. Nevinson and Stanley Spencer. Having enlisted in the army in 1915, he was assigned to the Bantam Battalion. Some of Rosenberg's best poems were written while serving on the Western Front. These include 'Break of Day in the Trenches' and 'Dead Man's Dump' (posthumously published 1922). He was killed while on night patrol.

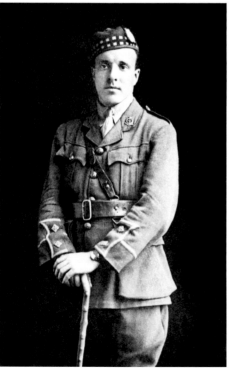

55

Captain Noel Chavasse

The only individual to receive a Victoria Cross and Bar during the Great War (and one of only three people ever to achieve this distinction). As medical officer to the 10th Battalion of the King's [Liverpool] Regiment, Chavasse (1884–1917) arrived at the Western Front in November 1914. He won his first VC on 9 August 1916 during the Battle of the Somme when, under heavy enemy fire, he rescued at least twenty wounded men. A Bar was added posthumously to this award for further bravery between 31 July and 2 August 1917, when he repeatedly traversed no-man's-land in search of the injured. He died of wounds received at that time.

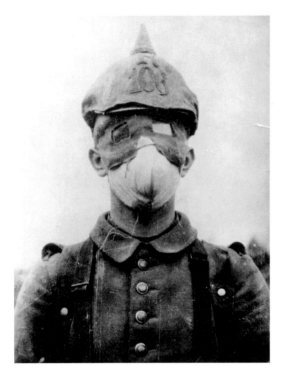

56

Unidentified

A German soldier wearing an improvised gas mask, 1915. The first widely reported use of gas during the Great War was by the German army on 22 April 1915, near Ypres. The release of 160 tons of chlorine against French and Canadian soldiers caused numerous casualties. The psychological effect was also profound, provoking revulsion among the Allies. However, on 25 September 1915, the British deployed gas for the first time at the Battle of Loos. Subsequently, both sides employed chemical weapons and developed various forms of protection. This soldier's mask comprises goggles and a gauze pad soaked in bicarbonate of soda.

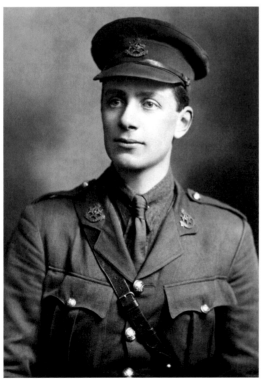

57

2nd Lieutenant Maxwell Dalston Barrows

Killed in action, at the age of twenty. Born in Nottingham, Maxwell Barrows was awarded scholarships at Sedbergh School and Pembroke College, Oxford. He received his commission in August 1917 and was posted to the Western Front the following month. He served as adjutant with E Company, 1st/5th Battalion, Sherwood Foresters (Nottingham & Derbyshire Regiment) from April to August 1918. During that time he was awarded the Military Cross. He died on 3 October in France, five weeks before the end of the war, during the Battle of St Quentin Canal (also known as the Battle for the Hindenburg Line), one of the last major offensives of the conflict.

58

Mata Hari

Exotic dancer. Mata Hari (1876–1917) was the stage name of Dutch-born Margaretha Zelle. Before the war she was one of Paris's most popular dancers and she also toured to Berlin, Vienna and other European capitals. These travels produced liaisons with several officials and military figures. As a result, on her return to Paris in February 1917, she was arrested and accused of being a German spy. Tried by a French military court, she was found guilty and sentenced to death by firing squad. The sentence was carried out on 15 October 1917 when she was taken from her Paris prison cell to an army barracks on the city's outskirts.

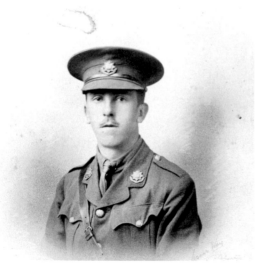

59

Captain Billie Nevill

Billie Nevill (1894–1916), commander of the 8th East Surrey Regiment, achieved fame for leading his men towards the German lines while kicking footballs. Arthur Conan Doyle reported in his major history of the war, *The British Campaign in France and Flanders* (1916–20), 'they were met by staggering fire … The support had to be pushed up to thicken the ranks of the East Surreys – a battalion which, with the ineradicable sporting instinct and light-heartedness of the Londoner, had dribbled footballs, one for each platoon across No Man's Land and shot their goal in the front-line trench.' Widely reported, this event made Nevill a national hero. He met his death on 1 July 1916, the first day of the Battle of the Somme.

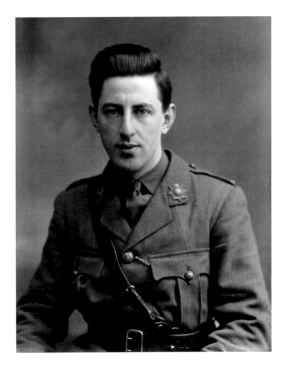

60

Paul Nash

Painter. Paul Nash (1889–1946) attended the Slade School of Fine Art in 1910. Subsequently turning to nature as his subject, his first exhibition was held in London in 1912. On the outbreak of war he enlisted in the Artists' Rifles, being commissioned in the Hampshire Regiment in 1916. Injured while serving on the Western Front, he was invalided home and, while recuperating, made ink drawings of his experiences. A successful exhibition of these works led to his appointment as official war artist and he returned to the front. His painting *We are Making a New World* (1918, page 56) is a powerful indictment of the war's destructiveness.

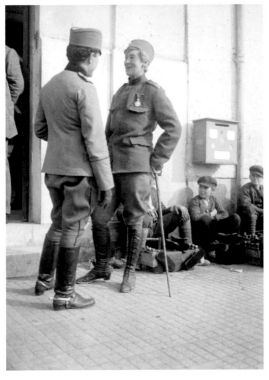

61

Flora Sandes

Nurse and soldier in the Serbian army. Flora Sandes (1876–1956) was born in Nether Poppleton, near York. After receiving first-aid training with the Ladies' Nursing Yeomanry, when war broke out she offered her services as a Volunteer Aid Detachment nurse but was rejected. Volunteering instead for nursing service in Serbia, she left London in August 1914. Committed to the Serbian cause, from 1915 she served with the army, was promoted to sergeant, and received the Kara George star for bravery. After being wounded by an enemy grenade, she returned to running a hospital. She remained with the Serbian army after the Armistice in 1918.

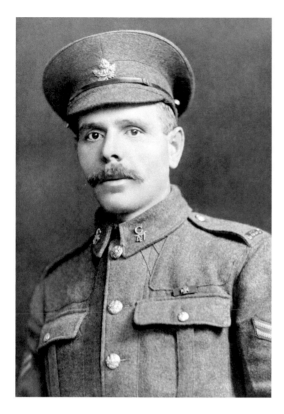

62

Corporal Filip Konowal

The only Ukrainian recipient of the Victoria Cross. Filip Konowal (1888–1959) was born in Kuzkivtsi, Ukraine, and enlisted in the Canadian Expeditionary Force, serving with the 47th Infantry Battalion. Trained as a bayonet instructor, he was awarded the VC for 'most conspicuous bravery and leadership when in charge of a section in attack.' The citation records that on 22–24 August 1917 at the Battle of Hill 70 in Lens, France, 'this non-commissioned officer alone killed at least sixteen of the enemy, and during the two days' actual fighting carried on continuously his good work until severely wounded.'

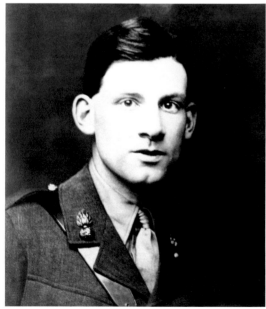

63

Siegfried Sassoon

Poet and prose writer. Siegfried Sassoon (1886–1967) studied at Cambridge University but left without taking a degree. In May 1915 he was commissioned into the Royal Welsh Fusiliers. Posted to France, he acquired a reputation for bravery and was awarded the Military Cross for bringing back a wounded comrade under heavy fire. After being wounded himself in April 1917, he returned to England to convalesce and his letter to *The Times*, accusing the Government of deliberately prolonging the war, was published. He returned to military service and was again wounded, but survived the war. Two volumes of his war poems were published: *The Old Huntsman* (1917) and *Counter Attack* (1918).

64

Sir Winston Churchill
William Orpen, 1916

Oil on canvas, 1480 x 1025mm
The Churchill Chattels Trust

Orpen's portrait of Sir Winston Churchill (1874–1965) was made in 1916, over eleven sittings. Aged forty-two, the statesman appears sunk in a slough of despond. He was having to endure the ignominy of blame for the disastrous Battle of Gallipoli and the mental burden of so many lives lost. Demoted, Churchill had resigned and submitted to a commission of enquiry. Orpen captures the brooding interior world inhabited by his sitter, whose facial expression and body language speak volumes. Hand on hip and clutching a top hat, there is an attempt at confident poise but the shoulders are bent forward, suggesting an invisible weight. A portrait of dejection, this work reveals the capacity of art to intimate truth, however unpalatable. Churchill was later exonerated, the Dardanelles commission reporting in March 1917 that he was not held responsible.

British soldiers being buried
Postcard, n.d.

While Orpen's portrait of Churchill intimates the weight of responsibility borne by leaders for casualties suffered in battle, this *Daily Mail* postcard reveals the reality of death. 'Passed by censor', the caption reads: 'Into their battlefield grave two dead British soldiers have been recently placed while the padre reads the solemn words of the burial service.'

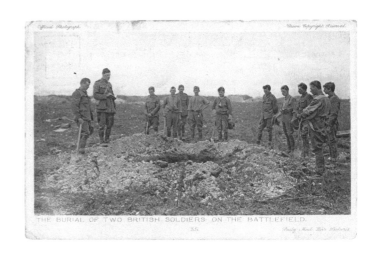

THE BURIAL OF TWO BRITISH SOLDIERS ON THE BATTLEFIELD.

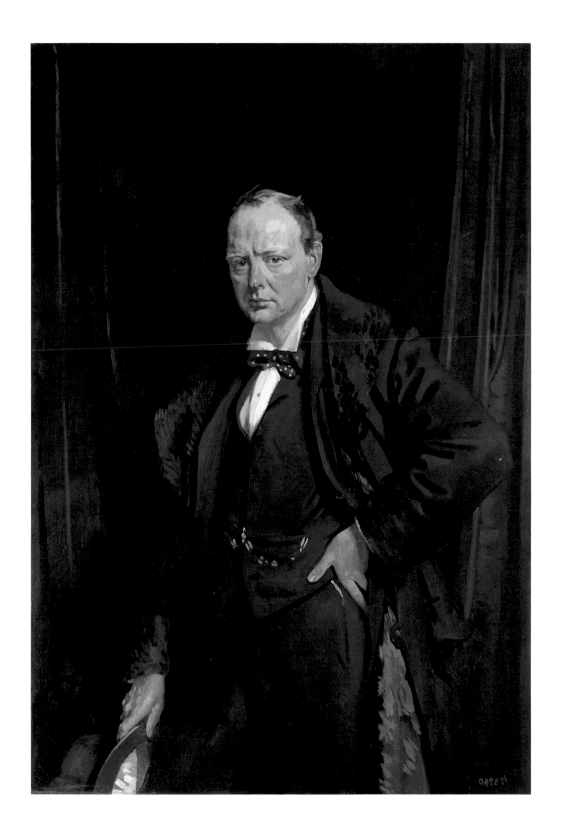

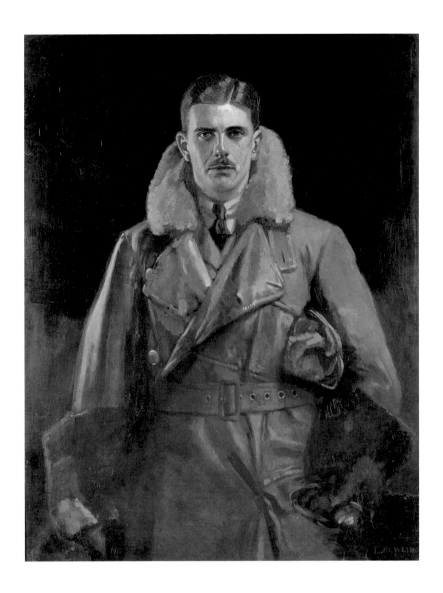

65

2nd Lieutenant Gilbert S.M. Insall
Edward Newling, 1919

Oil on canvas, 1123 x 869mm
Imperial War Museums

Gilbert Insall (1894–1972) joined the Royal Fusiliers in September 1914 and transferred to the Royal Flying Corps in 1915. That summer he was posted to the Western Front. On 7 November 1915, accompanied by his gunner T.H. Donald, Insall was patrolling in a Vickers fighter when they were attacked and pursued by a German plane. Firing at close range, Donald succeeded in bringing the enemy machine down. His own machine damaged during this action, Insall was forced to land close to German lines. Despite being shelled by the enemy, Insall carried out emergency repairs and flew the aircraft home. For these actions he earned the Victoria Cross.

66

Major J.B. McCudden
William Orpen, 1918

Oil on canvas, 914 x 762mm
Imperial War Museums

Orpen's portrait of James McCudden (1895–1918), the most highly decorated British pilot of the First World War, is one of several portraits he made of flyers. These were the result of encounters during visits to airfields from September 1917. By the time he sat to Orpen, McCudden had over fifty German aircraft to his credit and had been awarded the Victoria Cross, Distinguished Service Order and Military Cross, the first of these for 'most conspicuous bravery, exceptional perseverance, keenness and a very high devotion to duty.' McCudden was killed in a flying accident in July 1918.

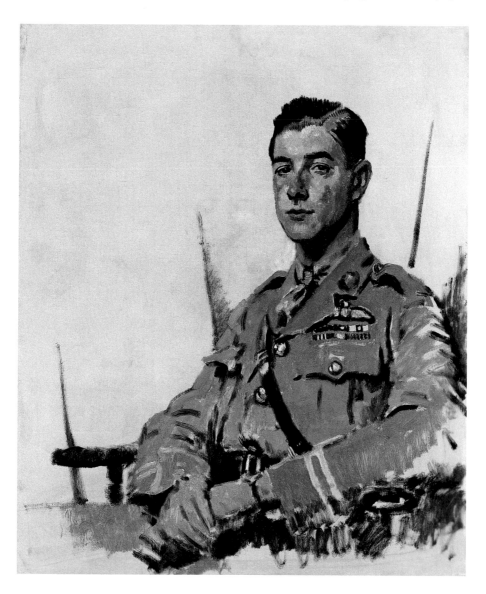

67

Captain G.B. McKean

G.C. Leon Underwood, 1919

Oil on canvas, 914 x 762mm
Imperial War Museums

George McKean (1888–1926) served with the
Canadian Expeditionary Force. Sent to France as
a private in June 1916, he was later commissioned.
Sustained by his 'pure love of adventure',[1] he was
often assigned to scouting duties, which involved
creeping across no-man's-land and reporting on the
enemy. On 27–8 April 1918, he dived over a barbed
wire barricade and led a charge along a German
trench, dispatching several enemy soldiers. He was
awarded the Victoria Cross for his esteemed
leadership and was later also awarded the Military
Cross for capturing over one hundred enemy troops.

1 George Burden McKean, *Scouting Thrills* (The Macmillan
 Company, Toronto and New York, 1919), p.3.

German soldiers receiving medals
Postcard, n.d.

Crown Prince Wilhelm, son of Kaiser
Wilhelm II (centre, wearing a cap),
presenting medals to German soldiers
on the battlefield.

68

Captain A. Jacka
Colin Gill, 1919

Oil on canvas, 914 x 812mm
Imperial War Museums

Australia's most famous First World War soldier,
Albert Jacka (1893–1932) was awarded the Victoria
Cross for his actions during the Battle of Gallipoli
on 19 May 1915. Resisting a Turkish attack on the
trench he occupied, Jacka shot five Turks, bayoneted
two others and repelled the remainder. During the
Battle of the Somme, despite being wounded three
times, he led a rebellion by prisoners against their
German captors. This has been described by the
Australian historian Charles Bean as 'the most
dramatic act of individual audacity in the history
of the war'.[1] Jacka was idolised in the ranks of the
Australian Imperial Force, the men of his battalion
describing themselves as 'Jacka's Mob'.

1 C.E.W. Bean, *Official History of Australia in the War of 1914–
 1918, Volume III – The Australian Imperial Force in France, 1916*
 (twelfth edition) (Australian War Memorial, Campbell, 1941),
 p.720.

69

An RAMC Stretcher-Bearer, Fully Equipped
Gilbert Rogers, 1919

Oil on canvas, 1524 x 1019mm
Imperial War Museums

Established in the late nineteenth century, the
Royal Army Medical Corps (RAMC) was greatly
expanded during the First World War. Providing
medical services to British army personnel, it was
confronted by a terrible range of injuries. These
included the effects of gas and artillery, bullet
wounds, gangrene and shell shock. Stretcher-
bearers such as the one depicted here by Rogers,
who served with the RAMC, played a vital role
in evacuating the wounded from the battlefield.
Injured soldiers were then treated at Advanced
Dressing Stations, Casualty Clearing Stations
or the Stationary Hospital. Of the 1,100,000 men
invalided home to Britain, two-thirds returned
to duty.

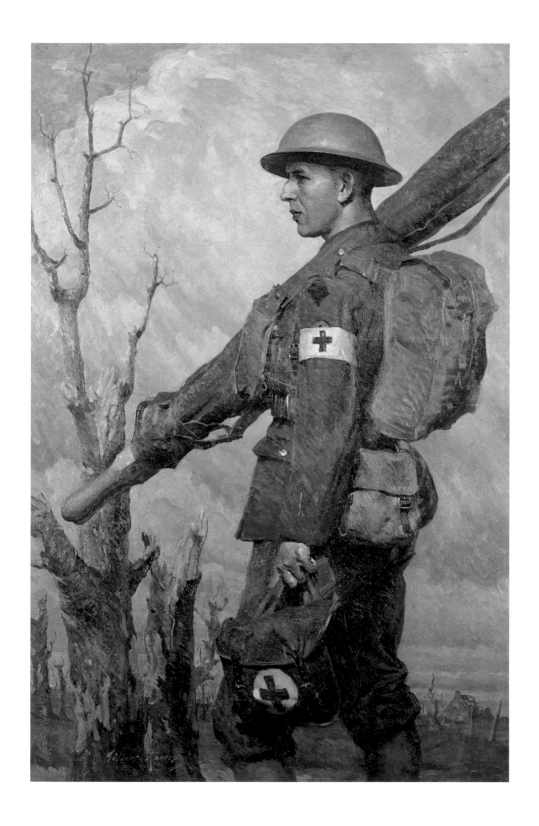

The Receiving Room:
the 42nd Stationary Hospital
William Orpen, 1917

Pencil and watercolour on paper, 457 x 558mm
Imperial War Museums

Responding to a range of subjects that included soldiers standing guard, resting and exhausted, as well as prisoners of war and – in the case of the enemy – corpses, Orpen's drawings are characterised by a compassionate objectivity. This is one of his most affecting images. It depicts three soldiers, evidently injured, awaiting treatment at a military hospital. Orpen had first-hand experience of such places having been admitted himself, suffering from what was described as scabies. He recalled, 'how more people did not die in that hospital beats me. I personally never got any sleep, and left in a fortnight nearly dead.'[1]

1 Orpen, *An Onlooker in France*, p.60.

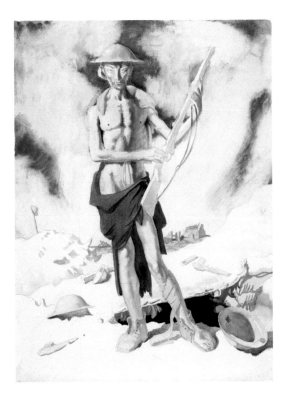

Blown Up
William Orpen, 1917

Though he stopped short of depicting dead Tommies, in this drawing Orpen depicted a shell-shocked soldier, wandering almost naked through the debris of a ruined landscape.

71

Gassed and Wounded
Eric Kennington, 1918

Oil on canvas, 711 x 914mm
Imperial War Museums

Eric Kennington (1888–1960) served in France from 1914 until June 1915, when he was invalided out. He returned in 1917 as an official war artist, focusing his work on the experiences of ordinary soldiers. This painting was based on drawings made at a Casualty Clearing Station. Its tight-knit composition powerfully conveys a sense of the station's cramped conditions, with wounded soldiers lying cheek by jowl and orderlies in attendance. The bandaged faces of the injured attest to the devastating effects of gas. Mustard gas caused internal and external blistering, resulting in damage to the lungs and other internal organs, and frequently blinded its victims.

Gassed
John Singer Sargent, 1919

As this harrowing image shows, for many soldiers exposed to gas attack, blindness was a terrible consequence.

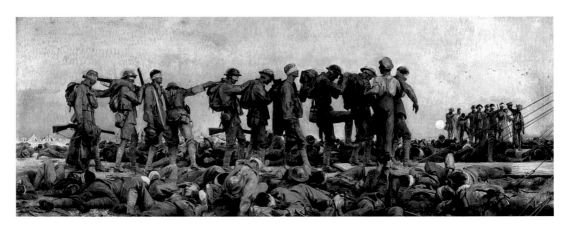

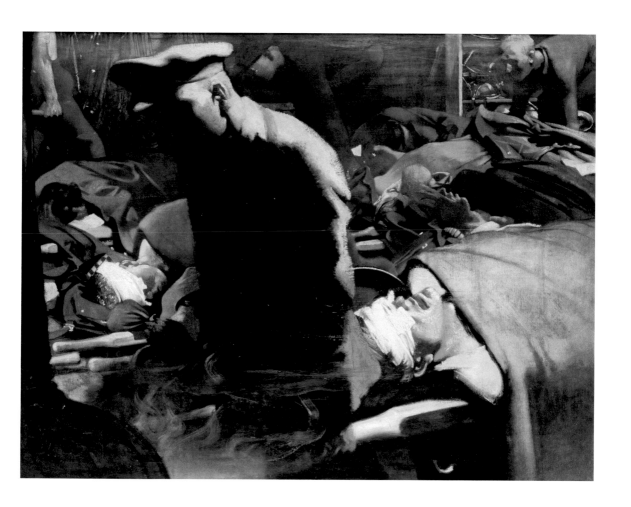

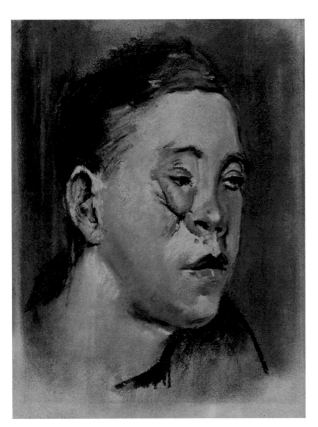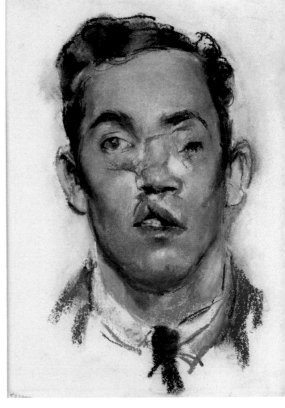

72

Soldiers with facial wounds
Henry Tonks, 1916–18

Pastels on paper, (left to right) 278 x 203mm,
277 x 198mm, 275 x 211mm, 278 x 211mm
The Royal College of Surgeons of England
(RCSSC/P 569.53/54/55/56)

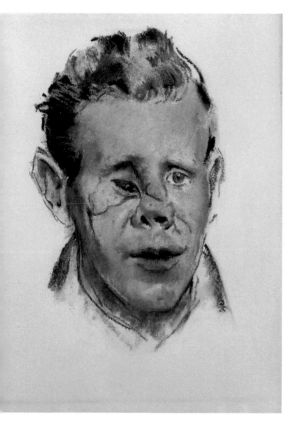

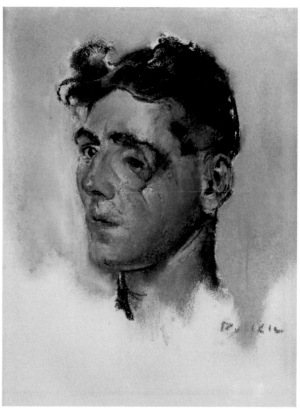

Opened in 1915, a dedicated unit at the Cambridge Hospital at Aldershot dealt with the specialised treatment of soldiers with facial wounds. The Battle of the Somme, which commenced in July 1916, caused a huge rise in the numbers of those admitted and a new centre was needed. The Queen's Hospital, Sidcup, became operational in August 1917. At both sites, a young surgeon, Harold Gillies, directed the process of plastic surgery, developing techniques to reconstruct facial features. Gillies asked Henry Tonks (1862–1937), a former professor at the Slade School of Fine Art, to draw the patients before and after surgery. Tonks made numerous drawings from life, these examples showing soldiers with gunshot injuries.

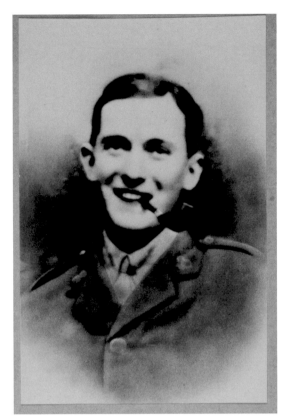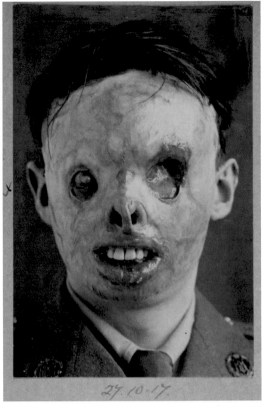

73

Soldier undergoing reconstructive surgery
2nd Lieutenant R.R. Lumley, n.d.,
29 December 1917

Photographs, 315 x 202mm (folio dimensions)
Gillies Archive
The Royal College of Surgeons of England

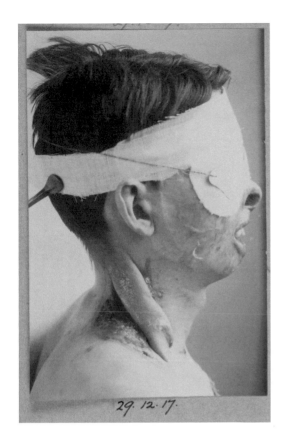

29.12.17.

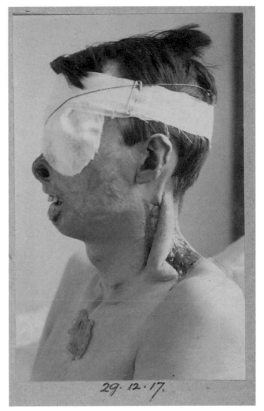

29.12.17.

Harold Gillies ensured that his reconstructive work was properly recorded. In addition to drawings made by Tonks, photography formed an important part of each patient's case notes, of which these are examples. The photographs from 2nd Lieutenant R.R. Lumley's file show treatment for the catastrophic effects of gas, which caused extensive damage to the facial tissue (opposite on the right and above; the photograph opposite on the left shows the patient before his injuries). Those relating to Private Dalrymple show gunshot wounds to the centre of the face (pages 146–7). Unlike other injuries, which through public exposure gained acceptance, the response to facial disfigurement was one of aversion. Until recently, such medical images have not featured in histories of the war.

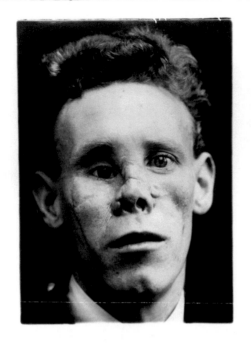

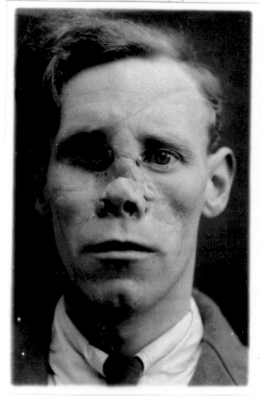

10 . 4 . 18. 20 . 1 . 20.

Soldier undergoing reconstructive surgery
Private Dalrymple,
10 April 1918 and 20 January 1920

Photographs, 307 x 192mm (folio dimensions)
Gillies Archive
The Royal College of Surgeons of England

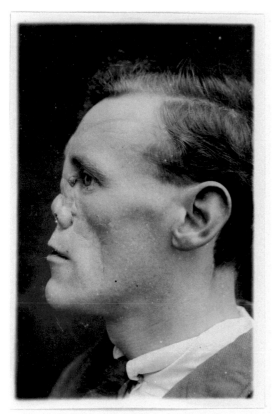

20.1.20.

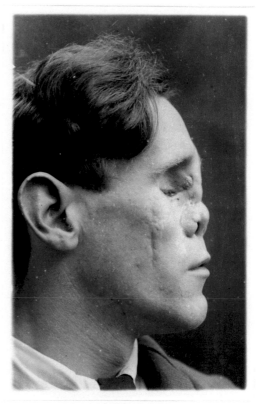

20.1.20.

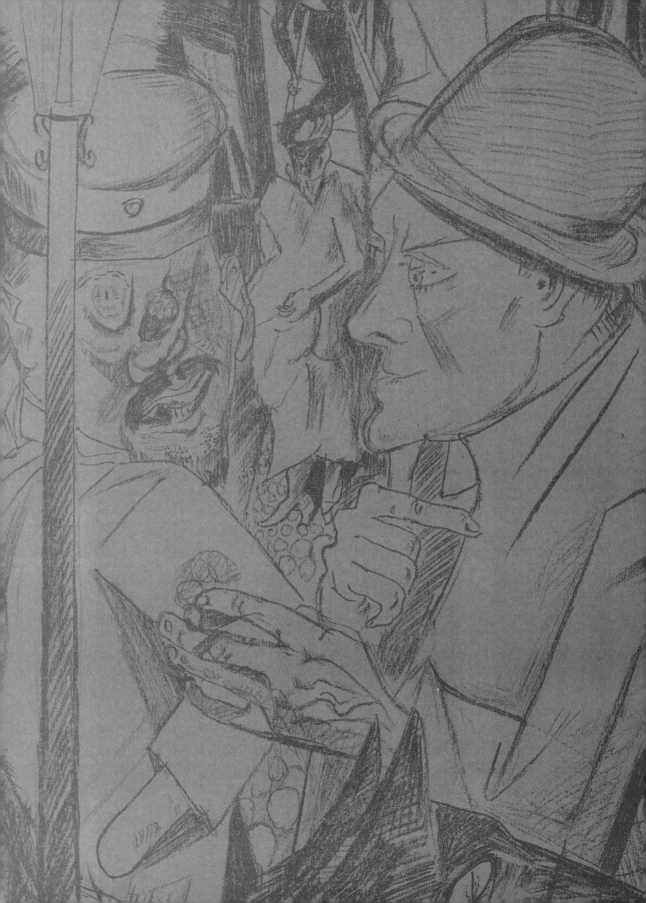

TRADITION AND THE AVANT-GARDE

The legacy of the Great War was death and suffering on a previously unimaginable scale, but this was not all. The methods of destruction and killing employed plumbed new depths of barbarism. With cavalry and the sword rendered virtually obsolete, modern warfare employed more effective and brutal means: gas, barbed wire, flame-throwers, machine guns, tanks and devastating artillery. The appalling consequences of these weapons suggested that human nature itself had changed, any vestige of compassion being snuffed out by unbridled cruelty and hatred. Such altered perceptions raised profound questions for artists: what meaning could be found amidst the debris of ruined lives, and how should it be represented?

In Britain, the incipient Modernist movement was dealt a heavy blow by the implication that new developments had severed contact with traditional, reassuring values. Rebuilding the psyche of a traumatised nation seemed to require the security offered by the familiar past. As a result, and as portraiture showed, in the visual arts there was a widespread return to earlier conventions. This view was not shared abroad. In Germany, defeat and social revolution produced a revulsion against the old order. Expressionism, which had taken root in the pre-war period, now seemed truer to the visceral suffering that so many had endured. The contrast in the portraits produced by these two nations expresses an unhealed division that would endure long after the guns had ceased.

74

Self-Portrait
Isaac Rosenberg, 1915

Oil on panel, 295 x 222mm
National Portrait Gallery, London

Painter and poet Isaac Rosenberg studied at the
Slade School of Fine Art. From 1912 he engaged
increasingly with a more Modernist style of
painting, moving away from his earlier, naturalistic
manner. In 1914, he exhibited in the Whitechapel
Gallery's survey exhibition of twentieth-century art.
This self-portrait of 1915 was painted the year he
enlisted in the army. He was sent to France with the
King's Own Royal Lancaster Regiment in June 1916.
There he wrote 'Dead Man's Dump' and other
poems that secured his reputation as a poet. He
was killed, at the age of twenty-eight, on the
Western Front on 1 April 1918.

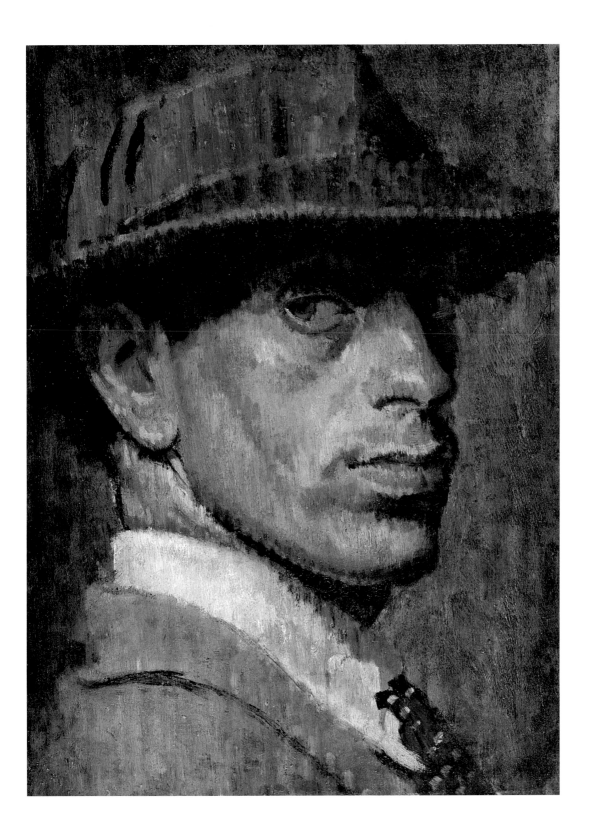

75

Siegfried Sassoon
Glyn Philpot, 1917

Oil on canvas, 610 x 508mm
The Fitzwilliam Museum, Cambridge

One of the leading poets of the First World War,
Siegfried Sassoon deliberately challenged patriotic
propaganda by evoking the brutal reality of the
conflict. In November 1915, he was sent to France
where, as a company commander, he served with
distinction. In July 1916, while under constant fire,
he rescued a number of comrades, an act of
gallantry for which he received the Military Cross.
Even so, the misery and suffering he witnessed
profoundly affected his outlook. In April 1917, he
was wounded and returned to England. During his
ensuing convalescence, this portrait was painted
in what Sassoon described as the 'peaceful'
atmosphere of artist Glyn Philpot's studio.[1]

1 Siegfried Sassoon, *Siegfried's Journey 1916–1920*
 (Faber and Faber, London, 1945), p.49.

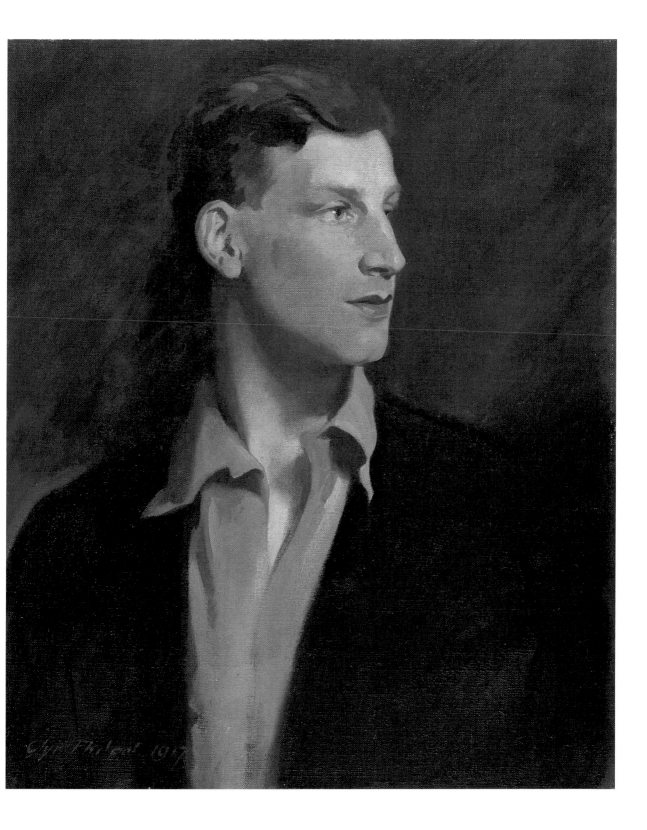

Self-Portrait
William Orpen, 1917

Oil on canvas, 762 x 635mm
Imperial War Museums

This is the last of three self-portraits that Orpen painted while serving as an official war artist on the Western Front. The first, painted shortly after his arrival in France, expresses the artist's initial idealism. The second depicts Orpen standing in a battlefield, with a soldier's grave in the distance. The final painting, completed during the winter of 1917, is the visual continuation of a journey during which Orpen comes to terms with war, both artistically and personally. Characteristically objective, he depicts himself in the act of drawing. Around this time, he wrote to his friend Alfred Rich: 'I work and work, but I don't expect anything I do will be any good or is any good – the whole thing is so vast …'.[1]

1 Quoted in Bruce Arnold, *Orpen: Mirror to an Age* (Jonathan Cape, London, 1981), p.323.

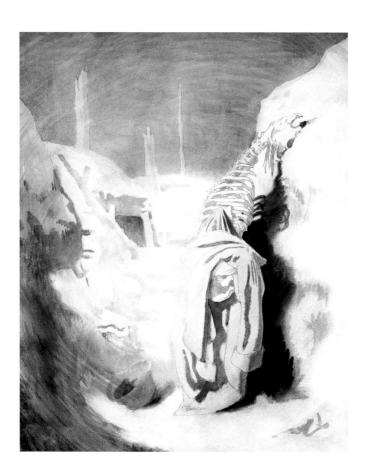

A Dead German in a Trench
William Orpen, 1917

Orpen did not depict dead British soldiers but this painting of the corpse of an enemy soldier is unflinchingly direct. The evidence of extreme violence, the resulting image is strange, seemingly divorced from reality.

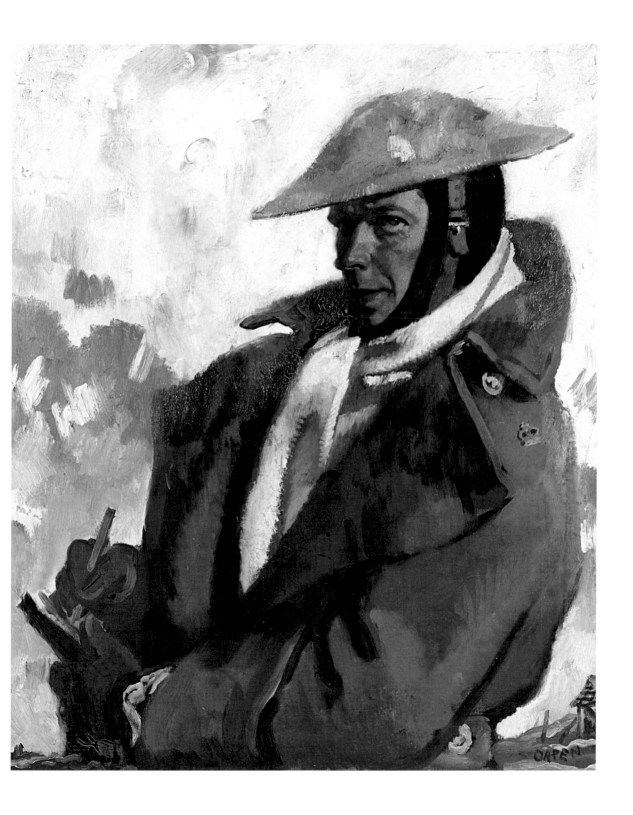

77

Bildnis Hermann Struck
(Portrait of Hermann Struck)
Lovis Corinth, 1915

Oil on canvas, 805 x 595mm
Städtische Galerie im Lenbachhaus und Kunstbau

As President of the Berlin Secession from 1911, Lovis Corinth (1858–1925) promoted academic styles of painting and was hostile to the experiments of the avant-garde, not least Expressionism. In 1910, the Secession had rejected paintings by Ernst Kirchner and Emil Nolde. Corinth's own painting manifested an affinity with Impressionism. Nevertheless, this portrait of Hermann Struck, an etcher and friend of the artist who was then thirty-nine and serving in the army, represents a development in Corinth's style toward greater expressive force. Focusing on Struck's officer's uniform, and employing agitated brushwork, Corinth suggests the unease and melancholy of his subject's war-imposed predicament.

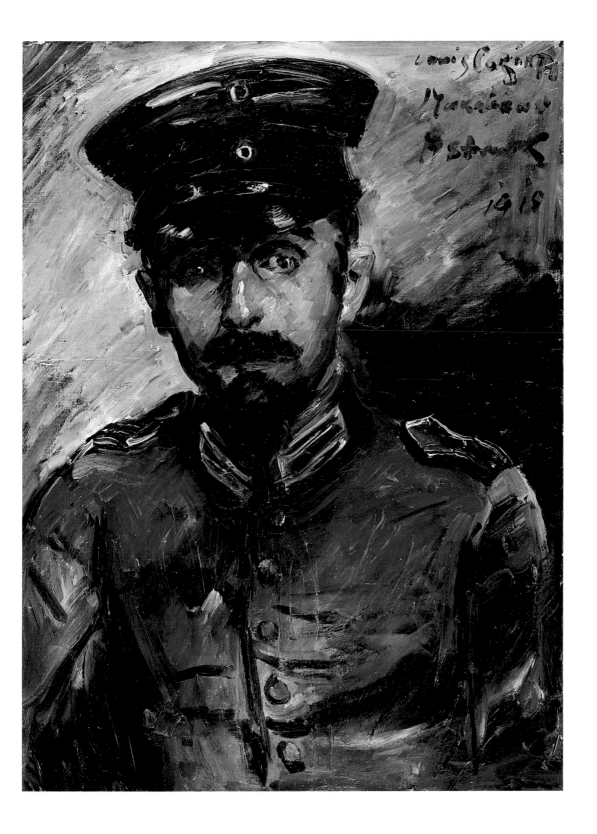

78

Selbstbildnis als Soldat
(Self-Portrait as a Soldier)
Ernst Ludwig Kirchner, 1915

Oil on canvas, 690 x 610mm
Allen Memorial Art Museum, Oberlin College, Ohio

In 1905, the Die Brücke group was formed in
Dresden, with Ernst Kirchner (1880–1938) as one of
its founders. The group became the focus for the
development of Expressionist painting in Germany.
Kirchner moved to Berlin in 1911, showed his work
in the important Armory Show in New York in 1913
and was given his first solo exhibitions in Germany.
The outbreak of war, however, interrupted this
artistic progress. Kirchner volunteered for military
service, but in 1915 he suffered a nervous collapse
and was discharged. This self-portrait was painted
during his convalescence in Switzerland. Dressed in
the uniform of the Mansfield artillery regiment, he
portrays himself with a severed hand, an imagined
injury expressing the crisis in his existence.

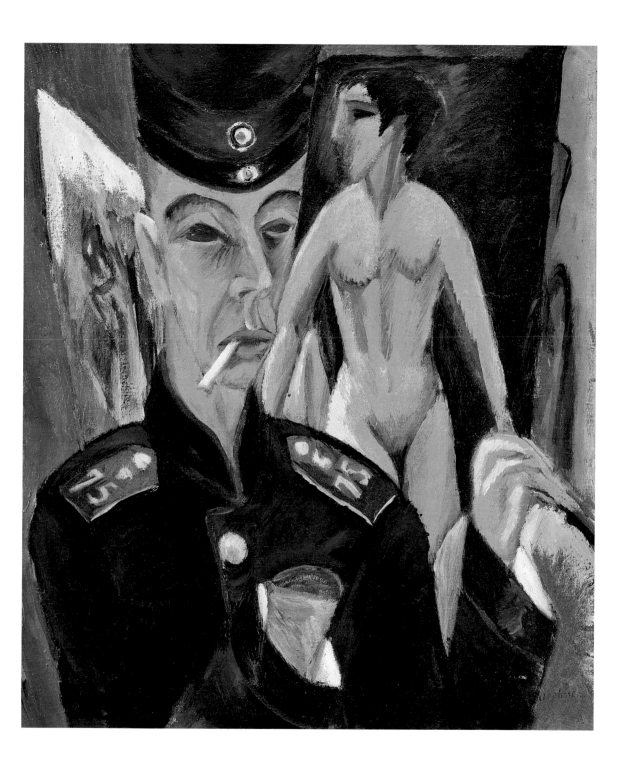

79

Die Hölle: Der Nachhauseweg (Hell: The Way Home)
Max Beckmann, 1919

Lithograph, 870 x 610mm
Scottish National Gallery of Modern Art

Max Beckmann (1884–1950) volunteered for the medical corps but, like Kirchner, in 1915 suffered a nervous breakdown and was discharged. The effect of his wartime experiences affected his art profoundly. Relinquishing the Impressionist style of his pre-war work, he adopted a harsher, more graphic way of painting. He also explored printmaking, employing an expressive, linear style.

This lithograph belongs to a set entitled *Hell*, which chronicles the lawlessness and turmoil that engulfed Germany after the November Revolution of 1918–19, a consequence of military defeat. Here the artist depicts himself confronting a soldier, one of many disfigured amputees then returning from the Front to a vanquished nation.

Selbstbildnis (Self-Portrait)
Max Beckmann, 1919

Beckmann's self-portrait appears on the title page to the publication *Die Hölle* (Hell). The text below the self-portrait states, 'We ask our esteemed public to step forward. You will not be bored for ten minutes. Anyone who is not delighted gets his money back.'

4/25 = Der Nassauer juwig = Beckmann

Arbres morts et tranchée après un bombardement (Dead trees and trench after a bombing)
Jules Gervais-Courtellemont, n.d.

Autochrome photograph, 90 x 120mm
Cinémathèque Robert Lynen collection, Paris

The sustained artillery bombardments on the Western Front were responsible for huge casualties and devastated the landscape. The bodies of many soldiers were never recovered. They had simply ceased to exist or, rather, had become part of the places where fighting took place. As this photograph by the French photographer Jules Gervais-Courtellemont shows, in the wake of battle such sites took on an unearthly aspect. Devoid of life they are, in a profound sense, a common grave. Courtellemont's photograph provides a haunting portrait of absence.

A dead German soldier outside his dugout, Beaumont Hamel, France
Unknown photographer, 1917

For thousands killed in battle the shattered landscape became a common grave. But many dead soldiers lay unburied where they fell.

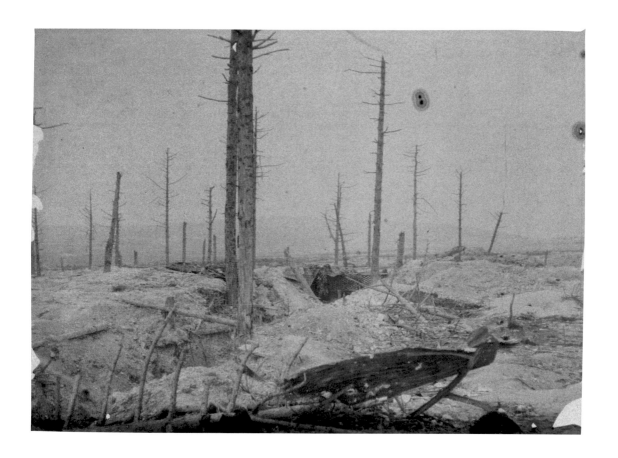

CHRONOLOGY
Paul Moorhouse

The chronology sets out, year by year, the principal events of the First World War. It focuses on the key military developments including the main battles and strategic movements. While the international nature of the conflict is intimated, the emphasis is on the war in Europe, in particular the Western Front. The introductions to the events that unfold during each year provide an indication of the wider political, social and artistic context.

1914

The suffrage movement gains momentum as Mary Richardson attacks Velázquez's painting *The Rokeby Venus* at the National Gallery, London (March). Four years of political and labour unrest lead to two million British workers going on strike (June). Following the assassination of Archduke Franz Ferdinand in Sarajevo that same month, the Home Rule Bill is deferred due to the escalating crisis (July). In August, the major European powers are drawn into war. Income tax for British workers is doubled to pay for the conflict, which by the end of the year is running at £1 million per day (17 November). Also in August, British explorer Sir Ernest Shackleton sets out on a major expedition to Antarctica and the newly completed Panama Canal opens to traffic. Cyprus is annexed to Britain (November) and in New York construction of the Beaux-Arts style Municipal Building, the first to incorporate a subway station into its base, is completed. In the arts, London's Whitechapel Gallery stages a survey exhibition of modern art (May–June) and at the Berlin Secession the Austrian Expressionist painter Oskar Kokoschka exhibits one of his greatest works, *The Bride of the Wind*, inspired by his relationship with Gustav Mahler's widow, Alma. In Britain the army bandmaster Lieutenant F.J. Ricketts (later Director of Music, Royal Marines) composes the hugely popular 'Colonel Bogey March'.

JUNE
28 Assassination of Archduke Franz Ferdinand, heir to the Austro-Hungarian empire, by Gavrilo Princip, a Serb nationalist, in Sarajevo, Bosnia.

JULY
5 Austria-Hungary seeks German support for a war against Serbia. Germany gives this assurance.
23 Austria-Hungary sends an ultimatum to Serbia.
28 Austria-Hungary declares war on Serbia. Russia commences mobilisation.
31 Germany warns Russia to cease mobilisation. When the Russians refuse, Germany declares war.

AUGUST
3 Germany declares war on Russia's ally, France. As part of the long-standing Schlieffen Plan (which prepared Germany to defeat France quickly before turning its forces to Russia in the east), Germany invades Belgium as a preliminary to an attack on France.
4 Britain, bound by a treaty of 1839 to protect Belgian neutrality, protests. Germany is undeterred and Britain declares war on Germany.
7 In Britain, Lord Kitchener, Secretary of State for War, calls for 100,000 men to join the British army. The British Expeditionary Force (BEF) is despatched to France.
11 France declares war on Austria-Hungary.
12 Britain declares war on Austria-Hungary.
14–24 Battles of the Frontiers between Anglo-French and German armies. The French Plan XVII, which concentrates a line of resistance between Belgium and Switzerland, ends in ruins.
15–23 The Russian army invades East Prussia.
23 Battle of Mons commences. The BEF inflicts heavy casualties but is forced to retreat. Subsequently, at Le Cateau, the retreating British army is embroiled in its worst battle for one hundred years. After suffering 7,800 casualties, the withdrawal continues.
26–30 Battle of Tannenberg. The Germans achieve an overwhelming victory over the Russian army. As a result, the German commanders Hindenburg and Ludendorff become household names.

SEPTEMBER
5–10 Battle of the Marne. A million Anglo-French and 900,000 German troops are involved. The German advance on Paris is halted.
13–28 Battle of the Aisne. The 'Race to the Sea' commences with Anglo-French and German armies moving northwards, each attempting to swing around the other's exposed flank.

OCTOBER
16–31 Battle of the Yser. The Belgians flood a large area between Nieport and Dixmude, rendering it impassible for the entire war.
19 First Battle of Ypres commences (ends 22 November). The Germans are prevented from capturing Calais and Dunkirk, but with 75,000 casualties the BEF is decimated.

NOVEMBER
6 Britain commences a naval blockade against Germany.

DECEMBER
24–25 Unofficial truce in some sectors between British and German troops.

1915

'The Great War', as it becomes known, intensifies with growing losses on all sides. In Britain the Munitions of War Act forbids strikes in key industries without Government approval, passport photographs are made obligatory (February) and anti-alcohol restrictions result in widespread resentment (May). In July the cost of the war in Britain reaches £2 million per day. Welsh miners strike for higher wages, returning to work on 31 August. Meanwhile, the historical monument Stonehenge is auctioned for £6,600 and bought by a Mr Clubb as a present for his wife (21 September). The sporting world pays tribute to the cricketer W.G. Grace (dies 23 October). In the literary arena *The Thirty Nine Steps* by John Buchan, *The Rainbow* by D.H. Lawrence and *The Voyage Out* by Virginia Woolf are published while, in Europe, Jean Sibelius completes his Symphony No. 5 and the French artist Marcel Duchamp commences work on *The Bride Stripped Bare by her Bachelors, Even* (also known as *The Large Glass*), an avant-garde piece that occupies him for the next eight years. In Britain, the song 'Pack Up your Troubles in your Old Kit Bag' achieves great popularity.

JANUARY

1 The Military Cross is introduced and awarded for the first time.

19 First Zeppelin raid by Germany on Britain. Nineteen missions follow in 1915, with twenty-two in 1916, seven in 1917 and four in 1918. Eventually, more than 5,750 bombs are dropped.

24 Battle of Dogger Bank between Britain's Grand Fleet and Germany's High Seas Fleet. The *Blücher* is sunk and the Kaiser orders his fleet to avoid future risks.

FEBRUARY

4 Germany begins submarine warfare against merchant vessels.

7-22 Second Battle of the Masurian Lakes. The Germans achieve a notable victory over the Russian army which loses 200,000 soldiers, including 90,000 taken prisoner.

MARCH

10-13 Battle of Neuve Chapelle. After initial success, the British offensive stalls.

APRIL

22 Second Battle of Ypres commences (ends 25 May). The Germans use chlorine gas for the first time and capture two-thirds of the salient. Despite inflicting 60,000 casualties on the British and 10,000 on the French, the German army is itself exhausted and unable to continue the offensive. Ypres is methodically razed.

25 Allied forces land at Gallipoli, aiming to capture Constantinople. Following a number of naval attacks, the campaign goes badly with heavy losses.

MAY

7 The British liner *Lusitania* is sunk by a German submarine.

9-18 Second Battle of Artois. The French-led attack on the German trenches between Arras and Lens follows a bombardment of 690,000 shells from 1,000 guns. After an initial advance, further gains are limited and the French sustain 100,000 casualties.

23 Italy declares war on Austria-Hungary.

JUNE

15 The artist Henri Gaudier-Brzeska is killed on the Western Front.

23 First of four Battles of the Isonzo, the river frontier between Italy and Austria-Hungary, begins (the fourth ends 2 December). Lacking modern equipment, ammunition, artillery and transport, the Italian offensives are largely unsuccessful.

JULY

9 Surrender of German forces in South-West Africa.

AUGUST

6-29 Battle of Sari Bair, the last unsuccessful Allied attempt to seize the Gallipoli peninsula. Total withdrawal is recommended and follows in December.

SEPTEMBER

1 Germany suspends unrestricted submarine warfare.

8 Tsar Nicholas II replaces Grand Duke Nicholas as Commander-in-Chief of the Russian army.

25 Battle of Loos commences (ends 16 October). This major British offensive captures Loos in north-eastern France but, short of reserves and supplies, the BEF is forced back by German counter-attacks, resulting in heavy losses for little gain.

OCTOBER

6 Serbia is invaded by Germany, Austria-Hungary and Bulgaria.

12 Nurse Edith Cavell is executed by a German firing squad.

NOVEMBER

27 Serbian resistance collapses after suffering half a million casualties.

DECEMBER

19 Sir Douglas Haig replaces Sir John French as Commander-in-Chief of the BEF.

1916

In the absence of a decisive breakthrough, the war settles into a pattern of attrition. Huge losses for the French and Germans are sustained on the Western Front and naval offensives end in stalemate. British casualties are the worst in the country's military history. On the home front Irish rebels stage the Easter Rising against the United Kingdom (23 April) and fourteen of the leaders are later executed. The House of Commons supports the Daylight Saving Plan to put clocks forward one hour in summer (8 May). The Irish nationalist Sir Roger Casement is hanged in London for treason (3 August). The novelist Henry James dies in Rye, Sussex (28 February). After their ship *Endurance* is crushed by ice in the Antarctic, Sir Ernest Shackleton and his crew leave the ice flow and take to the sea in small boats (9 April). Haydn Wood composes 'Roses of Picardy', which becomes one of the most popular wartime songs. Engineer Eugéne Freyssinet, who served in the French army, designs the first large-scale buildings to use reinforced concrete – the aircraft hangars at Orly. The artist Mark Gertler paints *The Merry-Go-Round* after seeing a fair for wounded soldiers on Hampstead Heath. Gustav Holst completes *The Planets* suite, whose first movement 'Mars' evokes war, and the anarchic Dada movement flourishes in Zurich. One of the classic films of the silent era, *Intolerance*, directed by D.W. Griffith, is released in Britain (September). In St Petersburg the mystic Rasputin is mudered by aristocratics opposing his influence on the Russian imperial family (30 December).

JANUARY
8–16 Austro-Hungarian offensive against Macedonia results in the latter's capitulation.
9 The Dardanelles Campaign ends in defeat for the Allies and an Ottoman victory.
27 The Military Services Act introduces conscription in the United Kingdom.

FEBRUARY
21 Battle of Verdun commences (ends 18 December). German strategy focuses on a battle of attrition at the fortress town of Verdun on the River Meuse. Stalemate ensues followed by French counter-attacks that finally repel the German troops. French casualties total 542,000 and German casualties 434,000, during the longest battle of the war.

MARCH
1 Germany resumes unrestricted submarine warfare.
1–15 Fifth Battle of the Isonzo.

MAY
10 Germany suspends unrestricted submarine warfare.
31 Battle of Jutland commences (ends 1 June). During the only major action between the German High Seas Fleet and the British Grand Fleet, the British lose fourteen warships and the Germans eleven smaller and older vessels. While these losses do not incapacitate the British, the German fleet is cautious about future engagements and remains at anchor for the remainder of the war.

JUNE
4 Brusilov Offensive commences (ends late September). The highpoint of Russia's involvement in the war, the advance by Russian troops against five mainly Austro-Hungarian armies on a broad front is almost entirely successful. In two weeks 200,000 prisoners are taken; the Austro-Hungarian army suffers one million casualties in total. This ensures Brusilov's reputation as the finest Russian general of the war.
5 Lord Kitchener drowns when HMS *Hampshire* is sunk off Orkney.

JULY
1 Battle of the Somme commences (ends 14 November). Following an eight-day bombardment of the German trenches, which proves largely ineffectual, the British advance is decimated by machine-gun fire, with 57,470 casualties by the end of the first day. German casualties totalled 4,000.

AUGUST
3–17 Sixth Battle of the Isonzo.
29 Field Marshal Hindenburg replaces von Falkenhayn as German Chief of the General Staff.

SEPTEMBER
15 First use of tanks by the British army at Flers-Courcelette during the ongoing Battle of the Somme.

NOVEMBER
14 With the ending of the Battle of the Somme, the total number of casualties on both sides reaches 1.3 million, including 400,000 British. The Germans have lost 650,000 men. In 140 days of fighting, Anglo-French troops advanced six miles.

DECEMBER
6 Lloyd George becomes British Prime Minister.
12 Marshal Joffre is replaced by General Nivelle as French Commander-in-Chief on the Western Front.

1917

An end to the war continues to prove elusive. Major Allied attacks result in enormous losses for both sides. With the collapse of the Russian army Germany turns her attention to the Western Front and America declares war on Germany. In Britain, Prime Minister Lloyd George announces a plan to give married women aged over thirty the vote (29 March). The British royal family drop their German titles and change the family name from Saxe-Coburg to Windsor (June). The Balfour Declaration gives official British support for the founding of a Jewish state (8 November). Following revolutions, rioting and chaos in Russia earlier in the year, the Bolsheviks secure a majority and a new Government under Lenin is formed (November). In July the cost of the war in Britain is reported as running at £7 million per day. Sergei Prokofiev completes his Symphony No. 1, titled the 'Classical Symphony', *Prufrock and Other Observations* by T.S. Eliot is published, in the United States. The Original Dixieland Jazz Band issues the first jazz record and Isham Jones's song 'You're in the Army Now' achieves popularity. Elizabeth Garrett Anderson, the first woman doctor, dies (17 December).

JANUARY

16 The German Foreign Secretary, Arthur Zimmermann, sends a telegram to the German ambassador in Mexico instructing him to propose to the Mexican government an alliance between Germany and Mexico against the United States.

FEBRUARY

1 Germany resumes unrestricted submarine warfare.

MARCH

1 General Arz von Straussenberg replaces Field Marshal Conrad von Hotzendorf as Austro-Hungarian Chief of Staff.

15 Tsar Nicholas II abdicates. A provisional government is put in place in Russia.

APRIL

6 The United States of America declares war on Germany.

9 Battle of Arras commences (ends 15 May). The French attack is a disaster and Australian troops suffer their worst ever losses on the Western Front. Canadian troops capture the reputedly impregnable Vimy Ridge but are then stopped at the Hindenburg Line.

16 The Nivelle Offensive commences (ends 29 May). The major French attack stalls after incurring high losses. This failure results in General Nivelle's replacement by General Pétain as Commander-in-Chief.

29 Morale shattered by the disastrous Nivelle Offensive, the French army is torn apart by mutinies, disabling it until the autumn.

MAY

12 Tenth Battle of the Isonzo commences (ends 6 June).

JUNE

7–14 Battle of Messines. With the French army in disarray, the BEF is the principal Allied army on the Western Front. General Plumer leads an offensive against the German-held Messines Ridge. This is preceded by the detonation of nineteen underground mines which inflicts heavy casualties on the enemy and results, unusually, in lower losses for the attacking forces. The outcome is a decisive victory for the BEF.

25 The first American troops arrive on the Western Front.

JULY

31 Battle of Passchendaele commences (ends 10 November). The British offensive east of Ypres encounters nightmarish conditions caused by heavy rainfall and incessant shelling. After the attack stalls, General Plumer is given overall command. Recognising that a breakthrough is impossible, Plumer opts for a battle of attrition. The BEF recaptures territory held by the Germans since 1914–15 but at a cost of 300,000 casualties.

AUGUST

18–28 Eleventh Battle of the Isonzo.

SEPTEMBER

20–25 Battle of the Menin Road Ridge precedes the First and Second Battles of Passchendaele.

OCTOBER

24 Battle of Caporetto commences (ends 12 November). Austro-Hungarian losses of 55,000 men in the Eleventh Battle of the Isonzo leads to a request for German support. A new army attacks the Italian troops at Caporetto, resulting in huge losses for the defending forces, with 275,000 men taken prisoner.

NOVEMBER

7 October Revolution in Russia. The Bolsheviks seize power.

DECEMBER

7 The United States of America declares war on Austria-Hungary.

16 Russia agrees a ceasefire with Germany.

1918

Germany's spring offensives aim for a breakthrough but their failure drains Germany's manpower. Strengthened by the arrival of American troops, the Allied counter-offensives lead to a sudden German collapse. Alongside the horrors of war, a worldwide influenza epidemic spreads across Asia, Europe and North America, claiming over 21 million lives, with 3,000 mortalities per week in London alone. In Britain the Representation of the People Act gives men over twenty-one and women over thirty the right to vote (6 February). In Britain conscription is raised to the age of fifty and extended to Ireland (18 April). The House of Commons votes in favour of allowing women to become MPs (23 October). *Eminent Victorians* by Lytton Strachey and *Married Love* by Marie Stopes are published and the pioneer of Suprematism, the abstract artist Kazimir Malevich, paints *White on White*. The popular song 'I'm Forever Blowing Bubbles' debuts in the Broadway musical *The Passing Show* of 1918. Stonehenge is restored to the British nation (15 September). The war poet Wilfred Owen is killed in action (4 November). On 11 November, the long-awaited Armistice is greeted with widespread celebrations in Britain.

JANUARY

8 President Woodrow Wilson makes a speech outlining his Fourteen Points, an explicit statement of post-war aims for discussion at the anticipated peace conference.

FEBRUARY

17 Fighting resumes on the Eastern Front when Germany launches a new offensive in order to bring the Russians to the negotiating table.

MARCH

3 Treaty of Brest-Litovsk is signed. Russia concedes huge territorial losses, including the Baltic States, Finland, Poland and the Ukraine.

7 Bonar Law, Chancellor of the Exchequer, asks the House of Commons for a war loan of £600 million.

21 First phase of the Spring Offensive: Operation Michael (ends 5 April). The German attack strikes at the 60-mile section between Arras and La Fère that connects the British and French forces. Superior Allied air power helps to deny the Germans a decisive victory.

APRIL

1 Royal Air Force is formed by combining the Royal Flying Corps and the Royal Naval Air Service.

3 The Allied Supreme War Council appoints General Ferdinand Foch Commander-in-Chief of the Allied Forces. The United States accepts Foch's authority even though, technically, it is not an ally but an Associated Power.

4 Second phase of the Spring Offensive: Operation Georgette (ends 29 April). Following the near victory of Operation Michael, a second German attack strikes at the British between Ypres and La Bassée. A prohibition on withdrawal by Haig stiffens resistance and the German advance is halted after it establishes a ten-mile salient.

MAY

27 The Aisne Offensive commences (ends 4 June). The German attack on the French along the Chemin des Dames creates a salient 30 miles wide and 20 miles deep, but there is no breakthrough.

JUNE

9–13 Final phase of the Spring Offensive: Operation Gneisenau. Forewarned by deserters, the French strengthen their defences and halt the German advance.

JULY

18 Second Battle of the Marne commences (ends 5 August). A German attack to the west of Reims is unsuccessful. The French launch a major counter-attack that eradicates the German-held Soisson-Reims salient.

AUGUST

6 Foch, the victor of the Marne, is created Marshal of France.

8–11 Battle of Amiens: the first phase of the Allies' Hundred Days Offensive. Combining infantry, tanks, artillery and aircraft, the Anglo-French offensive shatters the German line with 15,000 prisoners taken on the first day alone.

SEPTEMBER

26 Meuse-Argonne Offensive commences (ends 11 November). Continuing the Hundred Days Offensive, the Allied attack involves 600,000 troops, 5,000 guns, 500 tanks and 500 aircraft. The US First Army breaks through the enemy's first two lines of defences. Their inexperience incurs 117,000 casualties.

29 Battle of St Quentin Canal commences (ends 10 October). The last critical engagement of the war in which Allied troops attack and breach the most heavily defended section of the Hindenburg line.

OCTOBER

24 Battle of Vittorio Veneto commences (ends 4 November). The Austro-Hungarian forces fall apart with 300,000 prisoners taken.

NOVEMBER

4 Austria-Hungary signs an armistice with Italy.

11 Germany signs the Armistice, effective from 11.00am.

FURTHER READING

Bruce Arnold, *Orpen: Mirror to an Age* (Jonathan Cape, Fakenham, 1981)

Suzannah Biernoff, 'The Rhetoric of Disfigurement in First World War Britain', *Social History of Medicine*, vol. 24, no. 3, 2011, pp.666–85

Emma Chambers, *Henry Tonks: Art and Surgery* (The College Art Collections, London, 2002)

Richard Cork, *A Bitter Truth: Avant-Garde Art and the Great War* (Yale University Press, New Haven and London, 1994)

M. Egremont, *Siegfried Sassoon: A Biography* (Picador, London, 2005)

Jacob Epstein, *213/6 Jacob Epstein 1917–1936*, Imperial War Museum/First World War Artists Archive, (unpublished manuscript)

Mia Fineman, 'Ecce Homo Prostheticus', *New German Critique*, no. 76, Special Issue on Weimar Visual Culture (Winter 1998), pp.85–114

John Fraser, 'Propaganda on the Picture Postcard', *Oxford Art Journal*, vol. 3, no. 2, Propaganda (October 1980), pp.39–47

Julian Freeman, 'Plastic Surgery and War Artist', *Henry Tonks and the Art of Pure Drawing*, ed. Lynda Morris (Norwich School of Art Gallery, Norwich, 1985), pp.40–2

J.G. Fuller, *Troop Morale and Popular Culture in the British and Dominion Armies, 1914–1918* (Clarendon Press, Oxford, 1990)

Paul Fussell, *The Great War and Modern Memory* (Oxford University Press, London and New York, 1975)

Martin Gilbert, *The First World War: A Complete History* (Weidenfeld and Nicolson, London, 1994)

Paul Gough, *A Terrible Beauty: British Artists in the First World War* (Samson & Company, Bristol, 2010)

Michael Hammond, '*The Battle of the Somme* (1916): An Industrial Process Film that "Wounds the Heart"', *British Silent Cinema and the Great War*, eds Michael Hammond and Michael Williams (Palgrave Macmillan, Basingstoke, 2011)

Max Hastings, *Catastrophe: Europe Goes to War 1914* (William Collins, London, 2013)

Samuel Hynes, *A War Imagined: The First World War and English Culture* (The Bodley Head, London, 1990)

John Keegan, *The First World War* (Pimlico, London, 1999)

P.G. Kondoy and **S. Dark**, *Sir William Orpen: Artist and Man* (Seeley Service and Co., London, 1934)

Sue Malvern, *Modern Art, Britain and the Great War* (Paul Mellon Centre for Studies in British Art/Yale University Press, New Haven and London, 2004)

C.R. Nevinson, *266 A/6 C.R. Nevinson 1917–1918*, Imperial War Museum/First World War Artists Archive, (unpublished manuscript)

Edward Newling, *128/4 Capt. E. Newling, 1 Sept 1918–1939*, Imperial War Museum/First World War Artists Archive, (unpublished manuscript)

William Orpen, *An Onlooker in France: A Critical Edition of the Artist's War Memoirs*, eds R. Upstone and A. Weight (Paul Holberton, London, 2008)

Nicholas Reeves, 'Cinema, spectatorship and propaganda: "Battle of the Somme" (1916) and its contemporary audiences', *Historical Journal of Film, Radio and Television*, vol. 17, no. 11, 1998, pp.5–28

Nicholas Reeves, 'Film Propaganda and Its Audience: The Example of Britain's Official Films during the First World War', *Journal of Contemporary History*, vol. 18, no. 3, Historians and Movies: The State of the Art: Part 1 (July 1983), pp.463–94

Isaac Rosenberg, *The Collected Letters of Isaac Rosenberg: Poetry, Prose, Letters, Paintings and Drawings*, ed. I. Parsons (Chatto and Windus, London, 1979)

Rainer Rother, '"Bei Unseren Helden an der Somme" (1917): the creation of a "social event"', *Historical Journal of Film, Radio and Television*, vol. 15, no. 4, 1995, pp.525–42

Siegfried Sassoon, *Siegfried Sassoon: Diaries, 1915–1918*, ed. R. Hart-Davis (Faber, London, 1983)

David Silbey, *The British Working Class and Enthusiasm for War 1914–1916* (Frank Cass, London and New York, 2012)

Hew Strachan, *The First World War: A New Illustrated History* (Simon and Schuster UK, London, 2003)

A.J.P. Taylor, *The First World War: An Illustrated History* (Penguin Books, New York and Harmondsworth, 1966)

John Terraine, *The Great War* (New York, Macmillan, 1965)

R. Upstone, *William Orpen: Politics, Sex and Death*, with contributions by R.F. Forster and David Jenkins (Philip Wilson, London, 2005)

ACKNOWLEDGEMENTS

In many respects the Great War belongs to a different world. Nearly a hundred years have passed since the major nations were engulfed in unimaginable slaughter; and even though global conflict continues in the twenty-first century, there is something about the catastrophic events of 1914–18 that seems alien to the modern mind. There are the incomprehensible statistics relating to casualties sustained in bitter battles fought over long months at the Somme, Verdun, Gallipoli and Passchendaele, to name but a few of the many killing fields. The scale of loss and depth of inflicted suffering confound all notions of compassion. At the same time, the innumerable stories of selfless courage, dignity and fortitude in adversity illuminate mankind's nobler aspects. Such contradictions remain insoluble. To approach the Great War seeking an understanding of its human dimension is therefore to experience an abiding sense of inadequacy; and of all the emotions aroused by this complex subject perhaps the deepest is that of humility.

In curating *The Great War in Portraits* these perceptions were ever present. Aside from the formidable historical complexities explored by so many distinguished historians, presenting this subject from the perspective of portraiture involved confronting a huge field of imagery. The First World War generated a visual response of unprecedented proportions and diversity, ranging from fine art to various forms of documentary material, including film and medical records. The breadth of experience represented by this material is correspondingly wide. In making an exhibition with individuals at its centre and portraiture its focus, I have therefore relied on the knowledge, advice and assistance of many others to whom I owe a profound debt.

In the first instance, my director Sandy Nairne invited me to undertake the organisation of this project. In so doing, he astutely loaned me his personal copy of Paul Fussell's inspirational book *The Great War and Modern Memory*. I am very grateful to him on both these counts and also for his valuable support. The process of assembling much information from many sources was very ably led by Clare Barlow, Assistant Curator, and I would like to express my gratitude for her essential input. Other key research was also undertaken by Sarah Fletcher, Jenny Foot, Alice Strickland and Amelia Smith, interns at the Gallery whose energy and dedication were vital in sustaining momentum. In bringing the exhibition to fruition I have relied on the support of my colleagues in the Exhibitions department, particularly Michael Barrett, Michelle Greaves, Sarah Tinsley and Rosie Wilson. The editing of this book was skilfully overseen by Andrew Roff, and I also wish to thank Rob Carr-Archer, Christopher Tinker and Ruth Müller-Wirth who played an important part in its production. Without key loans, the exhibition would not have been possible, and several individuals at the Imperial War Museum have been particularly supportive, especially Diane Lees, Katherine Palmer, Jenny Wood, Maria Rollo, Matthew Lee and Sara Bevan. Ulrike Smalley was a vital early source of valuable advice. At the Royal College of Surgeons I received very welcome support from Sam Alberti, Louise King and Milly Farrell. To the many other lenders I extend warm gratitude. Final thanks are due to Rosemary, Sarah, Anne and Sam – all of whom, in a special way, served.

Paul Moorhouse

PICTURE CREDITS

The National Portrait Gallery would like to thank the copyright holders for granting permission to reproduce works illustrated in this book. Every effort has been made to contact the holders of copyright material, and any omissions will be corrected in future editions if the publisher is notified in writing.

Dimensions given height x width (mm).

Page 13 Harry Patch photographed by Giles Price, 7 December 2004. C-type colour print, 354 x 280 © Giles Price. National Portrait Gallery, London (NPG x127190)

Page 14 A French military cemetery, Verdun photographed by Jules Gervais-Courtellemont, 1916. © Galerie Bilderwelt/The Bridgeman Art Library

Page 15 Letter written by an unknown soldier recounting the Battle of Messines in 1917. Imperial War Museum.

Page 16 Telegram from King George V from the Private Papers of H.L. Davis, 1918. Imperial War Museum.

Page 20 *Ready to Start. Self-Portrait* Sir William Orpen, 1917. Oil on panel, 608 x 494 Imperial War Museums © IWM (Art. IWM ART 2380)

Page 22 Mr Muirhead Bone crossing a muddy road in Maricourt, France photographed by an unknown photographer, September 1916. Imperial War Museums © IWM (Q 1464)

Page 23 Lieutenant Ernest Brooks (left), the first British official war photographer (left), with the official cinematographer, Lieutenant Geoffrey Malins, at a coffee stall behind the lines on the Somme. Photographed by Ernest Brooks (Lt), 1916. Imperial War Museums © IWM (Q 1456)

Page 24 'Men of the Moment' Postcard, c.1914 Private Collection

Page 26 The *Rock Drill* (first version) Sir Jacob Epstein, 1913. By courtesy of the Conway Library, The Courtauld Institute of Art, London

Page 28 Study for the *Rock Drill* Sir Jacob Epstein, c.1913. Charcoal on paper, 641 x 533 Tate © The estate of Sir Jacob Epstein

Page 29 Reconstruction of the *Rock Drill* Ken Cook and Ann Christopher RA after Sir Jacob Epstein, 1974. Polyester resin, metal and wood, 2050 x 1415 Birmingham Museums and Art Gallery/ The Bridgeman Art Library © The estate of Sir Jacob Epstein

Page 30 King George V and Kaiser Wilhelm II in the funeral procession of King Edward VII, near Paddington, London, 20 May 1910. Photograph by Topical Press Agency/Getty Images

Page 33 (top) Archduke Franz Ferdinand and his wife Sophie, Duchess of Hohenberg, 28 June 1914. Photograph by Time Life Pictures/Mansell/Time Life Pictures/Getty Images © Time Life Pictures

(Below) Lord Kitchener, Secretary of State for War Postcard, c.1914–18 (photograph by Bassano, 1895) Image: © National Portrait Gallery, London

Page 36 (left) Lieutenant A.P.F. Rhys Davids Sir William Orpen, 1917. Oil on canvas, 914 x 762 Imperial War Museums © IWM (Art. IWM ART 3004)

(Right) An Airman: Lieutenant R.T.C. Hoidge MC Sir William Orpen, 1917. Oil on canvas, 914 x 762 Imperial War Museums © IWM (Art. IWM ART 2996)

Page 37 Gassed: 'In arduis fidelis' Gilbert Rogers, 1919. Oil on canvas, 1019 x 1524 Imperial War Museums © IWM (Art. IWM ART 3819)

Page 39 Invitation card for the premiere of the film Battle of the Somme at the Scala Theatre, Charlotte Street, London, 10 August 1916. Imperial War Museums © IWM (HU 59419)

Page 41 Poster for Bei unseren Helden an der Somme (With our Heroes on the Somme), designed by Hans Rudi Erdt, 1917. Lithograph on paper (printed by Hollerbaum and Schmidt), 1428 x 951 Imperial War Museums © IWM PST 7227

Page 44 'Happy "Tommies" wearing Helmets' Postcard, n.d. Private Collection

Page 47 Lieutenant Tonks, RAMC, at Aldershot, Hampshire Photographed by Sidney Wallbridge, 1916. Dr Andrew Bamji

Page 49 Wyndham Lewis photographed by George Charles Beresford, 1917. Modern print from original half-plate glass negative, 115 x 109 © National Portrait Gallery, London (NPG x6534)

Page 51 The Artist: Self-Portrait Sir William Orpen, 1917. Oil on panel, 609 x 495 Imperial War Museums © IWM (Art. IWM ART 2993)

Page 52 Selbstbildnis mis rotem Shal (Self-Portrait with Red Scarf) Max Beckmann, 1917. Oil on canvas, 800 x 600 Stuttgart, Staatsgalerie. Inv .: 2327. Photo: Lutz Braun © 2013. Photo Scala, Florence/BPK, Bildagentur fuer Kunst, Kultur und Geschichte, Berlin

Page 54 Selbstbildnis als Soldat (Self-Portrait as a Soldier) Otto Dix, 1914. Oil on paper Kunstmuseum Stuttgart © DACS 2013

Page 55 Die Skatspieler (The Skat Players) Otto Dix, 1920. Oil and collage of canvas, 1100 x 870 Berlin, Nationalgalerie, Staatliche

Museen zu Berlin. Inv. FNG 74/95. Property of the Association of Friends of the Nationalgalerie. Photo: Joerg P. Anders. © 2013. Photo Scala, Florence/BPK, Bildagentur fuer Kunst, Kultur und Geschichte, Berlin

Page 56 We are Making a New World Paul Nash, 1918. Oil on canvas, 711 x 914 Imperial War Museums © IWM ART 1146

Page 64 King Albert I of Belgium Postcard, n.d. (photograph by Keturah Collings, n.d.) Private Collection © reserved

Page 66 Kaiser Wilhelm II Postcard, n.d. Private Collection

Page 74 (left) Nedeljko Cabrinovic (one of Princip's six conspirators) is arrested in Sarajevo, 28 June 1914. Photograph by Milos Oberajger/Topical Press Agency/Getty Images

(Right) The conspirators on trial. Princip is seated in the centre of the front row, October 1914. © Hulton Archive/Getty Images

Page 78 Soldiers of King Albert the Ready Walter Richard Sickert, 1914. Oil on canvas, 1990 x 1538 Sheffield Galleries and Museums Trust, UK/Photo © Museums Sheffield/The Bridgeman Art Library

Page 80 A Group of Soldiers C.R.W. Nevinson, 1917 Oil on canvas, 914 x 609 Imperial War Museums © IWM (Art.IWM ART 520)

Page 90 The Tin Hat Sir Jacob Epstein, 1916. Bronze, 335 x 250 x 320 Private Collection/The Bridgeman Art Library © The estate of Sir Jacob Epstein/IWM (Art. IWM ART 2756)

Page 92 The Gas Mask. Stretcher-Bearer, RAMC, near Arras Sir William Orpen, 1917. Charcoal on paper, 482 x 431 Imperial War Museums © IWM (Art. IWM ART 3037)

Page 96 Paths of Glory C.R.W. Nevinson, 1917. Oil on canvas, 457 x 609 Imperial War Museums © IWM (Art. IWM ART 518)

Page 128 British soldiers being buried Postcard, n.d. Private Collection

Page 132 German soldiers receiving medals Postcard, n.d. Private Collection

Page 138 Blown Up Sir William Orpen, 1917. Pencil and watercolour on paper, 584 x 431 Imperial War Museums © IWM (Art. IWM ART 2376)

Page 140 Gassed John Singer Sargent, 1919. Oil on canvas, 2310 x 6111 Imperial War Museums © IWM (Art. IWM ART 1460)

Page 154 A Dead German in a Trench Sir William Orpen, 1917. Pencil, watercolour and ink on paper, 608 x 480 Imperial War Museums © IWM (Art. IWM ART 2385)

Page 160 Selbstbildnis (Self-Portrait) Max Beckmann, 1919 (appears on the title page of the publication Die Hölle (Hell). Print on imitation Japanese paper (chalk lithograph), 880 x 631 Hannover, Sprengel Museum. Inv. N.: Gr. 1965,172,b. Photo: Michael Herling/Aline Gwose © 2013. Photo Scala, Florence/BPK, Bildagentur fuer Kunst, Kultur und Geschichte, Berlin

Page 162 A dead German soldier outside his dugout. Beaumont Hamel, France, by an unknown photographer, 1917. Black and white photograph Australian War Memorial

Exhibition works

1. Torso in Metal from the Rock Drill Sir Jacob Epstein, 1913–14. Bronze, 705 x 584 x 445 Tate Image: © Tate, London 2014

2. King George V after Sir Luke Fildes, after 1912. Oil on canvas, 1870 x 1220 Government Art Collection (UK) Image: © Crown copyright: UK Government Art Collection

3. Kaiser Wilhelm II August Böcher, 1917. Oil on canvas, 1047 x 762 Imperial War Museums Image: © IWM ART 5608

4. Franz Josef I of Austria Kasimir Pochwalski, c.1900. Oil on canvas, 860 x 660 Government Art Collection (UK) Image: © Crown copyright: UK Government Art Collection

5. Raymond Poincaré, President of France Pierre Petit (Paris), c.1913–15 Postcard (n.d.), 153 x 99 Private Collection

6. Tsar Nicholas II of Russia and his cousin King George V of Great Britain Ernst Sandau, 1913. Photograph, 216 x 152 Mansell Collection, courtesy of Time, Inc.

7. Imperial Presentation Box Workmaster Henrik Emanuel Wigström; miniaturist Vassily Zuiev, 1916. Two-coloured gold, guilloche enamel, brilliant and rose-cut diamonds, 33 x 95 x 64 The Royal Collection Trust Image: © Her Majesty Queen Elizabeth II 2014

8. Archduke Franz Ferdinand Theodor Breitwieser, n.d. Oil on canvas, 310 x 240 Lobkowicz Collections Image: Lobkowicz Collections, Nelahozeves Castle, Czech Republic/The Bridgeman Art Library

9. Gavrilo Princip Unknown photographer, 1914. Modern print from a halftone reproduction Imperial War Museums Image: © IWM Q 91840

10. The Integrity of Belgium Walter Sickert, 1914. Oil on canvas, 910 x 710 Government Art Collection (UK) Image: © Crown copyright: UK Government Art Collection

11. La Mitrailleuse C.R.W. Nevinson, 1915. Oil on canvas, 610 x 508 Tate: Presented by the Contemporary Art Society 1917 Image: © Tate, London 2014

12. Field Marshal Sir Douglas Haig, KT, GCB, GCVO, KCIE, Commander-in-Chief, France, from 15 December 1915. Painted at General Headquarters. Sir William Orpen, 1917. Oil on canvas, 749 x 635 Imperial War Museums Image: © IWM ART 324

13. General Sir Herbert C.O. Plumer, GCMG, GCVO, KCB, painted at Headquarters, Second Army. Sir William Orpen, 1918. Oil on canvas, 914 x 762 Imperial War Museums Image: © IWM ART 2398

14. Field Marshal von Hindenburg August Böcher, n.d. Oil on canvas, 800 x 571 Imperial War Museums Image: © IWM ART 4216

15. Marshal Foch, OM Sir William Orpen, 1918. Oil on canvas, 914 x 762 Imperial War Museums Image: © IWM ART 3046

16. Aleksei Alekseevich Brusilov Unknown photographer, n.d. Postcard (c.1916), 135 x 86 Private Collection

17. A Grenadier Guardsman Sir William Orpen, 1917. Oil on canvas, 914 x 762 Imperial War Museums Image: © IWM ART 3045

18. An American Soldier Sir Jacob Epstein, 1917. Bronze bust, 405 x 265 x 282 Imperial War Museums Image: © IWM ART 2751

19. Royal Irish Fusiliers: 'Just come from the Chemical Works, Roeux: 21st May 1917' Sir William Orpen, 1917. Charcoal on paper, 520 x 419 Imperial War Museums Image: © IWM ART 3013

20. A Man in a Trench: April 1917, two miles from the Hindenburg Line Sir William Orpen, 1917. Pencil and wash on paper, 482 x 381 Imperial War Museums Image: © IWM ART 3030

21. The Dead Stretcher-Bearer Gilbert Rogers, 1919. Oil on canvas, 1019 x 1270 Imperial War Museums Image: © IWM ART 3688

22. Scenes from Battle of the Somme Geoffrey Malins and John McDowell, 1916. Film courtesy Bundesarchiv (Federal Archives); film stills (1917) courtesy Imperial War Museums (left to right): © IWM (IWM FLM 1658), © IWM (Q 79501), © IWM (Q 70696), © IWM (Q 101064)

23. *Bei unseren Helden an der Somme*
(*With our Heroes on the Somme*)
Bild und Film-Amt (BUFA), 1917
Film courtesy Bundesarchiv
(Federal Archives);
film stills courtesy Imperial War
Museums; rights: Bundesarchiv
Berlin; world sales: Transit Film
GmbH

24. Geoffrey Malins
Unknown photographer, n.d.
Imperial War Museums
Image: © IWM HU 93115

25. Unidentified
Unknown photographer, 1914.
Imperial War Museums
Image: © IWM Q 53343

26. Private Sidney Frank Godley
Unknown photographer, 1914.
Imperial War Museums
Image: © IWM Q 80449

27. Maria Bochkareva
Unknown photographer, n.d.
Library of Congress

28. Robert Graves
Unknown photographer, n.d.
The Private Collection of
Sir William Graves

29. Lieutenant Maurice Dease
Unknown photographer, 1914.
Imperial War Museums
Image: © IWM Q 70451

30. Sir William Orpen
Unknown photographer, n.d.
Imperial War Museums
Image: © IWM HU 93498

31. Alec Reader
Unknown photographer, n.d.
Imperial War Museums
Image: © IWM HU 63257

32. Shahamad Khan
Unknown photographer, 1916.

33. Captain Albert Jacka
Unknown photographer, 1915.
Imperial War Museums

34. Wilfred Owen
John Gunston, 1916.
© National Portrait Gallery,
London (P515)

35. Sir William Leefe Robinson
Unknown photographer, n.d.
Private Collection/The Bridgeman
Art Library

36. Walter Tull
Unknown photographer, n.d.
Courtesy of Phil Vasilli

37. Baron von Richthofen
Unknown photographer, n.d.
Paul Chamberlain Archive,
Royal Air Force Museum

38. Unidentified
Ernest Brooks (Lt), 1917.
Imperial War Museums
Image: © IWM Q 2860

39. Unidentified
Unknown photographer, 1915.
Imperial War Museums
Image: © IWM HU 57430

40. Boy (1st Class) John (Jack)
Travers Cornwell
Unknown photographer, n.d.
Imperial War Museums
Image: © IWM Q 20883

41. Paul Cadbury
Unknown photographer, c.1915.
Religious Society of Friends in
Britain (Quakers);
Image: © Religious Society of
Friends in Britain (Quakers)

42. Elsie Knocker
S.A. Chandler & co, n.d.
National Portrait Gallery, London
(NPG x87250)

43. Private Reginald Roy Inwood
Unknown photographer, 1918.
Imperial War Museums
Image: © IWM Q 68298

44. Corporal Leslie Wilton Andrew
F.A. Swaine, n.d.
Imperial War Museums
Image: © IWM Q 70010

45. Edith Cavell
Unknown photographer, 1910s.
Image: © National Portrait Gallery,
London (NPG x4185)

46. Stoker Petty Officer Harold Jordan
Unknown photographer, n.d.
Imperial War Museums
Image: © IWM HU 96667

47. Harold Gillies
Unknown photographer, 1915.
British Association of Plastic,
Reconstructive and Aesthetic
Surgeons

48. Private Harry Farr
Unknown photographer, 1916.
Press Association Images

49. Albert Ball
Unknown photographer, 1917.
Imperial War Museums
Image: © IWM Q 69593

50. Lance Corporal Harry van Tromp
Unknown photographer, n.d.
Imperial War Museums
Image: © IWM HU 93558

51. Kulbir Thapa
Unknown photographer, n.d.
The Gurkha Museum

52. Private William Cecil Tickle
Unknown photographer, n.d.
Imperial War Museums

53. Private Ivor Evans
Unknown photographer, n.d.
Imperial War Museums
Image: © IWM HU 93410

54. Isaac Rosenberg
London Art Studios, 1915.
© National Portrait Gallery, London
(P230)

55. Captain Noel Chavasse
Unknown photographer, n.d.
Imperial War Museums
Image: © IWM Q 67309

56. Unidentified
Unknown photographer, 1915/1917.
Bundesarchiv (Federal Archives)
© Bundesarchiv, Bild 183-S66745

57. 2nd Lieutenant Maxwell Dalston
Barrows
Unknown photographer, n.d.
Imperial War Museums
Image: © IWM HU 96610

58. Mata Hari
Unknown photographer, n.d.
Imperial War Museums
Image: © IWM Q 68201

59. Captain Billie Nevill
Unknown photographer, n.d.
Imperial War Museums
Image: © IWM HU37095

60. Paul Nash
Bassano Ltd., 29 April 1918.
Image: © National Portrait Gallery,
London (x4084)

61. Flora Sandes
Ariel Varges, n.d.
Imperial War Museums
Image: © IWM Q 32704

62. Corporal Filip Konowal
Elliot & Fry, 1917.
Imperial War Museums
Image: © IWM Q 69170

63. Siegfried Sassoon
Unknown photographer, n.d.
Imperial War Museums
Image: © IWM Q 101780

64. Sir Winston Churchill
Sir William Orpen, 1916.
Oil on canvas, 1480 x 1025
Lent by the Churchill Chattels
Trust
Image: © National Portrait Gallery,
London (NPG L250)

65. 2nd Lieutenant Gilbert S.M. Insall
VC, MC, RFC
Edward Newling, 1919.
Oil on canvas, 1123 x 869
Imperial War Museums
Image: © IWM ART 2629

66. Major J.B. McCudden, VC, DSO,
MC, MM
Sir William Orpen, 1918.
Oil on canvas, 914 x 762
Imperial War Museums
Image: © IWM ART 2979

67. Captain G.B. McKean, VC, MC, MM
G.C. Leon Underwood, 1919.
Oil on canvas, 914 x 762
Imperial War Museums
Image: © IWM ART 1924

68. Captain A. Jacka, VC, MC and Bar
Colin Gill, 1919.
Oil on canvas, 914 x 812
Imperial War Museums
© IWM ART 1915

69. *An RAMC Stretcher-Bearer, Fully
Equipped*
Gilbert Rogers, 1919.
Oil on canvas, 1524 x 1019
Imperial War Museums
Image: © IWM ART 3775

70. *The Receiving Room: The 42nd
Stationary Hospital*
Sir William Orpen, 1917.
Pencil and watercolour on paper,
457 x 558
Imperial War Museums
Image: © IWM ART 2952

71. *Gassed and Wounded*
Eric Kennington, 1918.
Oil on canvas, 711 x 914
Imperial War Museums
Image: © IWM ART 4744

72. Soldiers with facial wounds
(left to right)
569.53
Henry Tonks, 1916–18
Pastel on paper, 278 x 203
Courtesy of the Hunterian Museum
at the Royal College of Surgeons
Image: © The Royal College of
Surgeons of England

569.54
Henry Tonks, 1916–18
Pastel on paper, 277 x 198
Courtesy of the Hunterian Museum
at the Royal College of Surgeons
Image: © The Royal College of
Surgeons of England

569.55
Henry Tonks, 1916–18
Pastel on paper, 275 x 211
Courtesy of the Hunterian Museum
at the Royal College of Surgeons
Image: © The Royal College of
Surgeons of England
569.56
Henry Tonks, 1916–18
Pastel on paper, 278 x 211
Courtesy of the Hunterian Museum
at the Royal College of Surgeons
Image: © The Royal College of
Surgeons of England

73. Soldier undergoing reconstructive
surgery (pages 144–5)
2nd Lieutenant R.R. Lumley (file
number MS0513/1/1/1284), 29
December 1917.
Photographs, 315 x 202 (folio
dimensions)
From the Archives of the Royal
College of Surgeons of England
Images: © The Royal College of
Surgeons of England

(pages 146–7)
Soldier undergoing reconstructive
surgery
Private Dalrymple (file number
MS0513/1/1/514),
10 April 1918 and 20 January 1920.
Photographs, 307 x 192 (folio
dimensions)
From the Archives of the Royal
College of Surgeons of England
Images: © The Royal College of
Surgeons of England

73. Self-Portrait
Isaac Rosenberg, 1915.
Oil on panel, 295 x 222
© National Portrait Gallery, London
(NPG 4129)

74. Siegfried Sassoon
Glyn Philpot, 1917
Oil on canvas, 610 x 508
The Fitzwilliam Museum, Cambridge
Image: © The Fitzwilliam Museum,
Cambridge

75. Self-Portrait
Sir William Orpen, 1917.
Oil on canvas, 762 x 635
Imperial War Museums
Image: © IWM ART 2382

76. *Bildnis Hermann Struck* (Portrait of
Hermann Struck)
Lovis Corinth, 1915.
Oil on canvas, 805 x 595
Städtische Galerie im Lenbachhaus
und Kunstbau, Munich

77. *Selbstbildnis als Soldat* (Self-por-
trait
as a Soldier)
Ernst Ludwig Kirchner, 1915.
Oil on canvas, 690 x 610
Allen Memorial Art Museum, Oberlin
College, Ohio; Charles F. Olney
Fund, 1950
Image: © Allen Memorial Art Muse-
um, Oberlin College, Ohio

78. *Die Hölle: Der Nachhauseweg*
(*Hell: The Way Home*)
Max Beckmann, 1919.
Lithograph, 870 x 610
Scottish National Gallery of Modern
Art
Image: © Scottish National Gallery
of Modern Art

79. *Arbres morts et tranchée après un
bombardement* (Dead trees and
trench after a bombing)
Jules Gervais-Courtellemont, n.d.
Autochrome photograph, 90 x 120
Jules Gervais-Courtellemont/
Cinémathèque Robert Lynen/
Roger-Viollet

INDEX

Page numbers in *italics* refer to captions.

Published in Great Britain by
National Portrait Gallery Publications
St Martin's Place, London WC2H 0HE

Published to accompany the exhibition *The Great War in Portraits* at the National Portrait Gallery, London, from 27 February to 15 June 2014.

This exhibition has been made possible by the provision of insurance through the Government Indemnity Scheme. The National Portrait Gallery, London, would like to thank HM Government for providing Government Indemnity and the Department for Culture, Media and Sport and Arts Council England for arranging the indemnity.

The National Portrait Gallery's Spring Season 2014 is sponsored by Herbert Smith Freehills.

For a complete catalogue of current publications, please write to the National Portrait Gallery at the address above, or visit our website at www.npg.org/publications

ISBN 978 1 85514 468 2

A catalogue record for this book is available from the British Library.

10 9 8 7 6 5 4 3 2 1

Printed in China

Managing Editor: Christopher Tinker
Editor: Andrew Roff
Copy-editor: Denny Hemming
Proofreader: Laura Nickoll
Production Manager: Ruth Müller-Wirth
Design: Will Webb
Picture research: Zuzu Dowd

Page 2: *La Mitrailleuse*, C.R.W. Nevinson, 1915 (detail of cat. 11)

Page 4: Boy (1st Class) John (Jack) Travers Cornwell, n.d. (detail of cat. 40)

Page 8: *Selbstbildnis als Soldat* (Self-portrait as a Soldier), Ernst Ludwig Kirchner, 1915 (detail of cat. 78)

Page 58: Study for the *Rock Drill*, Sir Jacob Epstein, *c.*1913 (detail of image on page 28)

Page 62: Gavrilo Princip by an unknown photographer, 1914 (detail of cat. 9)

Page 76: *A Man in a Trench: April 1917, two miles from the Hindenburg Line*, William Orpen, 1917 (detail of cat. 20)

Page 98: A scene from *Battle of the Somme*, Geoffrey Malins and John McDowell, 1916 (detail of top image, page 101)

Page 104: Unidentified by an unknown photographer, 1915 (detail of cat. 39)

Page 148: *Die Hölle: Der Nachhauseweg* (Hell: The Way Home), Max Beckmann, 1919 (detail of cat. 79)